Rubies & Rebels

THIS EXHIBITION IS DEDICATED
TO THE MEMORY OF THE ARTIST SANDRA FISHER
WHO DIED IN SEPTEMBER 1994

Edited by
Monica Bohm-Duchen
and Vera Grodzinski

Rubies & Rebels

Jewish Female Identity in Contemporary British Art

Lund Humphries Publishers
London

First published in 1996 by Lund Humphries Publishers
Park House · 1 Russell Gardens · London NW11 9NN
on the occasion of the exhibition
Rubies and Rebels: Jewish Female Identity in Contemporary British Art
Barbican Concourse Gallery, 8 October–10 November 1996
The University Gallery, Leeds, and Leeds Metropolitan University Gallery,
22 November 1996–10 January 1997

British Library Cataloguing in Publication Data
A catalogue record of this book is available from the British Library

ISBN 0 85331 703 8

Distributed in the USA by Antique Collectors' Club
Market Street Industrial Park · Wappingers Falls · NY 12590 USA

Designed and typeset in Utopia and Strayhorn by Dalrymple
Made and printed in Great Britain by BAS Printers Limited,
Over Wallop, Stockbridge, Hampshire

THE MUSEUM OF WOMEN'S ART

The Museum of Women's Art is pleased to be collaborating on
the exhibition *Rubies and Rebels: Jewish Female Identity in
Contemporary British Art*. MWA is a charitable foundation
established in 1992, which exists to recover, represent and
celebrate the work of women visual artists. To achieve this it
intends to establish a permanent museum of national and
international standing in London for the exhibition and study
of women's art.

CONTENTS

NOTES ON CONTRIBUTORS

MONICA BOHM-DUCHEN is a freelance writer, lecturer and exhibition organiser with a special interest in women's issues and the question of Jewish identity in modern art. She has worked for the Tate Gallery, the National Gallery, the Royal Academy of Arts and the Open University, and has contributed to *The Jewish Quarterly, RA Magazine, Art Monthly, Women Artists Slide Library Journal*, and the catalogue of the Ben Uri Art Society permanent collection. Her previous publications include *After Auschwitz: Responses to the Holocaust in Contemporary Art* (Lund Humphries, 1995), which accompanied a major touring exhibition which she also curated. Her monograph on Marc Chagall is forthcoming.

VERA GRODZINSKI is a lecturer in modern Jewish history, curator and dealer in British modern and contemporary art. She was born in Hungary and was educated in Germany, Switzerland, Israel and England, where she has lived since 1965. She has been a language teacher and has worked as editorial assistant at the *Jewish Quarterly* and as lecturer and assistant Cultural Director at the Spiro Institute. She was guest lecturer at the Wagner Programme at the University of Judaism in California in 1989/90. She has curated photo-documentary and art exhibitions and is at present involved with the art and cultural programmes of several Jewish institutions. Her main interests are Jewish social and cultural history, modern art and Jewish women's studies.

GRISELDA POLLOCK is Professor of Social and Critical Histories of Art and Director of the Centre for Cultural Studies at Leeds University. She is the author of numerous books, including *Vision and Difference: Femininity, Feminism and Histories of Art* (1988), and *Avant-Garde Gambits: Gender and the Colour of Art History* (1993). One of her main research interests is the historical analysis of women's position in cultural production and consumption in the nineteenth and twentieth centuries. Forthcoming publications include *Cities and Countries of Modernism: The Case Against Van Gogh* and *Feminist Reconstructions in Art and Art History* (both 1996).

JULIA WEINER was until recently Curator of the Ben Uri Art Gallery where since 1990 she curated many exhibitions, including *Bernard Cohen: Thirty-Five Years of Drawing*, which toured to a number of regional galleries. She is the co-editor of *Jewish Artists: The Ben Uri Collection* (Lund Humphries, 1994), and is a regular contributor to *The Jewish Chronicle*. She holds a part-time post at the Courtauld Institute Galleries, where she is in charge of the education department.

ACKNOWLEDGEMENTS

The curators of *Rubies and Rebels* would like to extend heartfelt thanks to the following trusts, companies and individuals, without whose support the exhibition and related events programme would never have come to fruition:

The Austrian Cultural Institute, London; Christie's ; The Jewish Book Council; The Jewish Chronicle; The Jewish Quarterly; New Moon Magazine; The Oxford Institute for Yiddish Studies; The Spiro Institute for the Study of Jewish History and Culture.

b2 Exhibitions; The Bohm Foundation; Charities Aid Foundation; Cinenova; The John S. Cohen Foundation; Dwek Family Foundation; EG Charitable Trust; The Glass-House Trust; The Green Foundation; The Harbour Charitable Trust; The Headley Trust; The Kennedy Leigh Charitable Trust; The Kessler Foundation; The Catherine Lewis Foundation; NJL Foundation (one of the charities administered by Anthony Newton, Solicitor, 22 Fitzjohn's Avenue NW3); The Leopold Rothschild Charitable Trust; The Staples Trust; The Sir Sigmund Sternberg Charitable Foundation; Tapper Charitable Foundation; The Tedworth Charitable Trust; VG Charitable Trust; F. and D. Worms Charitable Trust.

Jean Balcombe; Jack Bentata; Lionel Black; Victor Blank; Janet de Botton; Denise Cattan; Ruth Cohen; Professor Sam and Dr Vivien Cohen; Bernard Eder; Muriel and Ralph Emmanuel; Manfred and Lydia Gorvy; Michael Green; Samuel Grodzinski and Marion Baker; Peter Held; Arnold Horwell; Marilyn Lehrer; Cecily Lowenthal; Leslie Michaels; Rozsika Parker; Suzanne Perlman; Godfrey Pilkington; Gordon and Karen Pollock; A. and F. Rubens; Esther Tager; Cathy Wills.

We are grateful to Zoe Adams, Marilyn Aron, Maurice Garfield, Sarah Phillips, Phyllis Rapp, Tanja Rebuck, Brenda Rosen and Rowena Williams for their invaluable practical assistance, and to Belinda Harding, Monica Petzel and Melanie Roberts of the Museum of Women's Art for collaborating with us on this project. Our thanks go too to R. B. Kitaj, Griselda Pollock and Julia Weiner for agreeing to contribute so interestingly to this catalogue and last, but by no means least, to the artists themselves, who have made this exhibition possible.

✻

All Jewish terms marked * can be found in the glossary on pages 110–12 at the end of the book.

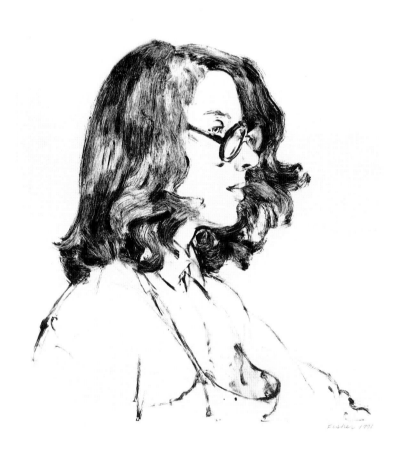

SANDRA

R. B. Kitaj

I've sent her ashes home to California where I will join her again and lie beside her again, far, far away from London. Many people thought that Sandra was the most beautiful woman they knew. As soon as anyone got to know her, it became clear that she was just as beautiful on the inside as on the outside. Motherhood became her radiant beauty as she designed Max (and painted him) during their ten short years together. She took him to Rabbi Friedlander's Religion School each Sunday and she taught Max the Shabbat* prayer for Friday evenings. Unlike me, she had been brought up in the faith in America and had never questioned it. Max and I don't light candles any more. God was out to lunch when Sandra was destroyed in London, as my comrade Philip Roth puts it.

She came into my life in 1970 as a passionate Jewishness began to form crazily in me. She seemed like a shining California miracle of new-old Jewish womanhood invented in the Diaspora*. She encouraged me to bring the art of drawing back into my daily work after it had been dozing fitfully for half a decade. All three – Sandra, Jewishness and drawing – became exciting dramas of high passion bursting upon me and my art in wave after fateful wave, combining and never subsiding during the twenty-four years she and I were to have together. Jewish Identity in Art. How often she and I talked about that controversial magic together and with many friends, Jewish and Christian and those who wished to be neither. A dear friend (Leon Wieseltier) – very Jewish – has just published a book: *Against Identity.* The more I acted out the all but forbidden and truly forbidding drama of Jewishness in art – which I identify with modernism itself (but that's another story) – the more 'advanced' the persuasion seemed to me, my *own* avant-garde, and I could spill it out to Sandra in all its folly and beauty each day for a quarter century. Many Jews in art hate the very idea of a Jewish Art but many Jews also seem to want to listen and watch and maybe come out to play. Sandra had to contend with my mania *and* with her own painting mania, and she did both with true grit. She was the Berthe Morisot of my dreams. About two in ten of her small unfashionable paintings were beautiful by the time she turned forty and she was almost at three in ten when she died. Any real painter will know that her (mostly) alla prima method is tough going. I don't think she could have perpetrated a crime, which Degas said was what painting was like for him, but I like to think the old bastard would have bought one or two of her little pictures even though she was Jewish.

As the great and aged historian Simon Dubnow was taken away to be murdered by Nazi thugs, he shouted out 'Varschreibt!' (Write it down!). There are many, many variants of anti-Semitism, all the way from gas ovens to harmless bias. Since this exhibition, dedicated to Sandra's memory, is concerned with Jewish female identity, I will share with you, dear reader, a beautiful line from one of the last letters sent to her. 'Dear Sandra Fisher, … As yet another Jew parasitising [sic] "goy" countries and their inhabitants, you have been marked down to be targeted…' Well, evil souls haven't changed much in the many genocidal years since Eliot targeted 'freethinking Jews' like Sandra and me, and the artists in this show. At least Eliot *did* something with his art, if not with his life, unlike the scribblers whose mean lives are measured only in column-inches of hate literature. After her death I showed Sandra's miserable letter to two Holocaust survivors, dear painter comrades whose advice I keenly listen to. One said: 'Bury the letter in the deepest place'. The other said: 'Publish it in *The Times*'. Sounds like a Hasidic* parable out of Buber, doesn't it?

Sandra, I will overpower the living dead (as in the movie) because you made me the Golden Lion (of Judah) that I am today, and because I'm now using your old brushes, your stained easels, your paints, your palettes, even your apron, every day.

> *My last goodnight! Thou will not wake*
> *Till I thy fate shall overtake*

Sandra Fisher, Kitaj's wife, died suddenly in September 1994, aged 47

INTRODUCTION

Vera Grodzinski

In traditional circles, each Friday night before the Shabbat* meal, it is customary for a husband to sing the praises of his wife by reciting from Chapter 31 of the biblical Book of Proverbs: 'A woman of worth who can find her? For her price is far above rubies'. The title of this exhibition – *Rubies and Rebels* – has been chosen to reflect the contrasting aspects of a Jewish woman as dutiful wife and rebellious individual.

When Rosalind Preston approached me in 1992 to give voice and space to Jewish women artists, I had no idea what I would find; in fact, I was doubtful whether this could be a serious proposition. After some months of early tentative searches, however, I began to see possibilities. Realising that I needed someone to share my investigations, I approached Monica Bohm-Duchen to see whether such an exhibition could become a reality. Together we embarked on a project that was to prove both rewarding and exhilarating. We soon found the unexpected: that there were many women artists working in this country, some within the Jewish community, some on the fringes and some outside it, all of whom felt that their Jewishness formed an integral part of their artistic identity.

Through the grapevine, more and more women heard about the planned exhibition, and slowly but steadily, over the last four years, some 130 artists submitted their work for consideration. In the event, we have selected twenty artists whose work we felt was not only of outstanding artistic merit, but also addressed issues of Jewish female identity in a way that seemed both pertinent and timely. Our apologies go to those we were unable to include.

If *Rubies and Rebels* is a success story, it has won out against the odds, not least financial ones. It is only through the faith and perseverance of those with vision, and the financial backing of a few organisations and individuals, that the exhibition, the related events programme and this catalogue have become a reality.

Although it forms part of a more wide-ranging debate about Diaspora* Jewish identity in the late 1990s, this project also continues a line of feminine / feminist activities initiated by me in the early 1970s at the height of the 'Women's Liberation Movement'. Arising from my academic research into 'Female Jewish Identity', I approached friends, who in turn approached their friends, with a view to forming discussion groups on the subject of women's position within the British Jewish community.

The first meetings were so well attended and proved so popular that we had to split into various smaller groups to find

living rooms large enough to accommodate us and our diverse interests. 'Consciousness-raising Groups' were formed – very much a feature of the 1970s cultural climate; a Get* and Agunah* Group emerged, as did a 'Body Group', dealing with physically related, halakhically * prescribed Orthodox* regulations within a marital relationship; furthermore, we addressed traditional, but highly personal issues such as women's covering of their hair and the wearing of sheitels*, the customs of Niddah*, and its effect on women's psyche and wellbeing. Within this group, women addressed the relevance of prayers after childbirth and their deeply felt need for a stronger participatory role in religious life: a natural progression seemed the planning of Women's Religious Services.

This in turn greatly influenced the planning of the first 'Jewish Women's Conference' at Carmel College under the auspices of the headmaster, an Orthodox* rabbi. Here, on a Saturday morning in the summer of 1975, the first 'Women's Service' was held in the modern synagogue in the grounds of the college; it was an historic occasion.

These events, both the founding, expansion and popularity of the Women's Groups and the historic 'Women's Service' at Carmel College, were duly reported in the *Jewish Chronicle* in December 1974 and July 1975. What went unreported, however, was the pressure that the leadership of the 'Movement' and many of its members had been placed under not to 'rock the boat' and incur 'damage' to the 'harmony and equilibrium of Anglo-Jewry'. Under Establishment pressure on their leadership, the groups dispersed.

Those in authority need not have worried: it took nearly another twenty years for the newly appointed Chief Rabbi Dr Jonathan Sacks to initiate a Review of 'Women in the Jewish Community'. Rosalind Preston, chairwoman of the project, headed the investigation, assisted by a dedicated group of women. Launched in 1992, the Review was intended to create a long-overdue 'opportunity for discussion of the critical issues affecting women's lives; spiritual and material, domestic and professional, individual and communal, in the home and in the synagogue'.

The report *Women in the Jewish Community: Review and Recommendations* was published in 1994, but even now, two years later, no major changes have been seen. Yet women will not be silenced again.

In those intervening twenty years, more and more women were attracted to communities which afforded them more 'space'. Within the Reform* and Liberal* Movements, Jacqueline Tabick was ordained rabbi at Leo Baeck College in 1975, and since those early days a further twenty-four women have been ordained to the rabbinate in Britain alone. These women rabbis form an important minority; in 1994 they published an aptly titled anthology *Hear our Voice: Women Rabbis Tell their Stories*, edited by Rabbi Sybil Sheridan. In

addition, over the years, women's Rosh Chodesh* groups have been set up in numerous communities all over the country. Undoubtedly, Judaism has become a feminist issue; many women from many sections of the community are seeking a reinterpretation of Halakhah*.

Despite Chief Rabbi Dr Jonathan Sacks's ban on the use by women of the Holy Scrolls (Torah*), which traditionally women were not even allowed to touch, let alone read publicly in the synagogue, women activists did just that at another historic 'Woman Only Service' at the New North London (Masorti*) Synagogue in July 1994. Since then, similar women's services have been held there regularly every four months. Moreover, women have taken on the responsibility of carrying out and teaching their daughters communal Torah* readings, prayers and rituals traditionally only performed by men.

Early Jewish feminists' voices were revived in the late 1980s, when, through the influence of Professor Alice Shalvi, a founder of the Israeli Women's Network, a London group called 'Doves' was formed. In 1993 another attempt was made to galvanise Jewish women with the formation of the Jewish Women's Network, headed by Sharon Lee, which now attracts a steady following.

The 'Half-Empty Bookcase' Conference, now an annual event, was instigated in 1992 by women rabbis trying to fill the 'other half' of the bulging Hebrew and Jewish bookcase. Totally unexpectedly, the first conference attracted over 300 partici-pants and the event continues to go from strength to strength, attracting internationally renowned Jewish feminist theolo-gians.

I am particularly happy that two women involved in those early heady days of the 1970s are contributing to the *Rubies and Rebels* project. Judy Bermant continues to be an artist of great integrity and talent, and Sonja Lyndon (who is participating in the related events programme), has emerged as a writer, editor and playwright of distinction. Both work with a strong sense of Jewish identity: it is their voices and images that we want to continue to hear and see, changing and growing as we adapt and change with the lives and cultures around us.

Possibly unaware of the historical milestones outlined above, but conscious of the general debate and the pervading cultural climate, the imagination of other artists – be they writers, poets, film-makers, painters or sculptors – has been ignited. For too long invisible and silent, today Jewish women carry their awareness of religious tradition, of the historical legacy of the Shoah* and the regeneration of life thereafter, in their everyday lives and work. Maybe it needed twenty years for this exhibition to come to fruition; its seeds, however, were surely sown in the 1970s.

IS FEMINISM TO JUDAISM AS MODERNITY IS TO TRADITION ?
Critical Questions on Jewishness, Femininity and Art

Griselda Pollock

A HAPPY ENCOUNTER

Scanning the pages of *The Englishwoman's Journal* for the year 1863, while researching advanced women's attitudes to women artists in the mid-nineteenth century, I came across the 'Notes of an Extempore Sermon Preached by the Reverend Professor Marks, on the first day of the feast of Tabernacles, 6 October 1862, at the West London Synagogue of British Jews, Margaret Street, Cavendish Square.' Titled 'The Status of Jewish Women in Biblical Times', Marks's sermon proudly declared the commitment of his synagogue – the first Reform* synagogue in Britain, founded in 1842 – to improving the status of Jewish women in the nineteenth century.

Delighted to find a Jewish presence in a 'modern' women's journal, I was intrigued to recognise a current debate already in full swing over a hundred years ago. The relation of women to, and their status within, Jewish religious tradition and social custom is certainly a topical issue. Since the early 1970s, the re-emergence of women's political and social self-consciousness in general has found an echo in the Jewish community. An early clutch of Jewish women's writings appeared in the 1971 issue of the American magazine *Davka,* to be followed in 1972 by a special issue of *Response* on 'The Jewish Woman'. Sally Priesand became the first American Jewish woman to be ordained a rabbi in 1972 and Jacqueline Tabick received Smichah* in London in 1975. The first National Jewish Women's Conference in the United States was held in 1973 while various Jewish Women's

Groups formed as early as 1974, with the first British conference of Jewish Women being held at Carmel College in 1975. Rosh Chodesh* and Women's Prayer Groups have been cautiously appearing over the last two decades in both London and the provinces and these early initiatives inform more recent British groupings like the Jewish Women's Network, founded in 1993, or the annual conferences entitled 'The Half-Empty Bookcase', launched in 1992, or the communal investigation chaired by Rosalind Preston under the aegis of the United Synagogue which explored all aspects of 'Women in the Community'.[1] Under these local initiatives social, legal, ritual as well as cultural and educational issues have been thrown up for heated discussion and possible improvement.

Since the early 1970s a considerable literature has appeared. Titles such as *The Jewish Woman, On Being a Jewish Feminist, On Women and Judaism: A View from Tradition,* further underline the diversity of the debate between a range of Jewish women and the changing faces of Judaism in the post-modern world.[2] Magazines such as *Lilith* (USA), established in 1976, or the short-lived British project *Shifra, A Jewish Feminist Magazine* (1984–5) further testify to this convergence of feminist and Jewish consciousness which has put the woman question on the Jewish agenda while raising, within the larger field of women's issues, those specific to women in the Jewish world.[3]

Questions circulate now as in 1863. What is the status of women within Jewish religious law and practice, Jewish history, communal life and social thought? What are the varying legacies of biblical texts, rabbinic interpretations of law and custom, and the accumulation of lived experience and social practice that we call history? Can any of these be challenged or changed? Why might we look back to history in order to go forward? Are the issues surrounding women in Jewish life and thought of social origin or of theological significance? Does feminism meet Judaism as modernity encounters and questions tradition? Or might they be creative partners both in a profound reassessment of Jewish tradition, and in a critical examination of modernity?

The social forces of modernity and post-modernity oblige us all to review the co-ordinates of identities which hitherto fell below the threshold of analysis. 'Being a woman' was a *fact;* it was simply one side of a natural division of the sexes. Based in biology and elaborated by social custom, the fact of one's sex created an unquestionable horizon for accepting a hierarchy of gender. Feminism radically questions the difference of the sexes and the power and social dominance of men to argue that the resulting gender hierarchy is not caused by natural difference but is a product of historical, social and cultural forces. Insofar as gender divisions are of social origin, rather than of purely biological determination, the meaning and status of 'being a woman' becomes something we can change.

By the same token, 'being Jewish' is not a 'fact', but relative to hugely diverse and historically varying cultural and religious identities and the changing circumstances of where and how such identities are lived. In the past, 'being Jewish' may have been primarily a mark of religious difference that determined life and death within persecutive or tolerant, Christian or Moslem societies. Modernity, in both its emancipatory and genocidal guises, has made 'being Jewish' almost a paradigm of 'the modern condition', intimately bound up with questions of strangeness and Diaspora*. The contemporary figure of 'the Jew' presents to modernist thought's desire for homogeneity and order the tenacious demand for acknowledgement of cultural specificity, while further touching on conflicts between secular and social ethnicities, and religious, often fundamentalist sectarianism.[4]

A NEW SUBJECT: JEWISHNESS, FEMININITY AND ART

Laid out in such sweeping terms, it is clear that we are marking out a new terrain by turning a women-focused spotlight upon a complex conjunction of modernity and the making or unmaking of social identities. Traditional certainties – often nostalgically invented in retrospect and, therefore, always suspect – crumble before the rapid assault of modernity, and more recently, post-modernity on all notions of fixed identities and stable meanings. When the cultural historian examines the shifting kaleidoscope of possibilities suggested by the conjunction of Jewishness, femininity and art, there is no single story to tell. Each term in the equation is a condensation of historical, religious, social and cultural complexity. Their conjugation, as in the title and topic of this exhibition, opens up a space for fascinating reflections on hitherto unconsidered relationships and differences. These need to be put into each of these perspectives: historical, cultural, political, economic, religious. The sermon I found in the the nineteenth-century women's journal is but one fragment of that monumental encounter whose legacies we still attempt to consider and accommodate: the confrontation of modernity and so-called 'Jewish experience'.

But I must immediately recoil from this term. There is no such thing as 'Jewish experience' in the singular. The phrase is far too homogeneous for the real diversity of the Jewish people in the modern world. Furthermore, even admitting the scatter of geographically and culturally diverse, politically and religiously divided Jewish communities (themselves variously influenced by the impact of larger social, economic and political forces), what most people might perceive as Jewish *experiences* – in the plural – tend to refer only to what has affected the privileged male members of the Jewish community and their consequent reactions and responses. There is still a 'half-empty bookcase' – and given the context of this event, I would

add, a 'half-empty art gallery'. Our cultural records do not fully record the lives and creative, intellectual, religious or literary contributions of women in the Jewish worlds. [5]

For instance, the major exhibition and book, *From Chagall to Kitaj*, dedicated to a review of 'Jewish Experience in Twentieth Century Art', surveyed a landscape scarcely populated by women artists.[6] Within an otherwise fascinating model for the analysis of a specifically Jewish cultural geography in our time, there was no category set aside to consider the way Jewish women negotiated and reacted to the major events of the twentieth century. Equally within the categories that the book's author, Avram Kampf, had set up for his study, there was no thought that life in, or liberation from, the ghetto might have elicited different responses from women who aspired to be artists compared to men in similar circumstances – assuming, of course, that they survived. Nor was there any consideration of the fact that bohemian life in modern Paris (where a whole community of Jewish artists made their names before 1914), or immigrant communities in New York or London's Whitechapel might have been qualified by different opportunities for, and expectations of, men and women; or, as recent research has begun to explore, that the tragedies of the Holocaust had particular inflections for women, whose experiences were further shaped by their gender, their sexuality, their maternity.[7]

The novelty of the exhibition *Rubies and Rebels* does not lie simply in presenting women as artists. After a quarter of a decade of feminist research and intervention in art history we have unarguably established women's continual and significant presence in all the histories of the world's art.[8] Nor does it lie in being a part of 'Jewish Studies', a still relatively young disciplinary formation that is, however, well established in the United States and now beginning to be recognised within British universities.[9] The special nature of this event emerges in letting these two strains cross-fertilise so that at a deeper, structural level, we then uncover unexpectedly important correlations between the predicament of women and that of the Jewish people in the modern world. Within modernity, both women and the Jewish people stand for a recalcitrant 'difference' from, or 'strangeness' within, what appear to be the dominant norms. They have come to represent a troublesome ambiguity which has often led to discrimination and persecution. Yet we must grasp the possibility, offered by that very dissidence, for a model of society that could genuinely celebrate and value difference.[10]

FRAGMENTS TOWARDS NEW HISTORIES

Attempts to correct the skewed cultural maps of modernity, that have occluded both Jewish experiences and those of women in all communities, allow us to address the complexity of that interface of the (always differentiated) 'feminine' and the (always diverse) 'Jewish' on the terrain of culture. We still only have fragments in the archive, but each is significant.

At a Rosh Chodesh* group in Leeds some years ago a member made a presentation about the first woman rabbi of modern times, Regina Jonas (1902–44), a 'German woman rabbi' who, although she was never given her own congregation, worked as a teacher, preacher and pastor in the Berlin Jewish community and in the Terezin ghetto before meeting her death in Auschwitz in 1944. Elizabeth Sarah, who has written a short memoir on 'Fräulein Rabbiner Jonas',[11] is herself a rabbi. Looking back to this courageous young woman from fifty years ago, she asks with poignancy: 'What contribution might she have made to Judaism had she survived? What difference would her survival have made to women in the rabbinate?'[12] As the first woman rabbi, recorded at least since Beruria, [13] Regina Jonas raises a highly symbolic issue. Some of the most privileged of male domains are those of theological knowledge and the right to teach.[14] What greater challenge can there be than women's demand to participate? Our ignorance of the relatively little known case of Regina Jonas is emblematic of a treble loss: the loss of the Jewish people as a whole; the loss of a generation or more of modernising Jewish women; the loss of a woman who, having entered the rabbinate in the 1930s, would have opened up that space for women forty years before anyone ever tried again.[15]

During the terrifying years of the Nazi era, the Jewish people in Europe were almost destroyed. Without diminishing the overwhelmingly comprehensive nature of this catastrophe, we need to acknowledge the real diversity of its impact. Not a massive erasure of an abstract number, six million – a number that is incomprehensible in its magnitude – the Holocaust must be thought of as a loss accumulating one by one, one by one; each unique and significant. We also need to recognise the meaning of the fact that whole generations of women died at a critical moment in the history of women.

We have but scattered relics to mark the enormity of the intellectual, artistic and spiritual loss inflicted in this century when, under the forces and possibilities of modernisation that produced the figure of 'the new woman', a 'new Jewish woman' had been emerging through those same portals: Gertrude Stein, Claude Cahun, Gluck, Chana Orloff, Sonia Delaunay, to name but a few who were eminent in the arts during the first decades of this century. Hugely well known since the publication of her diary, Anne Frank does not have to stand alone for a Jewish women's literary or artistic tradition that was prematurely cut off. Her fame, however, has eclipsed other Jewish women of that moment, like the diarist Hannah Senesh or the extraordinary Berlin artist Charlotte Salomon (1917–43).[16] In eighteen months beginning in the autumn of 1941, at the age of twenty-four, Charlotte Salomon produced a massive oeuvre of 769 paintings with hand-painted annotations, *Leben? oder Theater? (Life? or Theatre?)*. It now rests in

the Jewish Historical Museum in Amsterdam as one of the major artistic works of the Holocaust period. In this *singspiel*, or painted opera, Charlotte Salomon used her art to consider whether she could go on living under the circumstances that combined a tragic family history of female suicides with the new terrors of the Nazi era. Through an exceptional moment of creative resistance to looming horror and the disintegration of self caused by abandonment and exile, the artist analysed the historical and familial events that led to her living in hiding in the south of France, and deciding to live, until her capture and death in 1943.[17]

These few names stand for the thousands unknown and lost whose role as women in and beyond the Jewish world might have contributed in special ways to our current debates about how to see questions of identity from the complex interlacing of Jewishness and femininity as articulated through art. But were we to go back a further step in history we might find yet another chapter that bridges the gap between us and Reverend Marks in London in 1863. Consider the case of those young Jewish women of Vienna, the bourgeois daughters, who stand at the beginning of another major chapter in modern thought on identity – psychoanalysis – in which women such as Melanie Klein, Anna Freud and Helene Deutsch were to play such significant roles.[18]

Bertha Pappenheim, known through the pseudonym 'Anna O.' given her by Freud's older colleague and student of hysteria, Josef Breuer, was the first, indeed the founding, case of psychoanalysis. It was her description of the process she invented for herself with Breuer that gave its name to Freud's new science: the 'talking cure'. Bertha Pappenheim hinges the pre-modern to the modern in Jewish women's history in other ways as well. The daughter of a middle-class Orthodox* family in Vienna, 'markedly intelligent', with 'great poetic and imaginative gifts',[19] she was frustrated by lack of intellectual outlet and emotionally battered by repeated bereavement and the need to nurse her dying father. Bertha Pappenheim suffered a severe psychological illness the self-treatment of which, at times, created the insights that would bring fame to her near contemporary, Sigmund Freud, for his theories of sexuality and the unconscious. Eventually recovering, Bertha Pappenheim found a meaningful and highly respected career in the emerging discipline of professional social work.

A passionate reader of the feminist journal *The Woman*, she encountered many classic feminist texts that she made her own. In 1899 she translated into German *A Vindication of the Rights of Woman* (1792) by Mary Wollstonecraft, while also making a Yiddish to German translation of the *Memoirs of Glückel of Hameln* in 1910.[20] In 1904 she founded the *Jüdischer Frauenbund* – a specifically Jewish section of the larger Federation of German Women involved in social movements and social work with women. At one time membership of the JFB

comprised twenty per cent of Jewish women in Germany.[21] Bertha Pappenheim was mainly concerned with poor Jewish women in the east forced by poverty into prostitution. She set up the first refuge in Europe for Jewish girls and unmarried mothers on the principle that no Jewish child should be lost. Bertha Pappenheim made common cause with women across Europe and within the international Jewish community in the battle against the white slave trade to which the Jewish community had also closed its eyes. Raising the standard for the plight of agunot * – the chained women refused divorce, hundreds of thousands of whom were created by the mass immigrations to Britain and America – Bertha Pappenheim also argued as a modern feminist for women's right to education and, therefore, the means of self-support which would protect women from the economic vulnerability that made them prey to the traffickers of the sex trade.[22]

Such a case study[23] illustrates a specifically feminist consciousness among Jewish women in the early part of the twentieth century and a specifically Jewish dimension to the histories of feminism. Far from being an alien and recent intrusion into Jewish life and thought, feminism, or a critical self-awareness, discontent and ambition among women, takes us to the heart of many major historical moments in which, furthermore, Jewish women were active.

I called the disappearance, or forgetting, of the generation of Charlotte Salomon, Fré Cohen,[24] Regina Jonas and Anne Frank a treble loss. The loss of *Jewish* writers, artists and teachers can sometimes obscure another level: the loss of a historical continuity of women within the Jewish community, questioning tradition and practice, drawing from the wider debates about women and the polis, women and the family, women, work and education, and challenging the Jewish world to meet the obligations of its own principles of social justice. Where might Jewish women be now had the disastrous caesura in the activities of Jewish women never fractured our history in the twentieth century and taken from us the women who might have made such a difference to the situation and status of Jewish women as rabbis, social leaders, artists or writers?

FEMINISM AND JEWISH QUESTIONS: RELIGIOUS, LEGAL OR SOCIAL?

A major site of confrontation between Jewishness, women and modernity is, of course, religious practice – though it must be said that imagining Judaism simply as a religion (a word that does not exist in the vocabulary of Hebrew) is severely to limit it. In her provocative attempt, published in 1981, to explore feminism from within an Orthodox*, 'traditional' Jewish lifestyle in contemporary America, Blu Greenberg dared to pose the question: 'Feminism: Is it Good for Jews?' – that is, for religious and Orthodox* Jews. Committed to a new self-confidence created by women's liberation, but equally comfortable with

Orthodox* practice, Blu Greenberg carefully tracked the confrontation of these two terms while hoping to show how they could be mutually beneficial.[25] What if, asks Blu Greenberg, we nonetheless have to admit that Halakhah * [Jewish Law] has progressively eroded women's status within Jewish practice? Greenberg writes:

Though the truth is painful to those of us who live by Halakhah, honesty bids us acknowledge that Jewish women, particularly in the more traditional community, face inequality in the synagogue, in participation in prayer, in halakhic* education, in the religious courts and in areas of communal leadership.' [26]*

That is, in the Orthodox* Jewish world, full stop. The poet and novelist Cynthia Ozick makes a similar point when she writes:

In the world at large, I call myself, and am called, a Jew. But when, on Sabbath, I sit among women in my traditional shul and the rabbi speaks the word 'Jew', I can be sure that he is not referring to me. For him 'Jew' means 'Male Jew'… My own synagogue is the only place in the world where I am not named Jew.[27]

To balance this public exclusion of women we might underline the great value apparently placed on women in the family. But the family is, as Greenberg points out, a paradoxical space. There the special qualities and responsibilities of women are recognised and valued. But that difference can equally be abused as the grounds for the exclusion of women from any other Jewish space. Home and synagogue each have their own symbolic value, but it would be hard to deny, in the real world, a sometimes less than subtle hierarchy between them.

In the 1990s, both women and all the religious Jewish communities are in the midst of struggles for redefinition. Major changes in ritual and women's participation in religious practice and communal affairs have taken place within Masorti* (in the USA Conservative*), Reform* and Liberal* movements. Orthodox* women have publicly demonstrated for radical changes on legal issues such as get* and agunah*, while they too demand more possibilities for women in education and communal organisations.

The deeper questioning of self and world, however, is taking place through literature, art, poetry, cinema and theatre, where the imaginative and experiential legacy of these conflicts between shifting notions of Jewishness and radical questionings of femininity is played out in lives both observant and secular. Some reflexivity has been forced upon us by the vast and terrible events that have shaped Jewish history since the 1750s, and especially since the 1930s. Yet more is self-generated as a response to changing conditions and expanded worlds in which what it is to be Jewish and what it is to be a woman are in perpetual flux, and in which the very notions of fixed positions and identities are eroded by post-modernity.

LOOKING BACK TO MAKE THE FUTURE

Let us go back for a moment and reconsider the apparent certainties on offer at Succoth*, 1863.[28] The main thrust of the sermon delivered by Professor Marks of West London Synagogue was that, in biblical times, Jewish women consistently participated in religious, social, political and cultural activities. They were present at public readings of the Law, presiding, like the great judge Deborah, military strategist and ruler of the state for forty years, as 'chief person of the commonwealth'. Women like Huldah were consulted on politics and law by the young king Josiah even while the mighty prophet Jeremiah still lived. Jewish woman in biblical times seemed to have been as full a member of her society as she could be: Marks quotes *Proverbs* speaking of woman 'opening her mouth in wisdom, and having the benevolent law on her lips'. Women, Marks states, also transacted business, inherited property and were responsible for the education of children and the peace of the household. The story of Rebecca's consent being solicited before a marriage contract could be agreed is linked by Professor Marks with the book of *Malachi* which speaks of marriage as a covenant between equals, where the woman is styled *chabir*, which Professor Marks translates as 'equal'. Then, alas, Professor Marks notes the decline of women's status in the rabbinic period, when he says that Jewish thought became subject to Eastern, especially Greek influences. With no little self-congratulation, the reforming rabbi proudly confirms his own newly founded community's commitment to a return to more egalitarian biblical models of women's status.[29] In January 1842, the inaugurating sermon of that congregation had stated:

Woman, created by God, as a helpmeet for man, and in every way his equal; endowed by the same parental cares as man, with wondrous perceptions, that she participate (as it may be inferred from Holy Writ that she was intended to participate) in the full discharge of every religious and moral obligation, has been degraded below her proper station. The power of exercising those exalted virtues that appertain to her sex has been withheld from her, and since equality has been denied to her in other things, as a natural consequence it has not been permitted to her in the duties and delights of religion.[30]

The political philosophy of this sermon is typical of its nineteenth-century moment: the call for equal rights, which, just beginning in earnest in the 1860s, is still a battle to be fought and won today. But in 1996, there are other ways of conceiving of the issues. Rather than merely focusing on men and women's rights in public life, we might have to locate the arguments at a deeper, more structural and theoretical level. The term 'sexual difference' indicates our philosophical questioning of just how, and with what effects, a distinction is drawn between two almost indistinguishable elements of the human species. If, rather than stressing the potential sameness of men and

women as civil beings which underpins the equal rights argument, we want to stress and appreciate the value of the differences between men and women, psychologically or sociologically, how might we value different potentialities and interests – while not turning difference into a hierarchy which places men and women relatively in positions of advantage and disadvantage in society? How can we think of women as 'different' but not less and not 'other'?

The nub of the feminist debate is here. Do we want sameness, that allows only of one norm, the masculine one to which we aspire? Or are we arguing for the celebration of difference, the possibility of the real acknowledgement of human diversity and particularity without penalty or discrimination? Ironically, this latter perspective coincides closely with a Jewish desire to be allowed Jewish difference in non-Jewish societies (as well as within Israeli society) without fear of persecution or disadvantage.

THE AS YET UNKNOWN DIFFERENCE: WOMEN

Officially, those who have to power to say so, usually men, think that they know in advance what woman is. They tell us that woman is like this and, therefore, can, or more usually cannot, be allowed to do that. Virginia Woolf opened her famous *Room of One's Own* (1928) with a distress call from the reading room of the British Library where she was appalled to find how many men had had their confident say about woman's nature, capacities, feelings, abilities, and so forth while so few texts existed to provide women's own words and views on that matter.[31] Let us start, therefore, by assuming that we do not know what woman is or wants, but that by reading the literature or studying the art made by artists from that 'feminine' position of difference within culture, we might begin to discover it, as much for the benefit of those of us who are called women as for the rest of society. Women do not make art because they know what they are, but because they may not yet know and the creative activity provokes new meanings, bringing them into visibility and recognition in culture. This is why it is necessary to make exhibitions about women artists and their experience as Jewish women: because artists may be able to reveal what is *not yet known* about this particular predicament and this special potentiality that in the abstract I would dare to call 'the feminine'.[32]

Let me be clear. The term' feminine' usually means something utterly stereotypical. It is either endorsed by the conservatives as an ideal of motherhood and wifehood, or it is rejected by the feminists as the limited masculine fantasy of what 'woman' ought to be. I invoke it in neither sense. Rather 'femininity' can be understood as gesturing towards the potential of women's difference. By difference I do not mean anything biological or anatomical in the simple sense I rejected above. I mean the exploration, by those of us named by culture

' women', of those elements and possibilities of social experience and personal fantasy, imagination and thought, image and dreams, mental and bodily experience, that we can offer in order to create an expanded, more comprehensive but still diversified understanding of the world.

So the point of the exercise is to explore the difficult question of 'otherness', of difference, of how cultures deal with strangeness within, and how varying social forms and cultural systems have negotiated the paradoxical problem of the human species and its differentiated sexes. Judaism, with its ancient roots and enigmatic survival into the post-modern moment, represents one critical place to examine this very fundamental issue.

READING ANCIENT TEXTS FOR MODERN MEANINGS

Professor Marks offered a particular reading of the ancient text, the Bible, contrasting it favourably with later, 'contaminated' rabbinic sources, which modernising Reform* aimed to correct by 'returning' to biblical practice. However justifiable this argument may be, it can be countered by an equally compelling indictment of other biblical sources and an equally successful search for careful legal reasoning in rabbinic writings that seek to ameliorate with justice the cruder statements about women's position that can be found in the ancient texts. So how do we use the past, and read the Bible?

As Cynthia Ozick has written, it is not so much the right answer that we must seek, but the right question. She asks: should we be asking *theological* questions? Could the question of women's status and identity within Judaism, for example, be improved if we changed the words in which we spoke of God to allow a 'feminine' connotation in place of the relentlessly paternal images of father, ruler, king? There is a growing feminist theological tradition that seeks to resist the masculinisation of the Eternal and to stress feminine elements present in ancient Jewish concepts of the Almighty, for instance, noting that Shekhinah* – the Divine Presence – is a feminine noun.[33] There are others who draw attention to the names and attributes of the Jewish deity which, in their literal meaning, index aspects of the feminine: the Hebrew word for womb, for instance, *rehem*, gives us its derivation *el rahamim*, usually translated as 'God of mercy'. Jewish thought imagines that the world and all its contents have been created by a single deity, who created the human species in the image of that deity. Therefore, we might be able to attribute as part of that single, comprehensive deity elements that are variously distributed among the creatures of the world. Why not imagine the quality of mercy, typical of the greater and more powerful for the infinitely dependent and vulnerable, through the experience of the mother nurturing the child within her own body? The womb offers an *image*, or rather, a metaphor, by means of which our

experience of maternal tolerance and sustenance for the un-known child-to-be can be used to help us comprehend a quality at the very origin of that capacity in us all we call mercy.

Without having to anthropomorphise the deity as a Woman, as a Goddess, Queen, Great Mother etc., we can recognise the wisdom enshrined in the literal roots of ancient Hebrew words that allows us to use aspects of human life to imagine the unimaginable, and to recognise the way in which the images of the Jewish deity reflect potentialities of all types of humanity.[34] Such thinking saves us from reproducing the anthropomorphism of ancient religious and mythical thought, that could only imagine and thus image its gods in its own human, and thus sexually differentiated likeness. I am suggesting that we invert this way of thinking so that we do not have to make the One either a male God or a female Goddess to accommodate our desire to think about something that goes beyond the two-sex model within which we still operate.

Ozick has no doubt that it is a fruitless and ultimately *un*-Jewish solution to feminise the deity and substitute 'Queen of the Universe'. For her, such a move reverses the great historic leap represented by Jewish monotheism from pagan fertility cults of the Canaanites and the sexual imagery of Egyptian religion, both of which reflected human sexualities in their fantasies about gods and goddesses.

Jewish monotheism calls us to imagine a deity so transcendent of all that the human imagination can figure, that we are not allowed to use our imaginations and related arts to try to give it a figure or a form. Hence the second commandment prohibiting not art, but the making of idols, that is, images of the deity. Any pictorial conception of the deity can only reflect the forms in our heads that correspond with the shapes of our bodies. These will be inadequate to comprehend what – unlike the world of creation which is divided into types, species, sexes, etc. – must be thought of as undivided, as the originating unity. If the deity is conceived as One, nothing in our world marked by all sorts of divisions – havdalah* – is like the deity. Using sexual imagery that is based in anthropomorphism and sexual dimorphism, as did the ancient religions that Judaism superseded, limits our contemplation of the Creator to something already within our own field of knowledge and experience which will then reflect temporal hierarchies and human divisions. Thus, calling the deity Lord, or King, reflects traditional hierarchic social organisation, and using the term He inevitably reflects the social and historical tendency to masculine suprematism. But trying to balance such propensities with alternative feminine versions of already socially implicated terms of royalty or military leadership such as Queen will not relieve us of the residual traces of social sexism. Tactically, however, suspending all sexually marked terms, by using inclusive language, does raise people's consciousness by forcing us, for a moment, to think outside of sexually marked languages.

Setting aside what she dismisses as feminist theological fiddling, Ozick then addresses the problem of women and Judaism in *sociological* terms. If the problem is based in social practice, social change of women's status is possible. So we could begin by weeding out the worst influences on the rabbis' attitudes to women by showing that they are the result of social – Hellenistic and later Christian – and not divine influences. Then we can try to realign women's status with what we take to be an ancient Jewish respect for women's difference and special needs. Some feminists hope that once we have made some improvements with a little bit of social enlightenment, liberalising the worst excesses of rabbinic tradition that excluded women from ritual and communal authority, and cast them as legal minors and social 'others' along with children, criminals and the mentally disadvantaged, the question will be solved.

Yet, ultimately, Cynthia Ozick does not think sociology is enough. She comes back again to the Bible and argues that there is a much more profound question, a fundamental contradiction of justice that lies at the heart of the matter, directly with Torah*.

In her reading of the Ten Commandments, Ozick finds a shocking absence. She calls it the missing *eleventh* commandment.

This wall of scandal is so mammoth in its centrality and its durability that, contemplating it, I can no longer believe in the triviality of the question that asks about the status of Jewish women. It is a question which, reflected on, without frivolity, understood without arrogance, makes shock itself seem feeble, makes fright itself grow faint. The relation of Torah to women calls Torah itself into question. Where is the missing commandment that sits in judgment on the world? Where is the commandment that will say, from the beginning of history until now, Thou shalt not lessen the humanity of women? [35]

Cynthia Ozick interprets the Ten Commandments as a warning against 'the way the world ordinarily is'. The world will thieve, murder, lust, covet, abuse old people, fall prey to idolatry and show no respect for creation. She, therefore, discerns a general injunction to the rabble at Mount Sinai that will become the Jewish people: *'Thou shalt not … be the way the world left to itself will go.'* In this subtle reading of the *underlying principle* of the Ten Commandments, Ozick turns back to question a monstrous absence at their heart. She suggests that we should look to the principles embodied in the Law to derive from it the missing injunction against what world history has shown to be 'the way the world is': it will abuse, and lessen the humanity of women.

Quite unlike Professor Marks in 1863, Cynthia Ozick in 1979 finds no comfort in *the* ancient text, Torah*. We might, therefore, argue that, in those times, it was so inconceivable that people would abuse women's humanity that no direct prohibition was required. This would indicate the fundamental equality of the sexes in the exemplary society hoped for in Torah*; or we must,

as Ozick daringly tries to demand, confront the contradiction of women's uneven status in the Ten Commandments by using the very principles Torah* provides to amend its own omission. In exploring the question in ways which lead back to the founding principles of the Law, as opposed to Marks's celebration of great women like Deborah, Rebecca and Huldah, or his listing of laws and practices including women, Ozick brilliantly exposes what is at stake. It is not about equal rights that can vary according to what rights and for whom were allowed by different social systems in various periods. Ozick points to the problem of the *otherness* created for women. Through the very fact of being classified as a distinct element separate from the general category of humanity, which, thereby, becomes synonymous only with masculinity, woman becomes humanity's (aka men's) *other*.

If we call attention to ourselves – by organising an exhibition, for instance, about Jewish *women* artists, or notifying the world that there is something interesting in *Jewish* women's experience, we appear to be both demanding equal space in the sun and naming the difference that undermines that claim for equal participation in humanity. It is here that the political and philosophical confluence of the woman question and the Jewish question run in intriguing parallel. Equality with an acknowledgement of difference, particularity without discrimination, seem contradictory goals for modern liberal societies that allow you to assimilate to their norms as long as you abandon what makes you special or different. Yet it is the tension between being both part of general humanity and yet particular (Jewish, or a woman) that creates the necessity for, and the interest in, mounting exhibitions or developing theories about Jewishness and femininity as part of, yet distinct within, the totality we call culture.

Ozick's argument is based on the fact that the tenth commandment, the prohibition against covetousness, lists woman as an object that must not be lusted after. By being named, 'woman' is set apart for special treatment and her inclusion within the general category of humanity becomes questionable, sociologically variable and legally definable. We are all included in statements about honouring our parents, keeping Shabbat*, refraining from idolatry, not killing, thieving or committing adultery. There is a sudden moment of doubt, however, when, in the injunction against covetousness, the feminine term is listed with houses, oxen and servants, and thus counted among the properties of the 'you' addressed by the commandment, a 'you' that is, by this grammatical turn, clearly posed only in the masculine. Not only objectifying woman as an object of possession that might be coveted by a man, the sentence also excludes women themselves as desirous. *They* are not enjoined not to covet anyone else's husband, home or property.

Closely related to this shocking recognition that the prob-

lem is not, therefore, simply 'the status of women' in biblical, rabbinic or modern times, which might be improved, is the underlying ambiguity of women's position within human thought and culture including that moment which is encoded historically and religiously as Judaism. Through considering the notions of *difference*, of the feminine, which positions 'woman' as a particular figure of dissonance within human thought both religious and sociological, I am slowly moving into deeper water.

The term 'woman' is very complex. It can at one and the same moment refer to a full human, sovereign subject, there to receive the Covenant, and, at the same time, signify the property of a man. Yet, as Ozick says, within Jewish law, a slave or a criminal can be redeemed after a period of work, and can be restored to full independent subjecthood. For woman, there is no such relief. Woman is, to put it mildly, a kind of hybrid that can only ambiguously be accommodated with the models of thought that otherwise sustain the Jewish vision of the world. Woman is a person, and respected as such. Yet 'woman' is also 'othered'. At times, she is an object like a house or an ox, or a slave belonging to another person, merely by fact of sex. And the more or less restrictive definitions of woman, thought up and applied by men, whose humanity is never correspondingly impugned, merely play upon that ambiguity that seems to have perplexed most human cultures to date, including Jewish culture as recorded in biblical as well as rabbinic texts.

A DIGRESSION INTO STRUCTURAL ANTHROPOLOGY

The domination or privileging of men in society results in their having the power to use laws to define others and to limit their social destinies. The fact that male supremacy appears as the norm for so many cultures may not be so difficult to explain. It is, in part, the result of a certain way of thinking. In this logic, the masculine sex is more easily aligned with what is taken to be the norm or standard because it appears to present less complexity and ambiguity. Anthropologist Claude Lévi-Strauss identified this particular system of thinking about the world as the fundamental logical structure typical of the untutored mind, or of what he called 'wild thinking', 'wild' being used in the sense of uncultivated, like wild flowers: *la pensée sauvage*.[36] This is a complicated argument to make because it stems from a strand of structuralist anthropology unlikely to be familiar to the lay reader. But it is important because it helps us to challenge assumptions about the sexes so widespread that people mistakenly assume them to be a fact of nature. Far from being self-evident, these differences are shown to be the product of a complex mental and cultural construction, a system of meanings that is projected on to the world so that human beings can make sense of it. What makes us human, and defines us as different from animals, is the systematic meaning we have

invented for the world we live in; thought/language.

Thus, according to structural anthropology, the intimate and easy bond between masculinity and what has become the norm for humanity in general, and the difficult and unstable relationship of woman to the general term for humanity, is the result of structural principles of human thinking that underlie our social arrangements. This underlying structure, according to Lévi-Strauss, is binary; that is, it works on a logic of oppositions: on/off, positive/negative, culture/nature. He argues that human cultures produce meanings for the world by creating order through a construction of differences. Each of the two terms that this process creates, almost by default, tends to stand in a hierarchical relation to the other. One term is valued, the other devalued, not because of any intrinsic value in the two phenomena, but simply as a result of the system of oppositions itself. Thus, to anticipate a little, if the human collectivity is divided into man/woman, the very act of division can produce relatively different values, and a hierarchy for the two terms.

Let me delve a little further into this anthropological strain of thought to explain so strange a suggestion. Culture – by which anthropologists mean the realm of human meaning and social action – emerges only through acts of differentiation, that is the making of categories and the marking of distinctions, which creates sense, meaning, in a field of non-sense. Where previously there was only chaos, human thought imposes an order based on differences. Culture itself, however, only has meaning if differentiated from what, in the act of naming Culture (or human society), is simultaneously produced as its other term, Nature. So there never was a pre-human Nature, after which comes Culture. There was nothing (that made any sense); and then in the very act of there being any meaning at all, an opposition was set up that invented the pair as different from each other but dependent for their meaning on the existence of difference between the two. Nature/Culture is thus a binary opposition created by logic. It does not describe an existing, real difference between what is natural and what is cultural. In effect there is only Culture; the human acts of making sense and organising meaning. Nature and Culture are reciprocal terms in a system which is indelibly of cultural, human manufacture.

The systems of ordering are infinitely variable and creatively different across the world and across time, which is what makes anthropology, cultural studies or art history possible and interesting. The many cultures of the world show human inventiveness and they share a structural tendency, not a formal similarity. For all their apparent diversity, however, most cultures have some noticeably common characteristics.

One such recurring trait is the attribution of meaning to sexual difference: this produces differentiation between the sexes, masculine and feminine, that is almost always in some way turned into a social hierarchy between men and women. According to structural analysis of human culture, the recurring pattern of female subordination has no basis in a given Nature. Women are not subordinate because women are *naturally* weaker, or less this and men more that, or because men are stronger and women have babies. There is no rational explanation; there is the logical condition in the character of human thinking through binaries. Sexual difference – the meaning attributed to minor anatomical variation and sexual diversity – is always an effect of Culture. It is the product of the structure that creates difference by attributing meaning to hitherto indistinguishable phenomena.

Thus we can move to a second level of the argument. Where does woman fit in the Nature/Culture opposition? How do we account for women being sometimes imagined as a full part of humanity and sometimes as so different as to be treated as an object, a possession, a second-rung human? This has given rise to a famous feminist question in anthropology, from which I have borrowed my adapted title. Sherrie B. Ortner asked: 'Is Female to Male as Nature Is to Culture?' to which she gave a modified affirmative. Ortner argued that, within a structural opposition organised around the binary Nature/Culture, other terms become aligned on its axis: thus Nature (= Woman) versus Culture (= Man). By custom and social practice, furthermore, men are more easily fixed at the pole of Culture, becoming its formal representatives as priests, military leaders and legislators, that is, making up the rules.

Women, on the other hand, are not simply equatable with Nature for they are clearly human beings, part of the community. The trouble is that the feminine presents an ambiguity for this logic because of the particular aspects of feminine sexual and social life: menstruation, pregnancy, childbirth, lactation and the ensuing bond with the child she has brought forth from her own body. What is particular to the feminine, though not totally definitive of it, seems to oscillate between the poles along which human thought is strung, between Culture and Nature. Being at once a human agent and yet, through reproduction, childcare and menstruation, having certain special possibilities and experiences, 'woman' appears to be a kind of hybrid, ambivalent, even perhaps non-human creature. This does not mean that woman *is* more animal, but that, in such a way of making sense of the world, any confusion at the boundaries of categories creates a sense of disorder that will attract cultural attention: taboo, ritual, exclusion, subordination.[37]

Indeed, Jewish thought exemplifies the way in which a system of thought tries to deal with boundary confusion between purity and danger, between the typical and the unusual. Through Kashrut* and Niddah* Judaism sets up a strict system for food, for dealing with death and illness, and considering the special nature of men's and women's sexualities.[38] But it is

equally important – and I shall now argue this through a return to Jewish texts – to see how this specialness or ambiguity of woman can be imagined as the dynamic, creative force for change, for life itself, for the beginning of history.

RE-READING 'IN THE BEGINNING...'

The story of creation as given in the opening chapters of *Bereshit/Genesis* is a perfect example of the world being created out of chaos by the making of distinctions – the dividing of light and darkness, day and night, sun and moon, sea and land, human and animal.[39] But let us take a closer look at the actual text that deals with human creation and the coming of sex.[40]

In the story of the making of human beings, which we usually and inaccurately call the story of Adam and Eve, the first human thing created is simply the body of an earth-creature which is not in fact named. It is simply called *ha-adam*, which is not the proper name Adam, as the English translation would lead us to think. *Ha-adam* is a play upon the term *ha-adamah*, which means, in Hebrew, 'the earth', from which the creature has been fashioned. Then comes a second stage and a new term. Infused with the breath of God, this earth-body is then called *nephesh*, a living creature; a soul. In her feminist analysis of the creation story in *Bereshit/Genesis*, the narratologist Mieke Bal suggests that the term *ha-adam* insists upon the modest origins of the earth-creature, made, like a piece of pottery, from clay. At this point *ha-adam* refers to a species; it does not name an individual.

The work of creation, however, is incomplete for the creature is lonely. Not alone, for there are animals around. But they are too different. They are outside the category of *ha-adam*. The animal world is an 'other' in contrast to which humanity is defined as 'made in God's image'. For companionship there has to be a delicately calibrated tension between sameness, that is, belonging to the same species, and difference inside the category that will create the desire.[41] Sexuality will be produced within the species not only by this internal variation but by there being not identity, but equality. Sexuality represents a kind of fitting together of two people between whom there is comparability and not a hierarchy. The text makes it quite clear that there is hierarchy in the world – between humans and animals – and then there is sexuality/love/companionship between humans who must be distinguished from each other and yet, as Professor Marks claimed, be considered *chabir*, equal.

Mieke Bal notes that the verb used for forming *ha-adam* is that used in Hebrew for pottery making. The Hebrew verb to describe the making of a differentiated version of the earth-creature is the same as that employed to describe architecture and construction. Thus this refashioning of the earth-creature to produce its *chabir* is not a fundamental forming, but an engineered modification.

At this point in the text of *Bereshit/Genesis*, the words *ish* and *isha* are introduced, translating respectively as man and woman, the latter, in fact, being used first, and thus transforming the earth-being into earth-woman and earth-man. Woman is formed before man; or, as in the case of any meaning-creating pair, the formation of *woman* itself produces the distinct existence of a sexual other, *man*. Thus they have no intrinsic meaning or identity, but like Nature/Culture are a relative, interdependent pair of concepts. The subsequent verses of this part of *Bereshit/Genesis* recount the familiar story of the woman's encounter with the serpent, the eating of the apple, and the expulsion from the Garden of Eden. The differing interpretation of these narrative elements forms the division between the major religions.

Christianity stresses temptation and a fall, and makes the woman the victim of the former and the cause of the latter. This then places knowledge and female sexuality in a dangerous liaison of which woman is the permanent *memento mori*. The fallen Eve/woman can only be redeemed by the chastity of the second sinless Eve, the Virgin. The full weight of this tradition's gynophobia becomes clearer by contrast with Jewish theology and its quite distinct understanding of the Eden Story. In the Hebrew Bible there is no Fall and hence no original sin. The human beings who eat of the Tree of the Knowledge of Good and Evil are clearly disobedient in exercising their choice against God's commandment. It is not necessary to consider what happens as a punishment. As Mieke Bal argues, what happens is the spelling out of the consequences of the humans' action. God decrees that now they must do something: work. They must live by the sweat of their brow. Work becomes a constant reminder of God's six days of work, Creation. The humans are, in effect, expelled from a perpetual Shabbat* which they enjoyed in the Garden, into a cycle of work and rest, which is fundamental to the Jewish way of life. Not only is it their knowledge of good and evil, but their conformity to this cycle that makes these humans like their God: labouring and resting.

The humans are commanded to be productive: they must work and they will procreate with effort. The wily, or wise (*arun* in Hebrew means 'the latter'), snake ensnared the woman and made her eat the fruit after which she and the man, with whom she shared her discovery, realised they were naked. Knowledge is thus linked to shame, and so is sexuality, or so it appears in Greek, Latin and English. The Hebrew word which is usually translated as 'naked' can also mean 'wise'. Indeed the same word, *arun*, is used of both the serpent, 'naked' or 'wise', and the people, 'wise' or 'naked', after they have eaten the fruit of the tree. By eating the fruit, they did not only become conscious of their sexual bodies. They also found wisdom, or understanding, or even self-consciousness, and were precipitated into understanding of the process/responsibility of

(pro)creation. By the coming of wisdom, the human is deprived, i.e. stripped naked of the illusions veiling both the innocence and irresponsibility of ignorance.

Wisdom can only be operative when we know good and evil, when we have choice. This idea of choice is different from the opposition between knowledge and sexuality, an opposition used by Christianity and Islam to align men with the former, knowledge, while identifying women, representing temptation, with the dangers of the latter, sexuality. In my reading, sexuality is one element of human access to Creation. Sexuality initiates wisdom since it brings us face to face with the ethical moment, the moral human action, when one person will intimately touch another person's being and, in certain cases, potentially creates yet a third.

Significantly it is only at this stage of the narrative, that proper names are introduced. The woman, *isha*, the female counterpart to *ish*, acquires her name, Chava (Eve in English), from the man after the action that brings about the acquisition of wisdom. He calls her 'mother of all living things'. Chava is connected in the Hebrew to the word for life, and this is highly significant though capable of varying interpretations. What I would like to stress is that the name is given only after the humans find themselves naked in their knowledge, not of evil, but of time and personal responsibility for life and the coming of generations after them. It is at this point that sexual differentiation takes on specific meanings. The word *ha-adam* simply means 'earth, matter', while Chava/Eve is derived from the root for the word 'life'. Chava comes into existence through her action, which is that of moral choice. She was given a choice; she made it; and she shared it with the man. Life, therefore, as a consciousness that brings about choice, is that which dynamises the earth and introduces time and history. It thus links the feminine principle to life, to change, to history, to morality.

There is no immediate hierarchy here, but a complex sequence of transformations which introduce sexuality and ethics into the domain of the human via the founding principle of choice. The woman, formed in a movement that must reciprocally produce her sexual correlate within the human species, is the first to initiate time and history through her action, through the choice she makes, through her coming to self-consciousness. Because she chooses and shares, the woman comes to realise what she is. In seeing herself naked, she recognises her specificity. In that particularity, as a sexual woman, she is named a creative force, for change and for sorrow, for knowledge and for life.

Such an interpretation of this part of *Bereshit/Genesis* does not cause the misogyny of other moments of the biblical text to disappear. It does not provide a biblical ground for reversing the hierarchy of gender that has so often been read from these verses. Mieke Bal, like other biblical scholars, uses a close read-

ing of the actual sequence and vocabulary of the text of *Bereshit/Genesis* to reveal a structured narrative about the formation of human sexual and social identity and the question of relations of difference to sexuality.

Politics have intervened by converting this exemplary piece of ancient, wild logic into a clear-cut social hierarchy that maintains the power of men over women. This social translation of human variation by sex within a myth of origin becomes one of the major factors in the limitation or abuse of women's humanity against which Cynthia Ozick demands an eleventh commandment. This humanity was unquestionably part of *isha* when *isha* was an undifferentiated component of *ha-adam*, the earth-creature, as much as when *isha* acted to begin history and human consciousness, and was acknowledged by the name Chava, 'life-giving'.

FEMININITY AND DIFFERENCE

It may be unimaginable that there could be a society which did not establish a difference between the sexes. That difference, I have suggested, must always be understood as a culturally constructed meaning that reformulates the merely biological diversity of reproductive functions into an elaborated ethical, legal, social, economic and cultural division of humanity into types centred upon the question of the reproduction of the species. Sexual difference is always, therefore, a myth, deeply connected with mythic ideas about the origins of the world, of human beings, of life. The differences between the male and female of the human species are so minute compared with those between humans and even its nearest primate relatives as to be insignificant. But, culturally, they represent one of the most significant axes for making sense of the world. The history of so much of human culture revolves around the meanings attributed to the divide between masculinity and femininity, the status of men and the status of women. This is partly because reproduction of the species is as vital to any society as manufacturing the means of day-to-day subsistence. The 'magic' involved in human creation, however, remains very perplexing to the ways of thinking that anthropologists suggest structure our imaginative worlds and hence shape our social universes.

Faced with the difficulty of comprehending sexual reproduction which is not symmetrical and easy to assimilate to a binary model, human societies have, nonetheless, tended to fall back, nonetheless, into their binary modes of thought, linking what is difficult to think about with what is *unthinkable*: 'other'. Woman, made into the representative of the difficulty of thinking about sex, is then made into a symbol of what cannot be understood: so 'woman' comes to mean 'otherness', difference, enigma, threat to order. For no other reason than the tendency to make associations between categories in a particular pattern of thought, this makes 'woman' *appear* to be like Nature – the 'other' to Culture, the realm of non-sense, the non-man, the

non-human. Into a single, overfull bag falls woman, sexuality and Nature and out comes a phantasm: the naturalness of sexual difference, the givenness of the 'nature' of 'woman'. We need, therefore, to deconstruct these mythic associations and re-read the ancient biblical texts for ways to see if ancient Jewish writings offer a less predictable and less misogynist version of the origins of sexual diversity.

SOME CONCLUDING THOUGHTS

In conclusion, however, I would suggest that it is neither a matter of searching back to ancient texts, (re-readings like Ozick's or Bal's), nor of looking forward to modern movements for any moment that was, or is, better (as does Professor Marks). Rather I think we should examine carefully how this inevitable paradox of human societies – sexual difference – has been negotiated in the founding texts of Judaism and in the history of the Jewish people. We might then begin to appreciate the value of those differences between and within men and women that stem from their being differently positioned in the world and their having varied potential within the structures of human culture and myth. Until now these differences have been straitjacketed into social hierarchies that fundamentally lessen the full humanity, freedom and creativity of half of the world: women. They have kept the bookcases half-empty and made the art galleries an incomplete record.

In this essay, we have moved backward and forward in historical time: from the present, to 1863 and even back to the eighteenth century BCE in analysing parts of the Torah*. Ozick's 'missing commandment' is not the fault of too much patriarchy in Moses' time. The absence only becomes glaring through the self-consciousness of women created by modernity, while, at the same time, these forces of modernity have brought aspects of sedimented tradition and authority within Jewish thought and practice into question. Indeed, it is by the token of modernity – the breaking up of traditional communities under the pressure of socio-economic forces and exposure to an extending array of competing ideas and possibilities – that both the question of feminine identities and the issue of Jewish identities began to be posed in ways that have led to their mutual confrontation in our century.

You may, as a reader of an art exhibition catalogue, be asking why such theological and theoretical arguments should herald an exhibition about 'Jewish Female Identity in Contemporary British Art'. All these terms need to be questioned. They settle too easily into unexamined assumptions that there is such a thing as *Jewish, Female, Identity*. If we do not disturb that complacency, there is a danger that we will just end up discussing this artist's version of her life and that artist's vision of a Jewish world, or, dreaded fate, the question, is there a 'Jewish art' or another new category, 'Jewish *women's* art'? These would be both wrong and impossible questions.

Being Jewish, being a woman, being an artist, being British, being a modern, these are not on the level of *being* at all. Culture, it has been argued, is made; it is constructed through terms and structures that are larger than the individuals who are nonetheless its agents and speakers. So the expressive thesis that artists know what or who they are and communicate it through the vehicle of their art is no longer a sustainable position. Sure enough, artists are makers and, as the model of *Bereshit /Genesis* suggests, makers can be either potters or designers, formers or conceptual inventors.

What I want to stress is the idea that all meaning is produced by structures and forms – forms of society, forms of language, but also forms we call art. Art is part of this larger system for the production of meaning: Culture. Identity is not an inward, personal essence outwardly expressed. It is rarely singular. Identities, which are plural and often in tension, in terms of gender, class, race, religious affiliation, sexual orientation and so forth, are also social constructions. The elements that make up our unstable and multi-faceted identities may be in fact projections from the social world which fabricates images through which we are invited to recognise ourselves.

Our sense of who and what any one of us is, is always a negotiated transaction between the terms a culture offers with which to construct identities – in terms of race, class, gender, ethnicity, culture mediated by language and other signs – and the singular histories of each person as they invest and reinvent what is offered. Artistic practices work on the edges of these cultural constructions and social projections. They put something of the fixity of identifications necessary to negotiate the social world into a creative instability so that something unforeseen can emerge into cultural view. One of the transformative aspects and ambitions of artistic practices is to change the existing range of cultural meanings by inventive play and poetic de/reconstruction. Artistic practices by women are, therefore, not the expressive revelation of what women, Jewish women, women artists are. They are a place of radical discovery and exploration whose meanings will depend on the kind of understanding, interest and informed responsiveness of the viewer.

In the present climate there is an epidemic of the 'politics of identity'. As our post-modern world finally defaults on the misplaced hopes of universal citizenship, people trade ethnicities. In the United States many Jewish scholars and artists are turning their attention to what hitherto seemed of passing interest: their Jewishness and its histories, and more recently, its art histories. The formation of Jewish Studies in this country allows an intellectual interest in things Jewish to pass from private study to academic seminar room. And the emergence of the debate about a Jewish perspective in the visual arts, stimulated by exhibitions in the last decade, has opened the way to a Jewish art history and criticism. At

present, in this shifted alignment of interests and intense sensitivity to the fluctuations of identities and subjectivities, I would like to join the figure of the artist with 'Jewishness' and 'femininity' as symbolic figures of creative ambivalence, of cultural dissidence and of poetic transformation.

Artistic 'inscriptions' from the imaginative spaces of Jewish femininities, disappeared or ignored both within and outside the Jewish world, reclaimed and given new voice, may open up means to re-imagine a future.[42] In such a future, we might be able to accept diversity and ambiguity. We might imagine sexual difference without gender hierarchy. We might hope for the acknowledgement of cultural or religious particularity without racism. We might accept sexual diversity without prejudice. Far from being a matter of purely local interest, therefore, some of the issues raised by the historical confluence of questions of Jewishness and femininity on the terrain of art touch on deeply ethical questions about the nature of our futures.

Rubies and Rebels, precious and rebellious, this exhibition of work by contemporary artists working from the social and imaginative spaces of modern 'Jewishnesses' and their particular 'femininities' takes its historic place in a long, interrupted but resilient history of Jewish women in modernity and its cultures.

JEWISH WOMEN ARTISTS IN BRITAIN 1700–1940

Julia Weiner

The earliest recorded native Anglo-Jewish artist was Catherine da Costa (1678?–1756), daughter of the physician to Charles II, who studied under the famous drawing master and engraver Bernard Lens and painted portraits of her family and other members of the early Anglo-Jewish community in a charming, though somewhat naive style.[1] Not until a hundred years later, however, did another Jewish woman, Rebecca Solomon, make any impact whatsoever on the English art scene.

From then on the number of Jewish women exhibiting and working professionally increased steadily, so that in 1906 over one-third of the paintings exhibited at the exhibition of Jewish Art and Antiquities at the Whitechapel Art Gallery were by women, and a year later as many as sixteen Jewish women exhibited at the Summer Exhibition at the Royal Academy. This was in spite of the fact that Jewish women had to overcome all manner of obstacles to work professionally as artists, not only on account of their sex, but also because they were adopting careers for which there were few precedents in the Anglo-Jewish community, even among the men.

The majority of women who took up painting came from wealthy backgrounds, and were probably encouraged to paint and draw by their families, since such skills were considered assets on the marriage market. Indeed, the Royal Family set them a good example, for Queen Charlotte was a serious botanical painter, and Queen Victoria an experienced amateur artist.

However, it was painting in watercolour that was primarily taught, oil painting not being considered suitable for a number of reasons. It was far more messy, it left an unpleasant odour, and it could not be carried out in the drawing-room. In addition, more time and serious training were required for a high standard to be reached than with watercolours. Furthermore, oil paintings, tending to be on a far larger scale, necessitated stronger composition, a talent that women were considered to lack. In this way 'patriarchal discourses on art divided art practice into the categories of masculine art/feminine accomplishment and masculine professionalism/feminine amateur.'[2]

The chief obstacle for women wanting to become artists was the difficulty of getting art lessons. Women were barred from studying art other than at home with a private drawing master until 1843, when the Female School of Design opened at Somerset House. Even after this, it was hard to study art. One either had to be rich enough to afford the fees of such institutions as the Royal Academy (which opened to women in 1860) or prove that one intended to be a commercial artist. Only then could women enter the schools of design established by the government to train designers. The schools often refused entrance to middle-class women who did not have to support themselves. A further problem was that for many years women were not admitted to life classes, for drawing from the nude was considered outside the codes of respectability and propriety. If they were permitted to draw from the model or from antiques, these were either clothed or covered in draperies.

The majority of women who painted professionally in the nineteenth century were close relatives of male painters, and Jewish women were no exception. For example Rebecca Solomon (1832–86) was the sister of the genre painter Abraham Solomon (1823–62) and the Pre-Raphaelite Simeon Solomon (1840–1905). Their father, Meyer (Michael) Solomon, was a successful hatter who moved on the fringes of fashionable society. The fact that he could afford for three of his eight children to study as artists suggests that there were significant funds available, since painting has never been a very secure way to earn one's keep. Whilst his sons attended the Royal Academy Schools, women were not yet accepted and Rebecca therefore studied at the Spitalfields School of Design.

Rebecca began exhibiting at the age of eighteen, and her paintings were shown regularly all around the country, including at the Royal Academy. However, as an unmarried woman, she seems to have been quite dependent on her artist brothers and her career was directly affected by theirs. For many years she lived with Abraham, and since he already had ten years' experience of the profession when she began exhibiting, she must have relied on his advice considerably.

Abraham had successfully exhibited paintings of period dramas, and, probably encouraged by this, Rebecca painted a number of works in a similar vein, with titles such as *The Arrest of the Deserter* and *Fugitive Royalists*. Her brother, however, was best known for his pairs of pictures showing people in contrasting situations, including *First Class —The Meeting*, which depicts a rich gentleman and lady meeting in the first-class carriage of a train, and its pair *Second Class – The Parting*, which shows a widowed mother bidding her son farewell as he prepares to go to sea. Rebecca also painted works in pairs, such as *The Industrious Student* and *The Idle Student*, and other works contain a similar contrast within one painting. Examples include *The Lion and the Mouse*, shown at the Royal Academy in 1865, in which the wealthy old landowner is contrasted both with the poor poacher and his mother, and with the young girl who pleads on the boy's behalf. It has been assumed that in these works Rebecca was acting under Abraham's influence, though since both artists produced their first examples of these types of paintings in 1854,[3] it could well have been an idea that they developed together.

When Abraham died in 1862, Rebecca soon moved in with her younger brother Simeon. Although Rebecca had been exhibiting for seven years before her brother's works were shown in public, many critics simply saw her paintings as substandard works in a style similar to his.[4] Simeon and Rebecca became notorious for their flamboyant life-style and were so publicly linked in the public's mind that when Simeon was arrested for homosexual offences in 1873, Rebecca also fell from grace. Her works were not exhibited after 1874. Simeon took to alcohol, and Rebecca apparently followed suit. She died in 1886 after being knocked over by a tram.

Like Rebecca Solomon, Lily Delissa Joseph (1863–1940) hailed from a wealthy, cultured family, and was also the sibling of a well-known artist. Her brother Solomon J. Solomon (no relation of the previous Solomons) achieved considerable fame and standing and in 1903 was elected a Royal Academician, only the second Jew to gain this honour.[5] Like Abraham and Simeon Solomon, he had studied at the Royal Academy Schools, and then in Paris, while his sister instead studied at the South Kensington School of Art.

Lily Delissa Joseph was certainly a serious artist, and exhibited regularly throughout her life at the Royal Academy and other venues. However, this was only one of her interests. She was committed to the fight for women's suffrage, and was a pioneer in many fields, being one of the first women to own and drive her own car and learning to fly aeroplanes when in her late fifties. She was also deeply involved in the community of the Hammersmith Synagogue, where she founded the Ladies' Guild and was its first President.

As an artist, Lily Delissa Joseph did not suffer from comparisons with her brother in the same way that Rebecca Solomon did. The most important difference was that she married, and thus moved away from the immediate sphere of her family. In

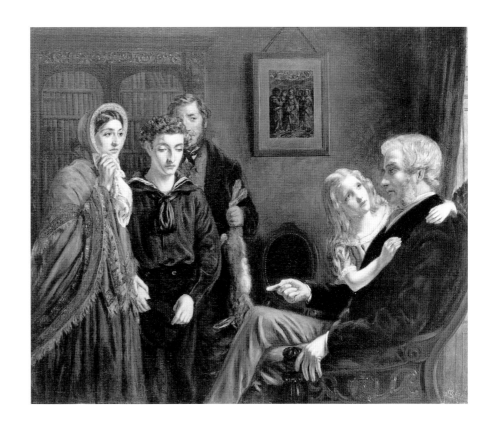

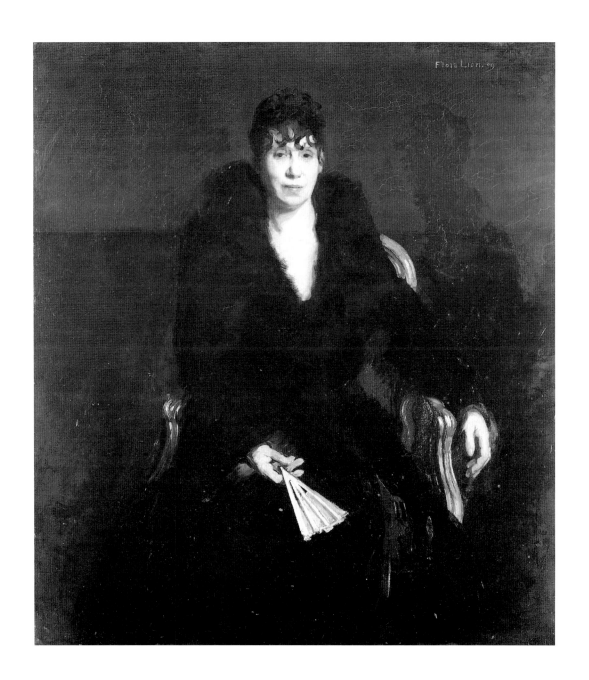

Flora Lion, *My Mother*, 1909

Oil on canvas, 50¼ × 45 in / 127.5 × 114.5 cm

Tate Gallery, London

her choice of career, she must have been supported by her husband, the architect Delissa Joseph, whom she married in 1887. He was certainly supportive of her other activities, including her struggle for women's rights, and in 1912 placed the following announcement in the *Jewish Chronicle* beneath the review of her 1912 exhibition. 'We are requested by Mr Delissa Joseph to state that Mrs Joseph was unable to receive her friends at the Private View of her pictures, as she was detained at Holloway Gaol, on a charge in connection with the Women's Suffrage Movement.'[6] Delissa Joseph's interest in women's rights spread to Jewish communal concerns, and he was described as an 'ardent supporter of the cause of women's suffrage in synagogue affairs.'[7]

Lily's work was also unlikely to be compared or confused with that of her brother, for their styles were very different. This was emphasised at the joint exhibition of their paintings held at the Ben Uri Gallery in 1946, where Lady Swaythling, who opened the exhibition, 'pointed out the great difference in their painting although they were not only contemporaries, but also brother and sister. The former, the 2nd Jewish RA being more conventional in his approach and the latter having an experimental approach.'[8]

Solomon's style of painting was very conservative, and remained unchanged by modern movements such as Cubism and Fauvism. Towards the end of his life, he painted a number of small works influenced by the Impressionists, but by then fifty years had already passed since the First Impressionist Exhibition. In contrast, many of Lily's works were obviously influenced by Impressionism, but were also described as 'experimental', particularly for the use of 'an extremely limited palette'[9] of white, cobalt, rose madder, orange madder and black. An example of this restricted use of colour can be found in her *Self Portrait with Candles*, a rare example of Jewish subject matter in her work.

Flora Lion (1876–1958) was a cousin of Solomon and Lily Delissa Joseph, and also came from a wealthy background. She studied first at St John's Wood Art School, at the Royal Academy Schools, and then at the Académie Julien in Paris. In 1915 she married the journalist and artist Ralph (Rodolphe) Amato, who took the unusual step of changing his name to hers rather than vice versa. She was obviously the better known artist of the two, and in one reference book Rodolphe is listed as the husband of Flora, a rare occurrence since it is usually the women who are defined in terms of their relationship to a male painter.[10]

Like Solomon J. Solomon, Flora Lion was a successful portrait painter, and although her style was not unlike his, their relationship was not mentioned by reviewers of her work. She was particularly praised for her strong use of colour and love of decorative detail, and the regular appearance of her work at the Royal Academy and Paris Salon brought her many commis-

sions, her preference being paintings of women. Like Solomon, she not only painted many of the most important members of the Jewish community, but also several members of the Royal Family including the present Queen Mother with her two sisters, the then Duchess of Kent, and other establishment figures including Mrs Anthony Eden and Mrs Clement Attlee.

It is interesting to note that neither Lily Delissa Joseph nor Flora Lion had any children. The demands of being a successful artist combined with raising a family were obviously too great for many women to contemplate. However, this must have been particularly difficult for other members of the Jewish community to accept, since children and the family have always played so central a part in Jewish life.

An artist who could well have suffered from comparisons with male members of her family was Orovida Pissarro (1893–1968), only daughter of Lucien Pissarro and grand-daughter of Camille. Although it could have been a helpful tool in her career, she decided not to trade on the family name, and preferred to be known by and to sign her works simply with her first name.

Orovida showed an early talent for drawing, and at five, her drawings were praised by her illustrious grandfather. Orovida began painting with her father, and from her uncle she learned to etch, using Camille's press and tools. She only studied for short periods at art schools, and was basically self-taught, referring to her father when necessary.

Like Rebecca Solomon, Orovida never married, and lived for many years with her parents. It was thus doubly important that she showed work in a different vein to her relatives in order to avoid the inevitable comparisons. Indeed, Orovida chose not to continue the family tradition of Impressionism, but instead, inspired by the British Museum's Chinese Art collection, soon gained a reputation as a painter and etcher of animal subjects imbued with an Orientalism whose novelty attracted a great deal of interest. She painted in tempera on silk, following the Eastern tradition, and experimented a great deal with her etchings, using different kinds of paper, many of them from the Far East. Her favourite subject was the tiger, and her successful depiction of these and other wild animals, and the Mongolian hunters in pursuit of them, was much admired. 'An expert of horses has declared that she realised to perfection not only the type of the Tartar horse but also the characteristic seat of the rider, though she had never been out of Europe.'[11]

Orovida was not the only Jewish woman who shortened her name when pursuing a career in art. Another to do so was Gluck (1895–1978), who was born Hannah Gluckstein. Like the other artists mentioned, she was born into a wealthy family, the only daughter of Joseph Gluckstein, one of the founders of J. Lyons and Co. Her American mother, Francesca Hallé, had musical aspirations but had been forced to give these up on her marriage to conform to the conventions of the family into

which she had married. Gluck was determined to escape a similar fate, and seems to have been convinced that her parents wanted to prevent her becoming an artist. In fact, it appears more likely that what upset them was the fact that she refused to conceal the fact that she was a lesbian.

Gluck shared her mother's talent for music, and initially wanted to be a singer, but had a sudden change of heart on viewing a photograph of a portrait by Sargent. 'There was a great whirl of paint in this, and this hit me in my solar plexus. All thoughts of being a singer vanished. That sensuous whirl of paint told me what I cared for most.'[12] She had already won a number of drawing prizes at school, and her parents agreed that she could attend art school. They chose the St John's Wood School which was very near their home.

Gluck did not enjoy her studies there, and commented, 'As far as I was concerned there was nothing taught that could be considered "training".' She also felt that the teachers took little notice of her because they expected her to marry shortly and give up art altogether. However, considering that the school opened in 1890 specifically to prepare ladies for admittance into the Royal Academy Schools, and that over the years 116 women, including Flora Lion, who was from a very similar background, had gone from there to the RA, this is difficult to believe. In any case, she did have some success there, for in 1913, 'at the annual distribution of prizes at St John's Wood Art School … Miss Hannah Gluckstein (daughter of Mr Joseph Gluckstein) … was awarded a prize'.[13] This announcement in the *Jewish Chronicle*, presumably entered by her proud father, suggests that her parents might not have been as opposed to her career as she suggested.

Nevertheless, she felt stifled and restricted at home, despite the fact that her father offered to build her a studio there, and after a painting trip to Cornwall where she met and was encouraged by two successful women artists, Laura Knight and Dod Procter, she left home in 1915 with little money and no ration card. At this stage, she cropped her hair and began to wear men's clothing, and insisted on being known only as Gluck. Despite this eccentric behaviour, her family soon agreed to support her financially. She had a private income, a large house in Hampstead, and several members of staff, and was therefore able to dedicate herself to her painting.

Gluck is best known for her portraits, her flower paintings inspired by her close relationship with the cookery and flower expert Constance Spry, and a series of works showing scenes from the London stage. These works particularly suited the spirit and fashions of the 1920s and 1930s, and Gluck's eccentricity must also have contributed in some part to the attention that she received. Indeed, after her 1926 exhibition at the Fine Art Society, she was furious that critical attention focused more on her appearance than on her paintings. Nevertheless, at two of her exhibitions all works were sold, and her 1932 exhibition,

again at the Fine Art Society, proved particularly popular. It was there that she installed 'The Gluck Room' in which she framed all her works in a three-tiered white frame that she later patented, and remodelled the room to echo the design of the frame. The exhibition was extended a month by popular demand, and there was even talk of transferring it to New York.

Gluck professed to be uninterested in commercialism, and stated, 'I made a vow that I would never prostitute my work and I never have… Never never have I attempted to earn my bread at the cost of my work.'[14] In fact, between 1937 and 1973, she painted only intermittently and did not exhibit at all. However, since she did not depend upon her painting at all for her income, this statement loses its daring tone.

These are the Jewish women who made a particular mark in the art world in the late nineteenth and early twentieth centuries, but there are indications that many more were studying art and going on to exhibit regularly, both at the Royal Academy and elsewhere. This does not seem to have caused any great outcry in the Jewish community, and their submissions to the Royal Academy were regularly referred to in the *Jewish Chronicle*, where most years the art critic was careful to list all the Jewish participants, even if mention of the women usually came after the men. The early years of the century produced a particularly high number of Jewish women exhibiting,[15] and this may have been as the result of the 1906 exhibition of Jewish Art and Antiquities held at the Whitechapel Art Gallery, which was a huge success and attracted over 150,000 visitors.

A similar exhibition had been organised at the Royal Albert Hall in 1887, but had not included the fine arts, and thus it was this part of the 1906 exhibition that attracted the most attention. The *Jewish Chronicle* covered the exhibition extensively, producing a series of supplements about the various exhibits, but by far the most impressive was the first supplement about the art on display,[16] which illustrated several of the paintings in the exhibition.

A number of women took part, almost all of whom had exhibited or would go on to exhibit at the Royal Academy. Almost half the watercolours on show and just under a third of the oils were the work of women.[17] Interestingly, Jewish women's contribution to the world of art is praised in the catalogue, along with that of the men. 'Young men and women of ability are arising on every side who will certainly remove the reproach of the past, and the graphic arts, like the others, will before long be recognised as equal witness of the emotional and intellectual genius of the House of Israel.'[18]

Although the exhibition was entitled 'Jewish Art and Antiquities', the artwork represented did not necessarily have to be of Jewish subject matter. Indeed, this was noted in the catalogue, where M.H. Spielmann remarked: 'The majority, identifying themselves entirely with their adopted country … show no trace of distinctive thought or differentiation of artistic

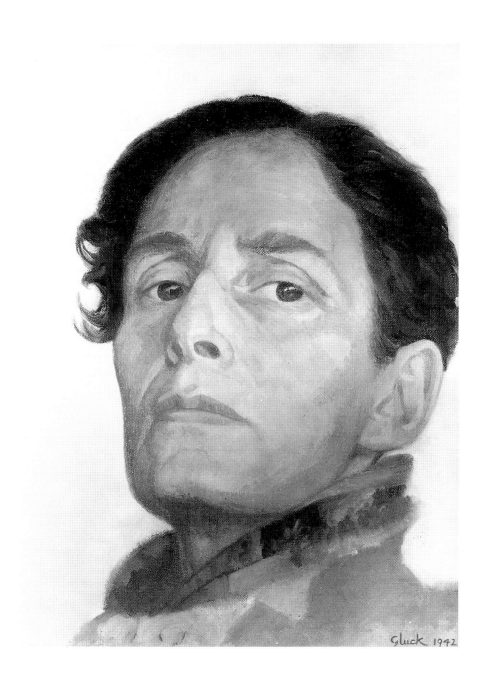

Gluck 1942

PLATE 5

Gluck (Hannah Gluckstein), *Self-Portrait*, 1942

Oil on canvas, 12¼ × 10¼ in / 31 × 26 cm

National Portrait Gallery, London

sentiment.'[19] Women were mostly represented by portraits, landscape, interiors and still life, subjects on which they were traditionally encouraged to concentrate.

There were a few exceptions, such as Rebecca Solomon's *Head of an Old Rabbi* and *Portrait of an Eastern Lady in Jewish Arabic Dress*, but these are very rare examples of Jewish subject matter in her oeuvre, and were presumably produced in response to the popularity of scenes of the Orient promoted by David Roberts and many others. It has been suggested that her own personal faith led her to believe that Jewish ritual was an inappropriate subject for painting.[20]

Lily Delissa Joseph exhibited her large-scale work *A Jewish Family*, which was a life-size painting of nineteen members of her family. In fact, she later ruined this painting by working and reworking the faces. It has been suggested that this was the result of her deep personal orthodoxy which inhibited her from painting portraits which she considered idolatrous. Luckily, *Self Portrait with Candles*, the only other known work with a strong Jewish theme, survived these destructive urges.

Similar feeling may have prevented other religious Jewish women from exploring their Jewish identity in their works, though others, born and brought up in England, may not have felt it necessary to touch on this subject matter in their work.

Among those women, not so far mentioned, singled out for praise in the *Jewish Chronicle*, was Mary Raphael, a pupil of Solomon J. Solomon's who, like him, had studied in Paris, and showed regularly at the Royal Academy between 1896 and 1915. For many years she submitted large canvases with subjects taken from the Romantic poets or from Shakespeare, although from 1906 she turned to landscape painting, many of them of French subjects. Like Solomon, she moved in the highest society and Queen Alexandra and Princess Victoria visited her in her studio in 1915.[21]

All the artists so far mentioned came from wealthy backgrounds. A study of the other Jewish women known to have participated in Royal Academy exhibitions between 1904 and 1915 reveals that of those who lived in London, all resided in the West End or in North London, and it seems likely that they, too, were not actually dependent on painting to support themselves. Amy Drucker (1873–1951), however, may have been the exception.

Unfortunately, there is very little information available about her early life, so it is difficult to ascertain much concerning her background. What is known is that she studied at Lambeth School of Art, a school intended for artisans who wished to earn a living from art, and it seems likely that she may have been that rare example of a Jewish woman who painted for a living.

She painted a number of atmospheric paintings of London life, including scenes from the East End where she was obviously aware of the poverty in which so many Jews lived. The painting she showed at the Whitechapel Exhibition in 1906 had a Jewish subject. Entitled *Aliens*, it depicted a family of new immigrants to the country, and was similar in style and subject to *For He Had Great Possessions*.

Like Gluck, Drucker must have been a striking figure, for 'her fashion in dress was always her own and many will remember the broad-brimmed black hat, the cloak designed for use as a cape and travelling rug and above all the ubiquitous many-coloured Mexican bag slung from her left shoulder'.[22] She travelled extensively, visiting Palestine, India, China and Abyssinia in search of new subjects to paint, but during both World Wars worked in other fields, serving in the Land Army in the First World War and as a factory hand and night watchman in the Second. This all suggests that despite her West End addresses,[23] she may have had more humble origins than her fellow exhibitors at the 1906 Whitechapel exhibition.

One thing is very clear. Not one of the women whose work was represented in the 1906 exhibition came from the East End despite the fact that the majority of the Jewish population of London lived there and that some of the best-known Anglo-Jewish artists of this century, including David Bomberg, Mark Gertler, Isaac Rosenberg and Leon Kossoff, grew up there.

It is perhaps not surprising that more Jewish women from the East End did not become artists, since this area was home to the 125,000 recent immigrants from Eastern Europe, many of whom were pitifully poor. Those women who did work outside the home either helped in family businesses or took on approved jobs, for example as seamstresses, but usually gave up work on marriage. It is unlikely that these families would have had the funds to pay for the studies and materials necessary for an art training; furthermore, the idea of women taking part in life classes would not have been tolerated.

Bomberg, Gertler and Rosenberg were only able to attend the Slade School of Art thanks to an enlightened organisation called the Jewish Educational Aid Society which was established in 1896 to give grants to Jewish children of promise to enable them to further their studies. The society helped a number of other male artists including Bernard Meninsky and Jacob Kramer, most of whom went to the Slade to study, but only had one application for help from a woman, fifteen-year-old Annie Aaronstein, who had a talent for drawing. However, rather than encouraging her to study to become an artist, they sent her to Goldsmiths' College for six years, to train to be an art teacher and thus be sure of earning a living.

It is interesting to note that a number of the Jewish artists from immigrant backgrounds who were given the opportunity to study at the Slade became involved with the emergence of the modern movement in this country. The fact that few East End women joined their male counterparts at the Slade meant that they did not share this involvement. When, in 1914, David Bomberg organised a Jewish section as part of the Whitechapel

PLATE 6

Amy Drucker, *For He Had Great Possessions*, 1932

Oil on canvas, 19¼ × 23½ in / 49 × 60 cm

Ben Uri Collection, London

Exhibition 'Twentieth Century Art – A Review of Modern Movements', and brought over work by Modigliani, Kisling, Nadelman and Pascin, the majority of the British artists selected were those who had received grants from the Jewish Educational Aid Society to study at the Slade,[24] and only one woman was represented. She was Clara Birnberg, a fellow student of Bomberg's at the Slade, about whom little else is known. The work of a similar group of artists was represented in the New English Art Club exhibition in 1913,[25] and this time no Jewish women were included.

There was, however, one important female artist who grew up in the East End, Clara Klinghoffer (1900–70), who was born in Austria but came to England as a small child. After a short

stay in Manchester, the family settled in the East End, where Klinghoffer's father had found work as the manager of a drapery shop. He proved a good businessman, and although they stayed in the East End, they had a house to themselves rather than living in a tenement block.

When Klinghoffer showed a talent for drawing, her mother was determined that she should be able to make something of it, and family funds were made available to further her artistic education. Significantly, none of her six sisters trained for a profession, and a special case was made for Clara because her talent was recognised as being extraordinary. She first went to the John Cass Institute in Aldgate, but left early after a teacher made a pass at her. This is the one recorded example of harass-

PLATE 7

Clara Klinghoffer, *Orovida Pissarro*, 1962

Oil on canvas, 40 × 34 in / 100 × 86 cm
Boundary Gallery, London

ment by a teacher of a female pupil, but one imagines that it was not an uncommon problem.[26]

Klinghoffer then went to the Central School, where her work was admired by Meninsky, who commented, 'Good Lord, that child draws like da Vinci',[27] and by Epstein, who called her 'a painter of the first order'.[28] From there she went to the Slade for two years, and won the admiration of Alfred Wolmark. He recommended her to the Hampstead Gallery, who organised a major exhibition of her work, the first of six exhibitions held in London before the Second World War. She had a preference for portraits, and her early works in particular are a delight. She captured her sitters in seemingly natural poses, and demonstrated a wonderful sense of form and mass.

Klinghoffer married a Dutch journalist, and in 1930 moved to Holland. She must have had her husband's support in her career, for she managed to combine painting and exhibiting with raising a family. With the outbreak of war, she and her family moved to New York, and from 1946 they divided their time between London and New York. Although Klinghoffer had exhibitions in the United States during the 1950s and 1960s, her work was so different from the Abstract Expressionism which prevailed there at the time that she never really established a name for herself. She obviously found it very difficult to appreciate 'the pretentious, yet meaningless abstraction'[29] and, perhaps in defiance, her own work developed very little, becoming slightly too sweet and light on the canvas.

As the century wore on, the number of Jewish women painting professionally appears to have decreased slightly, as did the interest in art in the Jewish community, for further exhibitions of Jewish Art at the Whitechapel in 1923 and in 1927 did not repeat the success of the 1906 exhibition, and failed to attract the same number of exhibitors. Clara Klinghoffer was well represented at both these exhibitions, as was a contemporary of hers from the Slade, Mabel Greenberg,[30] and Lena Pillico, the wife of the well-known painter of Jewish genre scenes, Leopold Pilichowski; but few new names appear. Painting and drawing were probably no longer seen as a necessary accomplishment for a wife, and as a result fewer wealthy women were taking up art studies. At the same time, the majority of Anglo-Jewish women now came from families of recent immigrants where tradition dictated that their role be in caring for their husband and family, and would not have had time to develop their artistic tendencies.

Lilian Holt (1898–1983), for example, the daughter of a civil servant, was interested in painting from an early age and studied at Putney Art School before starting work in an office. She took up painting again at the Regent Street Polytechnic and left a job when the opportunity arose to work for the art dealer Jacob Mendelson. She hoped that there she would learn enough about the art world to be able to follow a painting career herself, and her contract stated that she should be

allowed time to paint. Instead, she found herself exploited by Mendelson, although through her work she did meet a number of artists, among them David Bomberg.

They first met in 1923, shortly before Bomberg left for Palestine. When they met again on his return in 1928, they were both on the point of divorce (for Holt had married Mendelson in 1924) and they set up home together and married. Although she had always wanted to paint and was now living with an artist, Holt accepted that her primary role should be to help and encourage Bomberg in his art and that her desire to paint would have to wait. 'I had no time to paint while doing the housework and posing for David.'[31] She did not take up painting again until 1945, when Bomberg began teaching at the Borough Polytechnic and, realising that she had always remained frustrated in her wish to paint, suggested that she join his classes.

From then on, she painted regularly, and when in 1946 a group of his students formed the Borough Group to exhibit under Bomberg's guidance, Holt was a founder member, and exhibited regularly with them, and with the Borough Bottega which succeeded it in 1953. After Bomberg's death in 1957, Holt continued painting and travelled extensively, visiting isolated sites in Mexico, Morocco, Montenegro, Turkey and Iceland to seek inspiration for her painting. She had her first one-person show in 1971, and her work was purchased for the Tate Gallery in 1980. No doubt other women whose husbands were not painters also put their husbands' careers before their own.

In conclusion, it is noticeable that although a number of Jewish women worked as artists during the period 1850–1940, most came from wealthy backgrounds and did not derive their primary income from painting. Furthermore, several of those women who had successful careers as artists were closely related to male artists who had established a precedent in that field. This suggests that there may have been many other Jewish women unable to fulfil their artistic aspirations due to lack of money, or because their families simply could not contemplate the idea that being a professional artist was a suitable career for a Jewish woman.

REBELLIOUS RUBIES, PRECIOUS REBELS

Monica Bohm-Duchen

Those visiting the *Rubies and Rebels* exhibition
with expectations of an aggressively feminist
approach will emerge either disappointed or
relieved. The days when women artists intent on
making a feminist statement felt compelled to
adopt an overtly critical, even didactic attitude
in their work are, it seems, over. Not because – as
some people would have us believe – the
Women's Movement has won all its battles and
'post-feminism' now holds sway; but because
most women no longer hold the view (a view
that in retrospect seems both naive and perfectly
logical) that the key to victory over the male of
the species lies in the assertion of unwavering
unity among the female – irrespective of colour,
class or creed. These days, women artists for
whom gender matters tend to take a more
oblique and subtle approach.[1] Indeed,
dominant themes within feminist discourse in
the 1990s appear to be a realisation of the
daunting complexity of identity politics, an
acknowledgement of *difference* as a prerequisite
of true understanding and unity among women,
and an emphasis on solidarity *in spite of*
difference.[2]

Many early feminists (particularly in America)
were Jewish by birth and upbringing, but made
little of that fact – just as, perhaps, at the time of
the Russian Revolution, many leading
revolutionaries were Jews, fuelled by their
disadvantaged circumstances towards a fervour
for change, in the pursuit of which, however,
their Jewishness was subsumed by a greater
cause. Feminist artists, such as Judy Chicago,

Nancy Spero and Mary Beth Edelson, tended in 1970s America to adopt a similarly dismissive stance to their Jewishness. In Britain, as is well known, both feminism as such and feminist art took considerably longer to emerge and make their mark. Yet here too, many of the artists active in the Women's Movement in the 1980s – Jacqueline Morreau and Mouse Katz, for example – were indeed Jewish, but at the time felt this to be of secondary importance, even perhaps of little relevance to their struggles.[3]

There were, of course, other artists who felt that neither gender nor ethnic and religious issues had any bearing on their artistic identities; Jewish women who – wary of labels – wished to be seen purely as artists, independent of all such considerations. Some, it has to be said, continue to feel this way. Indeed, as Julia Weiner's essay in this catalogue makes clear, historically, Jewish women who had artistic aspirations (in Britain as elsewhere) had to do battle not only with the prejudices that reigned against all female artists and against all Jews, but with the male-dominated Jewish establishment as well. It is hardly surprising, therefore, that many of them chose, chameleon-like, to integrate themselves as inconspicuously as possible into the artistic establishment.[4]

In both America and Britain,[5] it is true, women intent on remaining loyal to their religion yet newly alert to the inequalities highlighted by feminism, sought – and continue to seek – a satisfactory way of participating more fully in a religious way of life.[6] And indeed, a small number of women artists, mainly from within the religiously observant Jewish community, have over the years revealed a consistent preoccupation with Jewish themes: above all, the anguish of the Holocaust and the reassuring power of domestic religious ritual – which to the non-observant Jew might seem mutually exclusive. Born out of a sense of familiarity with, and acceptance of, tradition, the art produced by such artists – however sincere – tends to be intellectually and aesthetically unchallenging, even somewhat predictable in its imagery, a confirmation of truths already known rather than an exploration of the unknown.

Jewishness, however, to many – and certainly to most of the artists featured in this exhibition – entails a strong sense of 'racial' loyalty, a culture and a history held in common, more than it does a strict adherence to Jewish ritual practices. The realisation that anti-Semitism exists even within some feminist circles, combined with the disturbing resurgence of neo-Fascism, racism and anti-Jewish feeling in society at large has caused many Jewish women to reassess their allegiances. Secularised Jewish women artists, whatever the extent of their previous commitment to the Women's Movement, have therefore begun increasingly to look to their Jewishness as fertile source material for their art.[7] It is striking, too, how many artists who are only half-Jewish, have chosen to acknowledge that half of themselves as the more important.

Thus, Judy Chicago chose in the 1970s and 1980s to create seminal works such as *The Dinner Party* (completed in 1979), in which the extraordinary cultural and religious diversity of the women celebrated was deliberately underplayed in favour of an emphasis on sisterly solidarity. In the early 1990s, in contrast, this artist turned her attention to a subject – the Holocaust – in which an awareness of her own Jewishness (she is in fact descended from twenty-three generations of rabbis!) formed an integral part of the work.[8] Similarly, Nancy Spero has for several decades been known for her eloquent tributes to the suffering of women throughout history and in every culture; but has recently focused her attention on the brutalities perpetrated on women by the Nazi régime.[9]

The response of British women artists to the challenge of a renewed confrontation with their Jewishness has, for the most part, been slower and less emphatic than that of their American counterparts.[10] But in Britain, too, as the current exhibition vividly testifies, there are now large numbers of women intent on confronting their Jewishness in all its troubling complexity, and on giving that complexity artistic form. The gender of these artists remains of crucial importance, however, even if the ways in which it finds expression in their art is sometimes oblique, even veiled. The most obvious manifestion of this is the frequency with which it is the matriarchal line, and its history, which fascinates them – it is after all the mother who determines whether a child is halakhically* Jewish, who traditionally, albeit in a circumscribed way, exercises a powerful influence within the Jewish family. Whether it is the role of the family, the problematic experience of immigration and assimilation or the yet more problematic legacy of the Holocaust, a reassessment of the Bible or a concomitant exploration of spirituality that the artist is addressing, it is nearly always the woman – and often, unsurprisingly, the artist herself – who forms the pivot of her attention.

These areas of concern of necessity overlap considerably, with the Holocaust in particular appearing as a dark undercurrent in many of the works in the exhibition. (Significantly, although they range considerably in age, virtually all the artists selected were born after the Second World War, and thus form part of the so-called 'Second Generation*'.) In the paintings of **MARLENE ROLFE**, the uneasiness of her position as both daughter and mother – memorably expressed in *Family* of 1990 (Plate 8) – is inextricably bound up with her awareness of her mother's and her aunt's past, dealt with more explicitly in other paintings. Born into an assimilated Berlin-Jewish family, her mother Ilse was active in the German Communist Party, and spent three years as a political prisoner in Nazi concentration camps before her release in 1939, when she emigrated to England. Her mother's twin sister Else, a Social Democrat, was also interned and released, escaping to Norway and thence to New York. The artist herself, born in London in 1946 (her father was non-

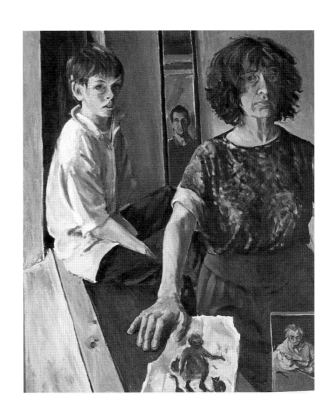

PLATE 8 (CAT.83)

Marlene Rolfe, *Family*, 1990

Oil on canvas, 36 × 30 in / 91 × 76 cm

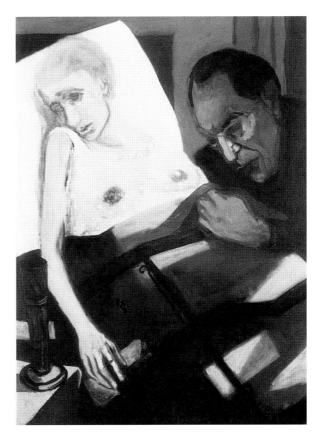

PLATE 9 (CAT.45)

Julie Held, *Dying Woman*, 1988–90

Oil on canvas, 40 × 30 in / 102 × 76 cm

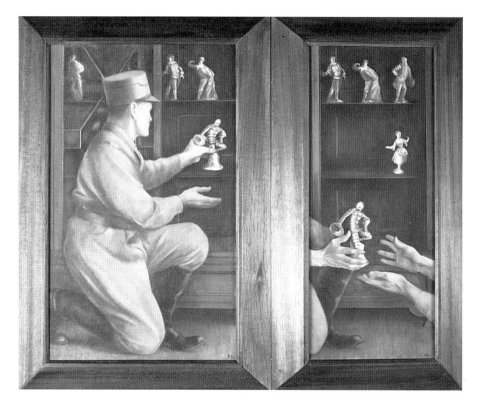

PLATE 10 (CATS 72 and 73)

Barbara Loftus, *Removing the Porcelain III and IV*, 1994

Oil on canvas mounted on board, 21 × 13 in / 53 × 33 cm and 21 × 9 in / 53 × 23 cm

PLATE 11 (CAT.63)

Liliane Lijn, *Her Mother's Voice*, 1996

10¼ × 9 × 1 in / 26 × 23 × 2.5 cm (134 pages, 129 images). Designed and printed by the artist on hand-made
Japanese Tosa Shoji paper; hand-bound by Romilly Saumarez-Smith in K. Yoseishi and Ogura mould-made
paper; published in an edition of 25 copies signed and dated by the artist.

Jewish), initially knew virtually nothing of this history; but since the 1980s, with the 'old age, frailty and death of my mother and aunt', she has 'increasingly wanted to recreate the lost worlds of their past and of my own childhood'.

'How,' she eloquently asks, 'can I deal visually with questions of the small action against the massive sweep of events; of personal, private histories and continuities; of female as opposed to male courage; of women's work and women's language? While I was in Berlin … to research my mother's story, I found some clues on a tiny scale, such as miniature subversive leaflets in false covers, or illicit embroideries and playthings made by the women at Ravensbrück. There is an alternative approach to the public, heroic struggle with past and present of some male artists. Such an approach might be private, adventitious, female. It might be small in scale. It could aim at simplicity, function expressed through decoration, and modesty of scale and intention: all features of women's work through the ages.'

Many of Rolfe's own paintings are correspondingly modest, seemingly ingenuous productions, in which 'feminine' elements are knowingly juxtaposed with de-humanised, abstracted forms (Cats 85-90) suggestive of the architecture of the concentration camps, though often in fact based on scenes of urban dereliction in her native London. Other paintings, larger in scale and more intense and non-naturalistic in colour, depict her mother and aunt, now old but reunited, pathetic in their physical frailty but spiritually indomitable. The title of *Wandervögel* (Colour Plate 10), literally 'Wandering Birds', alludes primarily to the two women, but also ironically to the name of a nationalistic rambling organisation popular in pre-war Germany.

The Holocaust casts a powerful and deeply personal shadow over the work of JULIE HELD as well. Both parents of this artist came as children to Britain just prior to the Second World War; their apparent (and by no means uncommon) inability fully to articulate their own sense of loss meant that this loss loomed even larger in the life of their daughter. The long illness and subsequent death of Julie Held's mother when the artist was only eighteen compounded and intensified that sense of loss still further. A self-portrait of 1995 entitled *Myself Remembered* (Cat. 48), with its reference to the traditional Jewish practice of covering mirrors during the seven-day period of mourning known as sitting Shivah*, speaks vividly of a childhood and adolescence deeply marked by loss. In many of Held's paintings, however, the often sombre, even tragic subject-matter is transfigured by the richness of the paint surface, a revelling in the emotive power of colour.

In an on-going series of canvases depicting family gatherings at a table set to celebrate a Jewish High Holy Day*, strident colour and angular composition vividly convey a sense of tension and anxiety verging on neurosis. When we learn that the protagonists include members of the artist's family who perished in the Holocaust, these images become almost unbearably poignant. The latest painting in the series, *Supper* (Cat. 50) is, atypically, unpeopled – except that the dark shadow cast over the festive table speaks eloquently for those who are absent. Equally if not more moving is the intimate *Dying Woman* (Plate 45), depicting – many years after the event, which she was unable to confront in her art until very recently – her mother on her deathbed. Most striking of all the elements in this unforgettable painting is the luminous bridal quality of her mother's body beneath its transparent nightgown – a disturbing acknowledgment of both the continuing sensuality and the vulnerability of the female form.

The Wedding (Colour Plate 8), typically for Held, is both melancholy and celebratory, its central female protagonist fragile, set apart, but strong nevertheless. The dark, ill-defined and shadowy figure of the groom, turned away from both his bride and the viewer, contrasts forcibly with the three generations of sisters – 'my grandmother and her sister, my mother and her sister, and my sister and myself' – in the background, like the bride, facing outwards towards the viewer. Held's renderings of Old Testament heroines, be they Judith (Cat. 46) or Eve, are similarly ambiguous – vulnerable and defiant at one and the same time.

Stylistically far removed from the hot colours and turbulent brushwork of Julie Held, and to a lesser extent, Marlene Rolfe, but nonetheless permeated with an awareness of the Nazi Holocaust and its rupturing not only of European Jewry as a whole, but of individual families, is a haunting series of oil paintings (Cats 64-74) begun in 1993 by the Hove-based artist BARBARA LOFTUS. Born in London immediately after the war to a lapsed Irish Catholic, communist father and a German-Jewish mother, who until relatively recently divulged virtually nothing of her traumatic past, Loftus has taken her mother's hesitant and fragmentary recollections of the day in November 1938 when the Nazis 'confiscated' the family's fine collection of porcelain and translated these memories into a compelling sequence of exquisitely crafted narrative paintings.

These works are reminiscent of Balthus in their refined and delicate paint surfaces and quietly enigmatic action (but with none of the erotic undertow of that artist's work), their deliberately understated quality, a stillness in which the viewer can almost hear the intake of breath as the family must have looked on helplessly, only emphasises the menacing nature of the events being depicted (see Plate 10). Typically, it is a very 'feminine' scene of bourgeois domesticity that is being desecrated: the artist's maternal grandmother presides over a game of bridge in her comfortable Berlin home (Colour Plate 1); a young girl dances … Interestingly, although Loftus's mother was already in her early twenties in 1938, the artist has chosen to depict her as a child – not only, one assumes, to elicit

greater sympathy from the viewer, but also to focus attention on the problematic mother-daughter relationship. The short film which accompanies *A Confiscation of Porcelain* carries the artist's evident interest in sequential imagery a step further. As in the case of the paintings, however, any tendency to be over-literal or over-literary is offset by her self-conscious and technically consummate manipulation of her chosen medium.

The complexity of the mother-daughter relationship, once again in the shadow of the Holocaust, forms an important leitmotif in the work of **SANDRA BRANDEIS CRAWFORD**. The artist's mother was a Viennese Jewess, who, unlike most of the rest of her family, escaped Austria in time. Crawford herself was born in England; but at a very young age accompanied her mother and her mother's mother to Australia, where she spent her early childhood. Her teenage years were spent first in England, then in Vienna, and again in England, where she attended art school. The very embodiment of the Wandering Jewess, she now resides in Vienna, resigned to the fact that she will never feel completely at home anywhere, but determined to use that rootlessness as fertile raw material for her art. This unequivocally matriarchal legacy is compounded by the fact that the artist herself is now the mother of a daughter.

It should therefore come as no surprise that many of Crawford's powerful mixed-media compositions allude to the complexity of these female relationships. *Guardian of the Swim* [11] (Colour Plate 2) deals primarily with the artist's protective attitude to her daughter; her own text, written to accompany this image, runs as follows: 'I have become the constant Watcher. I am rooted to the spot. I cannot join in the activity because I have to watch to see that nothing terrible happens. But in fact anything can happen. The Child is free to choose. I do not own the Child, I just care for her.' *Dear Mother* (Cat. 23) – as the title suggests – concerns itself with the artist's relationship with her own mother. Blurred fragments of letters written to her mother but never sent, form collaged elements in a composition which also contains references within a quasi-geometric structure formed by letters suggestive of the word 'mama', to female archetypes from other cultures, which stand in pointed and poignant contrast with the mother figure in her own life. In Crawford's own words: 'You are the Mother I always wanted, the nurturing all-good Mother, bountiful and soft, as in a dream. Reality is a letter I would never send because it is pointless to judge the past.' Another body of works on the theme of Jewish cemeteries (Cats 19-20), alluding both to her own family's history and to the collective history of European Jewry, are similarly resonant and multi-layered in their imagery.

American-born, London-resident **LILIANE LIJN** has long concerned herself with archetypal female imagery, embodied in her own inimitable combination of elemental and 'high-tech' materials. Her latest sculptures are an arresting homage

to the complexity of being female, and to the intimate alliance of the physical and the spiritual within a single, female body. *My Body, My Self* (Colour Plate 13) incorporates life-size bronze fragments cast from the artist's own body, layers of translucent ruby mica (a naturally occurring geological material) and a (neon-like) argon infrastructure which surfaces triumphantly at the top of the sculpture to form a radiant head-cum-halo. Seen in conjunction with another corpus of recent work inspired by her own mother's reminiscences, *My Body, My Self* can also be construed as an image of womanhood that is specifically Jewish in its awareness of the burdens and challenges of history. Book and video works such as *Her Mother's Voice* (Plate 11) deal explicitly with the artist's increasing preoccupation with her mother's story and its impact on her own life. The pain implicit in that story is kept at bay, rendered 'safe' by the artist's technical ingenuity, impeccable craftsmanship and poetic elegance.

Best known for her technically brilliant, psychologically incisive portraits, and more recently, her evocative, abstracted renderings of desert landscapes, **SARAH RAPHAEL** has also been haunted by her family's European past. During the early 1990s, she created a number of meticulously crafted, enigmatic acrylic paintings of tiny figures in landscape (Colour Plate 11), alongside monumental, claustrophobic charcoal drawings, all imbued with a strong sense of menace – accentuated (as in the canvases of Barbara Loftus) by the tense stillness of the compositions. These images were inspired on one level by her awareness of the suffering of her mother's Polish-Jewish family in the Holocaust; on another, by her reading of certain key literary texts. Although willing to divulge her sources in a general way, she is reluctant to discuss these references in any detail. Naming as artistic kindred spirits painters such as Piero della Francesca, Balthus, Kitaj and Michael Andrews, she clearly favours an art that tantalisingly hints at a hidden narrative while never allowing us to forget the physicality of her chosen medium.

Thus, in *Triptych* of 1993 (Cat. 81) – exhibited here for the first time – the left- and right-hand panels relate to passages from short stories by Isaac Bashevis Singer; while the central image alludes to incidents in *The Painted Bird* by the Polish writer Jerzy Kosinski. Although to the viewer, knowledge of these sources confirms the artist's preoccupation with Eastern European Jewish experience, the deeply disturbing, almost surreal nature of the image is self-evident. Another charcoal drawing, *The Emigration Game* (Plate 13) draws on two very disparate sources: one, the chance hearing by the artist of a poem read on the radio about the game a Jewish family played while waiting to leave Prague before the war – picking a sweet and guessing from the flavour of its filling what their destination might be. The second reference is to a black woman servant the artist encountered on a trip to the West Indies, who had

PLATE 12 (CAT.25)

Sarah Brandeis Crawford, *Feminist Self-Portrait*, 1996

Mixed media on canvas, 50 × 39 in / 126 × 100 cm

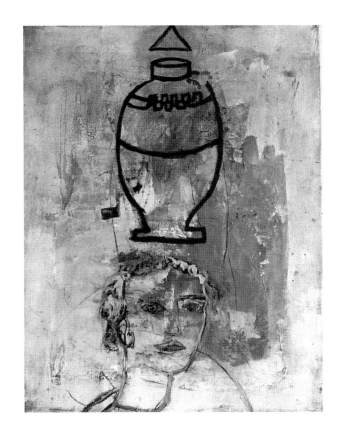

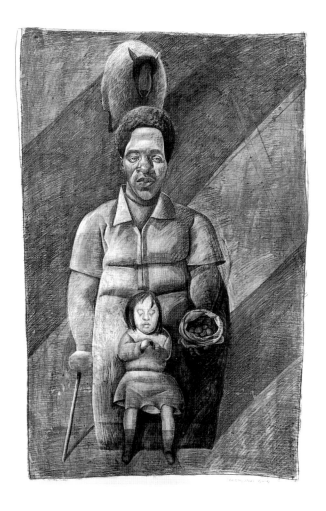

PLATE 13 (CAT.80)

Sarah Raphael, *The Emigration Game*, 1991

Charcoal on paper, 54½ × 36½ in / 138 × 93 cm

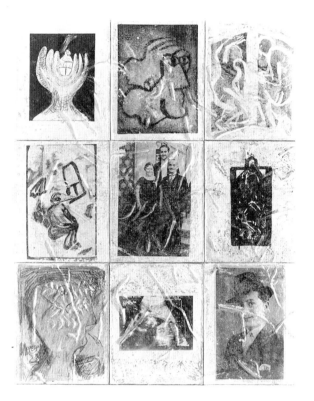

PLATE 14 (CAT.102)

Gillian Singer, *Untitled* (detail), 1996
Pulped paper and plaster with photographic emulsion
105 × 84 × 1 in / 266 × 217 × 2.5 cm

not seen her own family for many years. A sensitivity to these two very different, and yet in some ways kindred, experiences informs this powerful and compassionate composition.

In the recent work of **RACHEL LICHTENSTEIN**, family allegiances and a sense of history that is indisputably Jewish are once again inextricably linked. Since the death of her grandfather in 1987, she has been much preoccupied with perpetuating through her art the memory and legacy of her family's Eastern European roots. Currently resident in Arad, Israel, Lichtenstein has become increasingly aware of the even longer continuum of Jewish history. In *Kirsch Family*, 1996 (Colour Plate 12), she has created a life-size floor mosaic based on a photograph of her grandmother's family taken in Poland in 1915, but constructed of ancient shards collected from archaeological sites in Israel. (The large scale of this work is, she has stated, a self-conscious rejection of the predominantly male assumption that monumentality and masculinity form a natural partnership.) A wall panel, listing the names of the family members depicted and giving details of where they met their death, tells a story both unique and horribly typical; yet in one sense the family is preserved intact – a particularly female preoccupation – by the materials with which the artist has memorialised it. Her sense of the complex layering of historical experience and memory is given further expression by means of the deliberate fragmentation and stratification of the image.

Family and an ambiguous sense of continuity also haunt the work of Leeds-based sculptor and printmaker **GILLIAN SINGER**. As in the case of several other artists in the exhibition, Singer's interest in giving artistic expression to these issues was prompted by the death of a close relative – in this instance her father. This event, combined with a visit to Prague and in particular to its impressive and poignant Jewish cemetery, led in the early 1990s to a preoccupation with images of mortality and decay but also continuity, represented by Jewish ritual objects and ancient symbols. Initially exploring these themes through the intimate medium of etching, she later moved into the more public medium of relief sculpture; and for the present exhibition has produced a monumental forty-nine panelled relief, *Untitled* (Colour Plate 7). This piece incorporates images borrowed from her earlier work (as well as family photographs, xeroxed so as to become intentionally blurred and difficult to read) into a textured plaster background, moulded and incised so as to suggest – among numerous other references – both the organic forms of roots and branches (with their allusions to a symbolic tree of life) and ancient Hebrew calligraphy.

The tragic death of **EDORI FERTIG**'s mother while the artist was still at art school led to an obsession with images of maternity, reminiscent of the work of artists such as Amanda Faulkner and Eileen Cooper, but more powerfully ambivalent. Since becoming a mother herself, a preoccupation with motherhood and fertility has begun to combine (especially since her

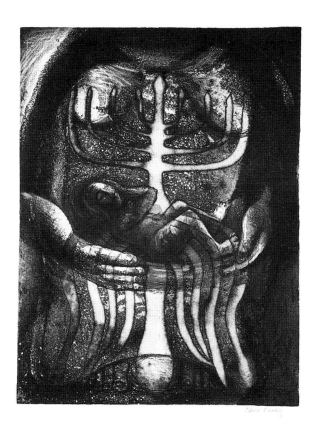

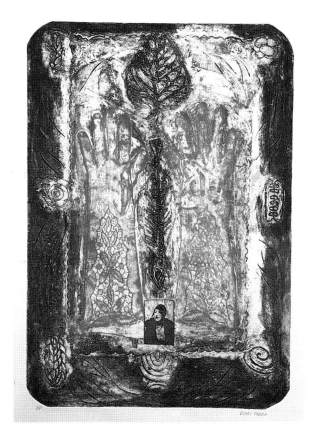

PLATE 15 (CAT.32)

Edori Fertig, *Hannukiah*, 1996

Etching, 15½ × 12 in / 39.5 × 30 cm

PLATE 16 (CAT.37)

Edori Fertig, *Shabbat (My Grandmother's Gloves)*, 1996

Collograph and chine collé with photo etching, 25 × 17½ in / 63 × 44.5 cm

partner is not Jewish) with a wish to explore the symbolic and emotional legacy of her Jewish origins. The Menorah*, with its references to the tree of life, to organic life forms and to flame, has proved a particularly rich source of imagery for this technically inventive and versatile artist. In the etching *Hannukiah* (Plate 15), for example, the Hannukiah* candelabrum fuses visually with the rib-cage of the central female figure, its inverted form suggestive not only of bones but of a tallit* (normally worn only by men). Ancient symbols combine in other works with imagery of a more directly personal nature, relating to her mother's, and her grandmother's past. In *Shabbat* (*My Grandmother's Gloves*) (Plate 16), for example, she has incorporated a plaster imprint of gloves actually owned by her grandmother into a image resonant not only of the Sabbath blessing but also of the abstracted hand motif (or Hamsa*) traditionally worn as an amulet to ward off the evil eye. The matriarchal lineage once more – indeed, one of Fertig's works is actually entitled *Maternal Line*.

ABIGAIL COHEN's father, an Orthodox* Jew, left the family home when the artist was a young child; unsurprisingly, her attitude to her own Jewishness in her formative years was ambivalent in the extreme. Recently, though, she has returned to religious observance with a new sense of self-assurance. She is also well attuned to current feminist debates. Indeed, her monumental series of paintings *Psalm I, II and III* originated in a wish to investigate the problematic dynamic of a woman artist painting a female nude. Having asked a female friend to photograph a naked model bending down to light two candles, accompanied by other symbolically laden objects such as an apple and a hairbrush, Cohen was struck by the fact that the form of the woman in the photograph almost exactly echoed (albeit in reverse) that of the Hebrew letter *shin*, which, as the first letter both of the word Shaddai*, one of the sacred names of God, and of Shechina*, the female element in divinity, is one of Judaism's most potent symbols.

Out of this serendipitous event grew the *Psalm* triptych, a young woman's painterly meditation on the complex relationship between female sexuality and women's spirituality. (Significantly, the paintings were once due to be hung in the hall of a London synagogue; but the rabbi deemed them too 'immodest' for such a context!) The Hebrew letters inscribed, graffiti-like, on the surface of *Psalm I* (Colour Plate 5) allude to a poem written by Cohen herself, which reads as follows: 'Welcome / a woman of worth / standing in generations, the bride / lights her kind of writing / and she makes the spirits dance.' In the other two works, readable detail is progressively eliminated, the forms increasingly abstracted, so as to emphasise both the symbolic power of the imagery and the rich physicality and glowing colours of the paintings as paintings.

CAROLE BERMAN's Jewishness has always formed an important part of her life; but co-exists in her art with a fascination for other religions and cultures – even, as in the works exhibited here, when the ostensible subject-matter derives from the Old Testament. Her complex mythic images are a striking amalgam of the visionary and the intensely personal, with a focus primarily on the female form and the female psyche. Although William Blake, Cecil Collins, Frida Kahlo and Francesco Clemente are some of the artists who have clearly influenced her, her artistic voice remains unequivocally her own.

Thus, *The Three Sisters* of 1995–6 (Colour Plate 4), suggestive, in Berman's own words, of 'both a personal and a collective sisterhood', was originally inspired by images of Cretan fertility goddesses seen on a visit to that island with her two sisters and their daughters. The original drawing travelled with the artist to Jerusalem, where she has been living for the past year, in the course of which time she has immersed herself in the Zohar* and other Jewish mystical texts. Some of the diagrammatic illustrations to these texts further inspired her, suggesting 'associations between the Sefirot* in the Tree of Life and the Chakras of the body'. The strange homunculi that people *The Three Sisters* thus allude to these symbolic energy points of the human body in both Yogic and Jewish mysticism; they also, more generally, imply the 'potential for new lives that will hopefully come into being'.

Eve (Plate 18), in which 'these homunculi have extensions into the outside world, which I hoped might suggest a metaphor for oscillations of energy or prana', followed shortly after. These 'extensions' are also reminiscent of the extra hands of Hindu deities, and in particular those of the powerful and fearful goddess Kali. Eve is thus in part transmuted into the more threatening figure of Lilith, Adam's first wife who dared to defy his wishes and was thereby relegated to the world of demons.[12] *Adam* in Carole Berman's rendering of him (Plate 17) is allied firmly with the animal world – in marked contrast to Eve, whose links, for all her physicality, are firmly with the spiritual realm.

RACHEL GARFIELD, unusually among the artists included in the exhibition, hails from a religiously Orthodox* Ashkenazi* family. Thus, the ritual artefacts that inhabit her canvases form an integral part of her being – in spite of the fact that she now regards what they represent with a more critical eye. She is strongly aware, too, of the need to pay her ambiguous homage to these potent symbols in a contemporary aesthetic idiom; and has chosen for that purpose the language of monumental colour-field abstraction.[13] Her awareness of gender, though not dealt with directly in her work, can be seen to express itself in a self-conscious preoccupation with surface pattern, and with religious rituals from which women are virtually excluded or, at best, in which the status of women is deeply ambivalent.

Garfield's canvases, although easy to appreciate on a purely sensuous, even decorative level, are never entirely abstract.

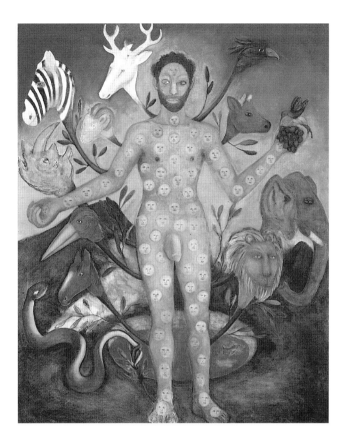

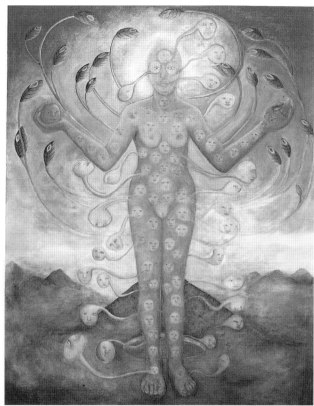

PLATE 17 (CAT.11)

Carole Berman, *Adam*, 1996

Oil on canvas, 60 × 48 in / 152 × 122 cm

PLATE 18 (CAT.12)

Carole Berman, *Eve*, 1996

Oil on canvas, 60 × 48 in / 152 × 122 cm

PLATE 19 (CAT.42)

Rachel Garfield, *Birthright*, 1995–6

Oil on canvas, 45 × 66 in / 114 × 168 cm

PLATE 20 (CAT.8)

Angela Baum, *Kaddish*, 1996

Black and white ink on gesso, 47 × 99 in / 120 × 251 cm

The artist herself has spoken of her interest in the concepts of layering, revelation and concealment – both iconographically, in terms of her symbolic vocabulary and technically, in terms of her handling of paint. Motifs derived from ritual objects – Seder* plates, Hannukah* candelabra, amulets, festive goblets and so on – from a wide range of different Jewish communities, even when fragmented and decontextualised, speak eloquently of their users; while Hebrew calligraphy serves too to anchor the imagery in an age-old but still vibrant tradition.

Thus, the title of *The Wicked Son* (Colour Plate 14) is a reference to the passage in the Passover Haggadah* in which four sons question their father as to the significance of the Seder*. The fact that the artist has chosen to focus on the wicked son (the Hebrew word for wicked – *rasha* – is literally inscribed upon the picture surface) suggests her own identification with the position of defiant outsider represented by that son.[14] Equally, the fact that the first letter of the word *rasha* is 'imprisoned' behind a grille in a composition reminiscent of a fortress testifies to Garfield's fascination with Jewish life in the Middle Ages and, more generally, with the complex interaction between Judaism and its host cultures throughout history.

ANGELA BAUM's abstract art is of an entirely different kind, although she too hails from an Orthodox* background. Whether both she and Rachel Garfield chose abstraction partly – even unconsciously – under the influence of the traditional (but now, it has to be said, virtually obsolete) Jewish suspicion of the 'graven image' cannot be proved, but at least provides food for thought. Baum's ambivalent position as a feminist negotiating a space for herself within Orthodoxy* first found expression in a series of paintings produced in the early 1990s entitled *Silent Letters*, comprising a calligraphic meditation on the significance of the letters *ayin* and *aleph*, both of them silent but essential components of the Hebrew alphabet – and hence metaphors for the position of women within traditional Judaism.

A painting of 1992, *Agunah* (Cat. 1), in which a photocopied fragment of the artist's own Ketubah* is held prisoner by a threatening abstract grid, alludes in a powerfully symbolic fashion to the dilemma of women trapped in unsatisfactory marriages by Jewish religious law. Similarly, a more recent sequel to the *Silent Letters* series entitled *Kaddish* (Plate 20), virtually monochrome in homage to the funereal theme of the work, stands both as a reproach to a religion that – in its Orthodox* form at least – denies a woman the right to recite the prayer for the dead (in this case, Angela Baum's own father) as part of a synagogue service; and as the means whereby the artist can indeed mourn her father in public.

Very different in mood is the series of celebratory images collectively entitled *Matriarchs* which Baum produced in 1995 (see Colour Plate 16). The artist describes these vividly coloured, vibrant compositions as 'abstract portraits of the matriarchs … which relate to my deep interest in the women in the Bible, their lives and more importantly the stories behind the stories'. However, unless the viewer knows those stories already, they can only be guessed at; for these are explosive painterly meditations on the idea of matriarchal power (with only the occasional Hebrew name to anchor them more precisely) rather than explicit descriptions of historical figures. Although Baum's *Chava (Eve)* (Cat. 2) stands in striking visual contrast to Carole Berman's emphatically figurative rendering of the same subject (see Plate 18), both – in their different ways – seek to celebrate the intimate alliance of the physical and the spiritual – a concern shared, as we have seen, by a number of other artists in this exhibition.

Surprisingly few of the artists featured in *Rubies and Rebels* have focused on the self-portrait as a means of expression. Julie Held and Marlene Rolfe are notable exceptions here (see Cats 48, 90); another is JUDY BERMANT. Long well-known in the mainstream Anglo-Jewish community for her sensitive portraits of its members (including her husband, the writer Chaim Bermant), her images of Israel and her illustrations to her husband's books, it is only in her troubled and penetrating self-portraits that she allows herself to vent the tensions she feels as an Orthodox* woman struggling to combine the demands of her religion, her family and her artistic creativity. *Negative / Positive Self-Image* (Plate 21) graphically embodies these tensions and the way they impinge upon her sense of self. The other prints exhibited here (Cats 14-18) similarly testify, both by their – slightly self-mocking – titles and the nervous energy of their surface textures, to the fragmentation with which she has to contend in her everyday life.

Although not only or straightforwardly a self-portrait image, the artist herself forms the unequivocal focus of JESSICA WILKES's monumental canvas, *Carousel* of 1989–91 (Plate 22). Although unashamedly autobiographical, this painting also makes reference to pre-existing images and symbols: most obviously to Mark Gertler's *The Merry-Go-Round* of 1916 (itself an expression of outsider angst), and the fascination felt by many artists since at least the eighteenth century for the circus or fairground as metaphors for human existence, and, more specifically, for the marginalised position of the artist. Unlike Sarah Raphael, Wilkes (who was in therapy for some years during the making of this painting) is happy to 'explain' the manifold references in her work. Thus, for example, the falling male figure on the right of the composition represents her Jewish, socialist father, whose sense of self Wilkes now perceives as having been very fragile; the red-haired child, a composite figure based on the artist's favoured younger sister, her (non-Jewish) mother and her niece, also represents her own 'better self'. The sexy, half-naked female figure clearly represents both female sexuality in general and the artist's own sexuality in particular; the monkey behind the central figure

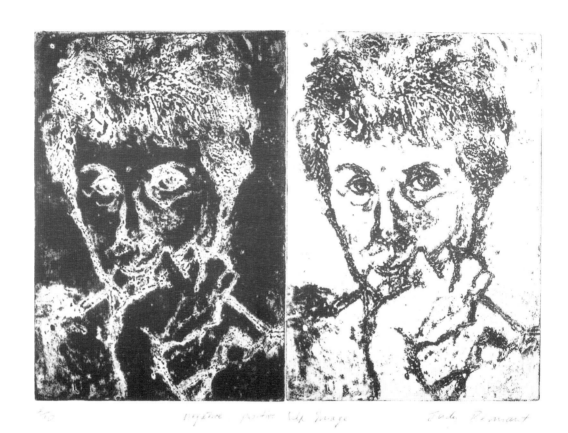

Judy Bermant, *Negative/Positive Self-Image*, 1995

Aquatint, 11 × 15½ in / 28 × 40 cm

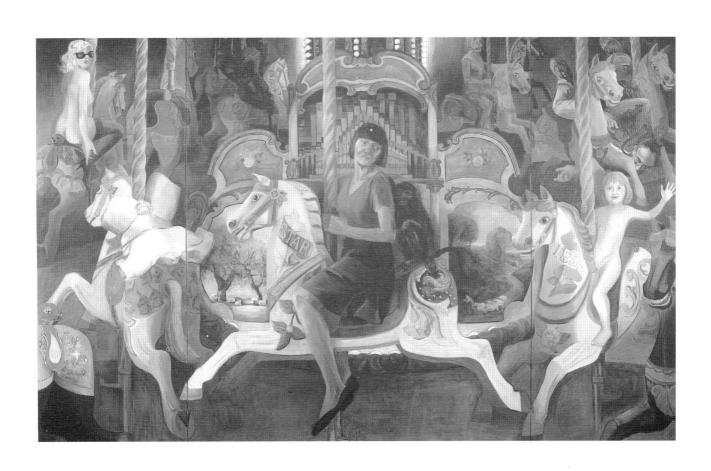

PLATE 22 (CAT.103)

Jessica Wilkes, *Carousel*, 1989–91

Oil on canvas, 70 × 112 in / 178 × 285 cm

PLATE 23 (CAT.91)

Hilary Rosen, *The Boat*, 1990

Charcoal and mixed media, 45 × 35 in / 115 × 89 cm

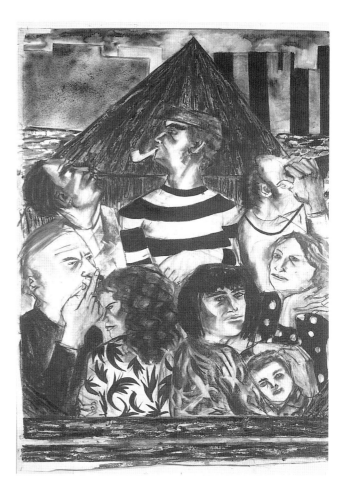

PLATE 24 (CAT.96)

Anne Sassoon, *Family Line-Up with Fez*, 1995

Oil on canvas, 14 × 11 in / 35.5 × 28 cm

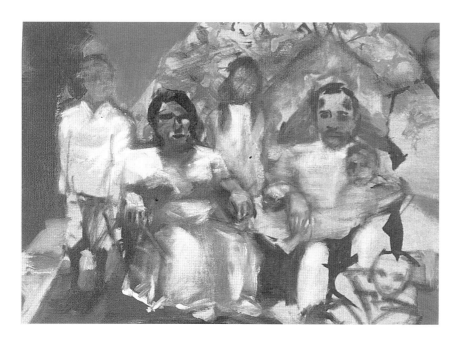

stands for the artist's past (but traditionally stands also for lust); while the word 'Star' refers not only to a much-loved horse from the artist's childhood, but also to her own refusal to be inconspicuous.

Less iconographically complex, though, if anything, more symbolically resonant are the more recent large paintings of a female fire-eater in harlequin costume. Strong yet vulnerable, the woman transgressively 'playing with fire' was originally intended as an exploration of female sexuality; but soon became overlaid with references (at first barely conscious) to the Holocaust. This first manifested itself in the canvas, *Torch Song* (not exhibited), which in the background featured a tall brick tower based on a structure close to the artist's London home, which only later took on more alarming references. In *Devil's Stick* (Colour Plate 15), these references are more veiled, but undeniably present.

HILARY ROSEN's attitude to bourgeois Jewish festivities – above all, to wedding parties – as well as to the social niceties of synagogue worship (Colour Plate 9), is both witty and profoundly ambivalent. In *The Selection* (Cat. 95), her fascination with social mores and the seductiveness of ritual is compounded by a darker undercurrent. Inspired in part by her memories of a Jewish wedding in which dancing couples were paired off by a master of ceremonies, the idea of 'selection' also brought to mind the terrible process whereby the fate of Holocaust victims on arrival at the death camps was decided by the wave of a hand (hinted at here both by the figure seen from the back with outstretched arms and the suggestive title). In her restless, crowded compositions – most often executed in watercolour on an unusually monumental scale for that medium – the celebrants are depicted in a floridly exaggerated manner bordering on caricature, stylistically reminiscent of those mordant critics of Weimar culture, Otto Dix, Max Beckmann and George Grosz but possessing a warmth and a humour far removed from the angry cruelty of so many *Neue Sachlichkeit* images. The recurring motif of a disproportionately large single figure occupying the centre foreground is clearly inspired by a device also to be found in the work of George Grosz – but in Rosen's work that figure is nearly always female, both alienated from, and an unwilling participant in, the action behind her.

Rosen's strong identification with the immigrant of any race and colour – as witnessed, for example, by her lively and sympathetic renderings of London street markets – undoubtedly has its roots in her vivid childhood memories of London's East End, home of her maternal grandparents. It expresses itself, too, in images of quite a different kind: in which a sombre, empathetic awareness of the plight of the refugee, the evacuee, the homeless (Cats 91, 93, 94), born of her own family's experiences as poor Russian-Jewish immigrants fleeing the pogroms* around the turn of the century, reaches beyond the particular to the universal. For many of these images, Rosen abandons

the fluid sensuousness of watercolour in favour of charcoal applied with a stark dramatic power (Plate 23).

ANNE SASSOON's family on her father's side was of Iraqi origin. She herself was born in Wales, but grew up in South Africa (acutely aware, it seems, of her disadvantaged position as a woman in a tightly knit Sephardi* community), before returning to settle in Britain in 1986. A year recently spent in the USA further reinforced, and compounded, her already complicated self-image, her strong sense of the dislocation felt by all immigrants. Indeed, in South Africa, her work revealed a strong empathy with the migrant black and coloured populations of that country. It was in America that she painted the series of images exhibited here (Cats 96-101; Colour Plate 3; Plate 24), inspired by a photograph of her father's family taken just before they left Baghdad in 1918 to settle in Britain. She admits to being fascinated by the slightly strained formality, the exotic clothing of the sitters – and to being moved by the piquancy of the image, the sense of alienation it conveys to her, and which she in turn conveys by means of a hot palette and a restless, nervous brushstroke.

VERDI YAHOODA's family left the Yemen in the early 1960s, bringing much of their Sephardi* culture with them. Although her photographic work frequently makes reference to that culture, she has until recently tended to play down its significance, stressing instead the more conceptual and formalist aspects of her work. One might indeed argue that the cerebral, almost detached nature of her imagery suggests a suppression of its emotional importance to her; certainly, a tension seems to exist between this apparent coolness, verging on sterility, and a sense of nostalgia for the world to which it alludes. The result of this tension is a poetic body of work, of greater poignancy than the artist, I suspect, intended.

Seven Wrapped Objects (Cat. 110) makes use of artefacts, some of them purely domestic (a set of table knives, a delicate woven handkerchief), others associated with religious ritual (a piece of Afikoman*, a rolled-up Ketubah*) found in Yahooda's parents' home. The act of wrapping and unwrapping these objects in white cloths alludes not only to an ordinary physical act (albeit one that brings to mind the white kittel*, the prayergown-turned-shroud, in which male Orthodox* Jews are buried), but also a metaphysical one – a metaphor for concealment and discovery. *A Question of Faith* (Plate 26) juxtaposes three objects (one of them a mezuzah*) used for mainstream ritual purposes with three others used in more obviously superstitious rituals (the collecting of nail parings, for example), thereby implying that superstition, however primitive, forms an integral part of the Jewish – or indeed, any – religion. The title of *Sifting Through* (Cat. 111) alludes to the domestic, exclusively female practice in Yemenite Jewish culture of sifting grains for culinary purposes; but also suggests, when allied to the motley assortment of domestic objects depicted in this

PLATE 25 (CAT.78)

Jenny Polak, *To Self-Destruct: To Identify (Jew Life in a Christian Country No.6)*, 1993

Mixed media display unit with books to take away

PLATE 26 (CAT.109)

Verdi Yahooda, *A Question of Faith*, 1986

1 set of 3 black-and-white photographs (from a set of 2), each set 20 × 30 in / 51 × 76 cm

series of photographs, the complex layering of identities faced not only by the artist herself, but by all immigrants.

As we have seen, the problematic status of the immigrant and the displaced person informs a great deal of the work in this exhibition, if only obliquely. In contrast, much of JENNY POLAK's work of the early 1990s concerns itself explicitly and directly with the experience of immigration. *Like It Or Not* (Colour Plate 6) is a vivid and disturbing work, comprising a lightbox showing a photograph of her mother's head, eyes closed, grimacing as if drowning, and framed by a flower-like structure made of papier-mâché, inscribed uncompromisingly with the words 'Jew', 'Mother', 'England'. *Repatriate (England Still)* of 1993 (Cat. 77) invites the viewer to relive the immigrant experience of walking up a makeshift jetty, which incorporates another version of the same luminous image of the artist's mother found in *Like It Or Not*, as well as some disconcerting statistics, alerting one to the fact that at no time has immigration to this country ever exceeded emigration.

To Self-Destruct: To Identify (with the deliberately provocative and self-conscious subtitle, *Jew Life in a Christian Country No.6*) (Plate 25) sets out to analyse – in a manner that, typically for Polak, is both conceptually acute and visually arresting – illness, particularly of the female, as a metaphor for 'otherness' inscribed upon the body. In her own words, this is 'a personal story of illness as a Jewish signifier in relations with Christians'. Quotations from Walter Scott's *Ivanhoe* referring to Rebecca, the epitome of the exotic, 'beautiful Jewess', combine in this work with references to the childhood illness of colitis, suffered by Polak herself and particularly prevalent among Jews, these texts being superimposed on photographs of the artist's own naked torso.

Not all of Polak's work is concerned with specifically Jewish issues.[15] Since she moved to America, her work has become more openly political and confrontational, tackling issues of black/white female relationships as well as the collusion of the Diaspora* (and the US in particular) with right-wing forces in Israeli society. Like several other artists in *Rubies and Rebels*, she is acutely aware that her position as a Jewish woman entails an almost moral duty to empathise with the underdog, to alert the world to injustice, inequality and suffering irrespective of tribal allegiances.

LYNN LEON is certainly a case in point here. Whereas for Carole Berman a sojourn in Israel led to an immersion in centuries-old mystical texts, it caused Leon to produce images more topical, provocative and implicitly political than anything she had created heretofore: namely, a series of small pen-and-ink drawings collectively entitled *Identities* (Cats 54–7). She is also represented in this exhibition by an earlier body of work, a powerful group of large-scale, composite black and white photographs from the mid–1980s (Cats 51–3), which use the artist's daughter as her model. These visually compelling

and technically inventive images form a disturbing exploration of the nature of confinement and violence, many of them containing references both to the Holocaust (see Plate 27) and to the latent tensions of life in Israel as well as to the vulnerability of the female body.

When exhibited in Haifa, Israel, *Identities* caused a furore among right-wing extremists, who chose to interpret the intentional ambiguity of their imagery as deliberate blasphemy. The cunning allusion in these pairs of heads to Magritte's unsettling painting of *The Lovers*, not surprisingly, went unheeded. While it is perhaps understandable that some, even in this country, might find Leon's device of bringing together the Jewish tallit* and the Palestinian keffiyah* unpalatable (see Plate 28), her motives are unimpeachable, fuelled by a humanist desire for communication and, through communication, the possibility of dialogue and eventual understanding between erstwhile enemies.

The title of Lynn Leon's *Identities* series might well stand for the exhibition as a whole. If *Rubies and Rebels* has a thesis, it is that identity can never be fixed; but that the search for identities is a fascinating and necessary one. By focusing on Jewish women artists working in Britain today, whose Jewishness and gender are central to their artistic output, it offers valuable insights into the diverse ways in which women perceive their Jewishness in contemporary Britain. Aware of their complex 'otherness' as women, Jews and artists, they put that awareness to good creative use; and in so doing, prove that art has a crucial role to play in exploring – and perhaps crystallising – issues of identity.

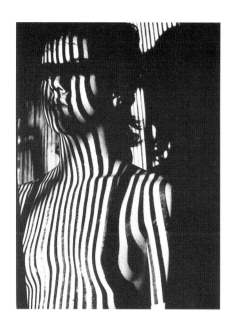

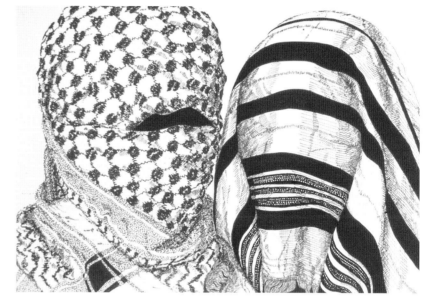

FOOTNOTES

GRISELDA POLLOCK, PP.15–27

1 It was one of Rosalind Preston's personal hopes that Jewish women artists, overlooked in the official investigation, should also become visible. *Rebels and Rubies* is in part a result of that vision.

2 H. Koltun (ed.), *The Jewish Woman: New Perspectives*, Schocken Books, New York, 1976; Aviva Cantor, *On the Jewish Woman: A Comparative and Annotated Listing of Works Published 1900–1979*, Biblio Press, New York, 1979; Ora Hamelsdorf and Sandra Adelsberg, *Jewish Woman and Jewish Law: Bibliography*, Biblio Press, New York, 1980; Blu Greenberg, *On Women and Judaism: A View from Tradition*, The Jewish Publication Society of America, Philadelphia, 1981; Susannah Heschel (ed.), *On Being a Jewish Feminist*, Schocken Books, New York, 1983; Susan Weidman Schneider, *Jewish and Female: Choices and Changes in Our Lives Today*, Simon and Schuster, New York, 1984; Melanie Kaye-Kantorowitz and Irena Klepfisz, *The Tribe of Dina: A Jewish Women's Anthology*, 1986, reprinted Beacon Press, Boston, 1989; S. Henry and E. Taitz (eds), *Written Out of History: Our Jewish Foremothers*, Biblio Press, New York, 1988; Judith Plaskow, *Standing again at Sinai: Judaism from a Feminist Perspective*, Harper Books, San Francisco, 1990; Ilana Pardes, *Countertraditions in the Bible: A Feminist Approach*, Harvard University Press, Cambridge, 1992; Adrienne Baker, *The Jewish Woman in Contemporary Society*, Macmillan, London, 1993; Sybil Sheridan (ed.), *Hear Our Voice: Women Rabbis Tell Their Stories*, SCM Press, London, 1994; Rosalind Preston et alia, *Women in the Jewish Community: Review and Recommendations*, Office of the Chief Rabbi, London, 1994; Judith S. Antonelli, *In the Image of God: A Feminist Commentary on the Torah*, Jason Aronson, New York, 1996.

3 Another example would be Rozsika Parker's article 'Being Jewish: Anti-Semitism and Feminism' which was published in the feminist magazine *Spare Rib*, no.79, 1979, at the height of feminist debates about racism.

4 In 1993, Bryan Cheyette organised a conference in the University of London called 'Modernity and the "Jew"', while this theme of Jewishness and the contradictions of modernity have been the theme of Zygmunt Bauman's major reflections in *Modernity and the Holocaust*, Polity Press, Cambridge, 1989, and *Modernity and Ambivalence*, Polity Press, Cambridge, 1991.

5 I owe this concept to the work of Judith Plaskow, whose inaugurating lecture at the conference in June 1992, 'The Half-Empty Bookcase', powerfully brought this missing component to light. A similar thought appears in Cynthia Ozick's essay 'Notes Towards Finding the Right Question' in Heschel, op.cit., pp.120–51.

6 Avram Kampf, *Chagall to Kitaj: Jewish Experience in 20th Century Art*, Lund Humphries, London, 1990. Of 133 artists exhibited, only eleven were women.

7 Or that Israeli experience is not homogeneous and that ideals and actualities of femininity stretched between the extremes of religious separatism, socialist kibbutz life, displacement and generational memory, created particular dimensions and stresses within and despite Zionism*. I am indebted for these insights to Irit Rogoff, 'Daughters of Sunshine: Israeli Femininities', in Sigrid Weigel (ed.), *Judische Kultur und Weiblichkeit in der Moderne*, Böhlau Verlag, 1994. For a study of the particular ways in which women's gender, sexuality and maternity shaped their specific experience of the Holocaust, see also Dina Wardi, *Memorial Candles: Children of the Holocaust*, Routledge, London, 1992.

8 See Linda Nochlin's critically important essay, 'Why Have There Been No Great Women Artists?', in E. Baker and T. Hess (eds), *Art and Sexual Politics*, Macmillan, London, 1972, and major exhibitions of women artists and critical deconstructions of masculinist art history such as Rozsika Parker and Griselda Pollock, *Old Mistresses: Women, Art and Ideology*, Pandora Books, London, 1981, and HarperCollins, London, 1996.

9 Four Centres for Jewish Studies have been established in British Universities in 1995–6 alone: at Sussex, Southampton, Manchester and Leeds.

10 In *Modernity and Ambivalence*, Zygmunt Bauman advances an analysis of the Jewish predicament in terms of modernity's dream of order frustrated by the unassimilable strangeness of the 'other', figured by the Jewish presence in Christian and post-Christian Europe. The analysis is strikingly similar to feminist theories of the 'otherness' of the feminine proposed, for instance, by Julia Kristeva, a theorist who in her book *The Powers of Horror*, Columbia University Press, New York, 1982, reads the laws of Kashrut* and Niddah* deriving from *Leviticus* as metaphoric of a system for abjecting and mastering the maternal body: that which cannot be admitted to the symbolic space, the Temple.

11 Apparently she insisted on this title to avoid the confusion of 'Frau Rabbiner', which might indicate merely that she was the spouse of a rabbi.

12 Elizabeth Sarah, 'Rabbi Regina Jonas 1902–1994: Missing Link in a Broken Chain', in Sybil Sheridan (ed.), *Hear Our Voice: Women Rabbis Tell Their Stories*, SCM Press, London, 1994, p.3. I am grateful to Jacqueline Rothschild for introducing me to Regina Jones.

13 Wife of Meir, Jewish rabbi of 2nd century AD, cited as an example of fortitude and faith, the only woman in the Talmud* to have participated in legalistic discussion.

14 The issue in the Christian community of women's ordination raises similarly intense questions while being different insofar as religion still has a priesthood, whereas 'rabbi' means teacher and has behind it the tradition of the Pharisees whose stress on lived religious observance and ethical principle ensured that Judaism survived the destruction of its cult centre, the Temple and its priesthood. These early rabbis interpreted the law, and in redacting the Talmud* established the frameworks of Diaspora* Jewish life, law, observance, study and prayer. Thus a woman rabbi occupies not a sacerdotal function, but one in relation to that fundamental aspect of rabbinic Judaism: the law.

15 Henrietta Szold applied to be trained as a rabbi in 1903 at the Jewish Theological Seminary in the United States. She was allowed to study on condition that she did not come forward for ordination. Heschel, op.cit., p.1.

16 The poet and martyr Hannah Senesh (1921–44), who was executed by the Nazis at the age of twenty-three, also left a diary, letters and poems. *Hannah Senesh: Her Life and Diary*, introduced by Abba Eban, Schocken Books, New York, 1972.

17 Mary Lowenthal Felstiner, *To Paint Her Life: Charlotte Salomon in the Nazi Era*, HarperCollins, New York, 1994. The first texts on Salomon were published in 1963; 1981 saw the publication in book form of the first full edition of the 769 paintings. An exhibition in Paris at the Centre Pompidou in 1992 brought her work to a much wider audience. Four films have also been made.

18 See Lisa Appignanesi and John Forrester, *Freud's Women*, Weidenfeld and Nicolson, London, 1992, and Janet Sayers, *Mothering Psychoanalysis*, Hamish Hamilton, London, 1991.

19 Sigmund Freud and Josef Breuer, *Studies in Hysteria* (1895), Freud Library, Vol.3, p.73, Penguin Books, London, 1974.

20 The Yiddish text of Glückel's autobiography was first published by David Kaufmann (ed.), *Die Memoiren der Glückel von Hameln 1645–1719*, J. Kaufmann, Frankfurt am Main, 1896; Bertha Pappenheim's translation appeared in Vienna in 1910, published by Stefan Meyer and Wilhelm Pappenheim. The most complete English version is *The Life of Glückel of Hameln 1645–1724, Written by Herself*, edited and translated by Beth-Zion Brahams, Horowitz Publishing, London, 1962. For a recent study see Nathalie Zemon Davis, *Women on the Margins: Three Seventeenth-Century Lives*, Harvard University Press, Cambridge, Mass., 1995. I am grateful to Eva Frojmovic for this reference.

21 Marion A. Kaplan, *The Jewish Feminist Movement in Germany: The Campaigns of the Jüdische Frauenbund 1904–1938*, Greenwood Press, Westport, Conn., 1979.

22 Lucy Freeman, *The Story of Anna 'O'*, Paragon House, New York, 1972. See also a recent article on 'Bertha Pappenheim' by Sally Berkovic, *The Jewish Quarterly*, Spring 1966, no.161, pp.42–3; and Lisa Appignanesi and John Forrester, op.cit.; Penina Stone, *Bertha Pappenheim: Bildung and the Jewish Prostitution Problem*, MA Thesis, Worcester College, Oxford University, 1984; I am grateful to Vera Grodzinski for this reference.

23 Another possible example would be 'Dora', the name given to another Jewish patient of Freud's, Ida Bauer, whose tangled story of sexual transactions in a bourgeois Jewish family in turn-of-the-century Vienna has fascinated analysts and feminists alike. Recent research has also returned this woman's story to a history of Jewish women by showing that far from remaining an uncured and unpleasant neurotic, she became a keen player of the newly fashionable game of bridge, surviving to escape to New York in 1938 where she remained a gifted exponent of this intellectually intricate game until her death in 1945. See Appignanesi and Forrester, op.cit., pp.146–67.

24 Fré Cohen (1903–43) came to my attention when a friend visiting Amsterdam's Historical Museum saw an exhibition there devoted to this major modern designer. The discovery was eloquent of these erased careers whose end in the death camps we must counter by patient and dedicated historical recovery of their artistic practice and legacies. See Peter van Daam and Philip van Praag, *Fré Cohen: Leven en Werk van een Bewogen Kunstenares*, Uniepers Abcoude, Amsterdam, 1993. My thanks to Nanette Salomon for the catalogue.

25 Blu Greenberg, *On Women and Judaism*, p.6.

26 ibid.

27 Ozick, op.cit., p.125. This essay was first published in *Davka*, 1971.

28 The sermon was given in 1862, the year in which the first claim for women's suffrage was put to a British Parliament.

29 West London Synagogue was founded in 1842; the first Reform* synagogue in Yorkshire was established in 1848, and predates any Orthodox* communities in the region.

30 R. d'Avigdor, 'The Status of Jewish Women in Biblical Times', *Englishwoman's Journal*, Vol.X, 1863, pp.255–9.

31 Virginia Woolf, *A Room of One's Own* [1928], Penguin Books, London, 1974, pp.28–9.

32 For a fuller discussion of this point and the use of the term 'feminine', see my 'Inscriptions in the Feminine' in Cathérine de Zegher (ed.), *Inside the Visible: An Elliptical Traverse across the Twentieth Century*, MIT Press, Boston, 1996.

33 Rita M. Gross, 'Steps Toward Feminine Imagery of Deity in Jewish Theology' in Heschel, op.cit., pp.234–47.

34 I am indebted for the comments about the root of *rehem* and *rahamim* to the artist and theorist Bracha Lichtenberg Ettinger, who has in addition pointed out how Shaddai*, a name used of the Jewish deity, literally means 'my breasts'. The same argument applies: why not imagine the nurturing and life-giving aspects of the deity through something as powerful as the metaphor of the breasts without, however, confusing these qualities in our known experience with the bodies and persons associated with them: therein lies the importance of the second commandment prohibiting the worshipping of figurative idols – mistaking the form of what is in the world for the idea that it represents to our experience. See Bracha Lichtenberg Ettinger, 'Matrix: A Shift Beyond the Phallus', given at the international congress *The Point of Theory*, Amsterdam, 10 January 1993, and printed in a limited edition by the BLE Atelier, Paris. Other discussions of the names of God appear in 'The Becoming Thresholds of Matrixial Borderlines', in G. Robertson (ed.), *Travellers' Tales: Narratives of Home and Displacement*, Routledge, London, 1994, pp.38–62.

35 Ozick, op. cit., in Heschel, op.cit., p.150. First published in 1979 in *Lilith*, no.6.

36 Claude Lévi-Strauss, *La Pensée Sauvage* [1962], translated as *The Savage Mind*, Weidenfeld and Nicolson, London, 1966.

37 Sherrie B. Ortner, 'Is Female to Male as Nature is to Culture?', in Michelle Zimbalist Rosaldo and Louise Lamphere (eds), *Woman, Culture and Society*, Stanford University Press, California, 1974, pp.67–88.

38 See Mary Douglas, *Purity and Danger*, Pantheon Books, New York, 1966, and Julia Kristeva, *The Powers of Horror*, translated by Leon Roudiez, Columbia University Press, New York, 1982.

39 Walter Orenstein, *Letters to My Daughter: A Father Writes about Torah and the Jewish Woman*, Jason Aronson, New York, 1995, stresses the fundamental principle of Havdalah* – separation or differentiation within Judaism, by which is acknowledged the heterogeneity of all, and their unique and particular functions within a whole.

40 I shall be closely dependent on the important work of Mieke Bal, 'Sexuality, Sin and Sorrow: The Emergence of the Female Character' in her book, *Lethal Love: Feminist Literary Readings of Biblical Love Stories*, Indiana University Press, Bloomington, 1987, pp.104–31. Also reprinted in Susan Rubin Suleiman (ed.), *The Female Body in Western Culture: Contemporary Perspectives*, Harvard University Press, Cambridge, Mass., 1986, pp.317–38. Some of the following interpretation of the figure of Eve is my own and differs slightly from that of Mieke Bal.

41 This creation story is about the making of sexual difference and I do not intend in what follows to normalise this as identical with sexuality, thus creating again a biblical precedent for intolerance towards diverse forms of human sexuality.

42 The concept of art as 'inscription' is developed in my essay 'Inscriptions of the Feminine' in Catherine de Zegher (ed.), *Inside the Visible: An Elliptical Traverse across the Twentieth Century*, MIT Press, Boston, 1996, accompanying the exhibition of that title at the Institute of Contemporary Arts, Boston, and Whitechapel Art Gallery, London, in 1996–7.

JULIA WEINER, PP.29–39

1 Examples of her work can be seen at the Jewish Museum, London and at the Spanish and Portuguese Synagogue, London.

2 Deborah Cherry, *Painting Women – Victorian Women Artists*, Rochdale Art Gallery, 1987, p.3.

3 Rebecca Solomon's *The Governess*, in which a poor governess, dressed in black, minding a small child, is portrayed with her employer's daughter, who is about the same age but dressed in pink, and flirting with an admirer, was shown at the Royal Academy in 1854, as were Abraham Solomon's *First Class* and *Second Class* paintings.

4 For example, 'Miss Solomon's colouring bears a strong affinity to her brother's; it has in it nothing feminine.' *Spectator*, 4 March 1865.

5 The first was Solomon Alexander Hart (1806–81) who was elected in 1840.

6 Show Sunday, *Jewish Chronicle*, 29 March 1912.

7 Obituary of Delissa Joseph, *Jewish Chronicle*, 14 January 1927.

8 Review of Art Exhibition, *Jewish Chronicle*, 17 May 1946.

9 See footnote 7, above.

10 See the Lions' entry in Grant M. Waters, *Dictionary of British Artists Working 1900–1950*, Eastbourne Fine Art, 1975.

11 Obituary of Orovida, *The Times*, 13 August 1968.

12 Gluck, Biographical Notes, undated.

13 *Jewish Chronicle*, 12 December 1913.

14 Gluck, *Notes on the Philosophy of Painting*, 1940.

15 From 1904 to 1915, the number of Jewish women mentioned in the *Jewish Chronicle* reviews of the annual Summer Exhibition at the Royal Academy were as follows: 1904 – 4, 1905 – 10, 1906 – 11, 1907 – 16, 1908 – 15, 1909 – 9, 1910 – 8, 1911 – 7, 1912 – 3, 1913 – 3 (but most of the article was devoted to discussion of an anti-Semitic painting selected, so not all the women showing may have been mentioned), 1914 – 5, 1915 – 9. Among those whose works were shown most regularly were Miss Ellen G. Cohen, Miss Minnie Agnes Cohen, Mme Helena Darmesteter, Miss Annette Elias, Miss Lizzie Hands, the Misses Louise and Helena Horwitz, Miss Marie Johnson, Miss Dorothea Landau, Miss Ada Levy, Miss Bertha Lowenthal, Miss Emma Magnus and Miss Florence Marks. The last-named was almost certainly related to the Cardiff portrait painter B. S. Marks, since a painting by each of them was shown at the 1906 Whitechapel exhibition.

16 Supplement to the *Jewish Chronicle*, 9 November 1906.

17 Twenty-eight out of 60 watercolours and 36 out 124 oil paintings were the work of women.

18 M. H. Spielmann, *Jewish Art and Antiquities*, Whitechapel Art Gallery, London, 1906.

19 See footnote 18, above.

20 In her article on Rebecca Solomon in *Solomon – A Family of Painters*, Geffrye Museum, London, 1985, Pamela Gerrish Nunn states that she did not produce any works on Jewish subjects. These must have escaped her notice, but Solomon did not exhibit any works of Jewish subjects at major exhibitions.

21 Reported in the *Jewish Chronicle*, 19 November 1915.

22 P. E. Hanson, 'Memorial exhibition of the works of Amy J. Drucker', Ben Uri Art Gallery, 1952.

23 She had a studio first in Upper Baker Street and then in Cartwright Gardens, Bloomsbury.

24 The British artists whose work was represented were David Bomberg, Mark Gertler, Horace Brodzky, Isaac Rosenberg, Bernard Meninsky, Alfred Wolmark, Hubert Schloss, Morris Goldstein, Mark Weiner and Jacob Kramer. All but Brodzky, Schloss and Wolmark received grants from the Jewish Educational Aid Society.

25 Bomberg, Meninsky, Goldstein, Gertler and Weiner all participated.

26 Recounted by Joseph W.F. Stoppelman (the artist's husband) in *Clara Klinghoffer 1900–1970*, Belgrave Gallery, 1976, p.4.

27 ibid. p.6.

28 ibid. p.6.

29 ibid. p.6.

30 Born in Edgbaston in 1889, Greenberg studied at the Slade from 1916–19, where she won a number of prizes, and exhibited at the Royal Academy in 1930 and 1932.

31 Lilian Holt, quoted in Richard Cork, *David Bomberg*, Yale University Press, 1987, p.180.

MONICA BOHM-DUCHEN, PP.41–59

1 There are of course notable exceptions to this generalisation. In Britain, one has only to think of the feminist group Fanny Adams or the artists included in the exhibition Bad *Girls* (ICA, London, 1993) to realise that shock-tactics still prevail in certain quarters.

2 As Griselda Pollock discusses in her essay in this volume, an acknowledgment of, and respect for, difference pertains also to the relationship between the sexes, and between Jews and non-Jews. One could, and should, extend this point to embrace other religious and ethnic minorities too.

3 This attitude is borne out by the content and ethos of seminal exhibitions such as *Women's Images of Men* (ICA, London, 1980) or *Pandora's Box* (Rochdale Art Gallery, 1984).

4 This tended to be true also of artists working in this country during and after the Second World War. Many of these – Marie-Louise von Motesiczky, Milein Cosman, Erna Auerbach, Katerina Wilczynski, for example – were émigrés from Nazi Europe, the majority hailing from an assimilated, middle-class Jewish milieu and embracing broadly humanist ideals which found expression in an essentially naturalistic method of working. Ghisha Koenig would be an example of a first-generation English-born artist whose working practice followed similar lines.

5 For practical reasons, this essay – and the others in this catalogue as well – focus exclusively on these two countries.

6 See Vera Grodzinski's Introduction and Griselda Pollock's essay for a more detailed discussion of this phenomenon.

7 After all, women artists belonging to other minority groups have for some time felt able, even compelled to explore issues of identity in their work. Exhibitions of, for example, the work of black women artists, in which these issues are paramount, are now an accepted part of the contemporary art scene – and, indeed, if anything, slightly passé.

8 This was The *Holocaust Project*, published in book form by Viking Penguin, New York, in 1993.

9 See works such as M*asha Bruskina* (1992) and *The Jew's Whore* (1993).

10 The exhibition *Too Jewish? Challenging Traditional Identities*, shown early in 1996 at the Jewish Museum, New York included work of a brashness and forthrightness (by men and women alike) that could only, one speculates, be the product of American-Jewish culture, in which humour, too, plays a central role.

11 The image of water and/or the swimmer is one that occurs in the oeuvre of a number of other Jewish women artists (notably Lily R. Markiewicz and Julie Held). Its richness as a metaphor is self-evident; for Jewish women, however, it has the additional resonance of being associated with the mikveh*, and hence with the ambiguous notion of ritual purity.

12 The legend of Lilith probably has its origins in Babylonian or Sumerian culture. According to Midrashic* sources, however, she was actually Adam's first wife, who refused to adopt a submissive position in their lovemaking. In punishment, she was banished and entered the world of demonology, doomed to suffer the deaths of one hundred of her children every day, but also the slayer of other women's children. For obvious reasons, Lilith has exercised a particular fascination for Jewish feminists.

13 It is surely no accident that many of the leading practitioners of Abstract Expressionism, such as Mark Rothko, Barnett Newman and Adolph Gottlieb, were Jews intent on forging a style that would express a sense of sublimity by abstract means alone.

14 In the Haggadah*, the wicked (or evil) son asks: 'What does this mean to you?', thus deliberately placing himself outside the community of believers.

15 This, of course, is true of most of the artists included in *Rubies and Rebels*. Had space permitted, a broader representation of each artist's work would have done greater justice to its scope – although equally, it might have diluted the impact and blurred the parameters of this unashamedly thematic exhibition.

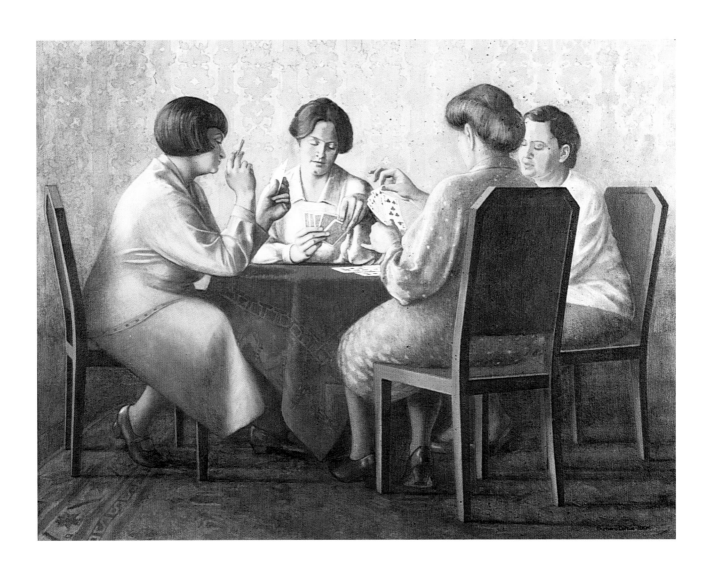

Barbara Loftus, *The Bridge Party*, 1995

Oil on canvas mounted on board, 25 × 33 in / 63 × 84 cm

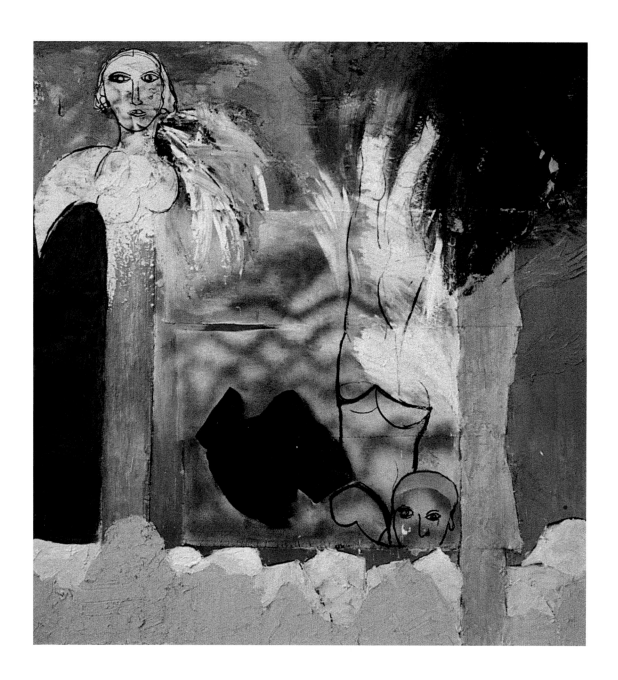

Sandra Brandeis Crawford, *Guardian of the Swim*, 1995

Mixed media on canvas, 69 × 72 in / 175 × 180 cm

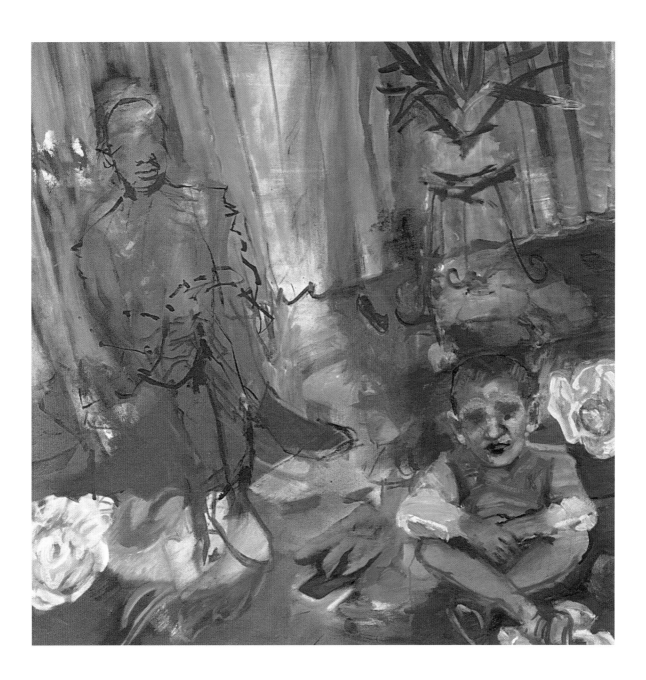

Anne Sassoon, *The Child is Father to the Man*, 1995

Oil on canvas, 40 × 40 in / 102 × 102 cm

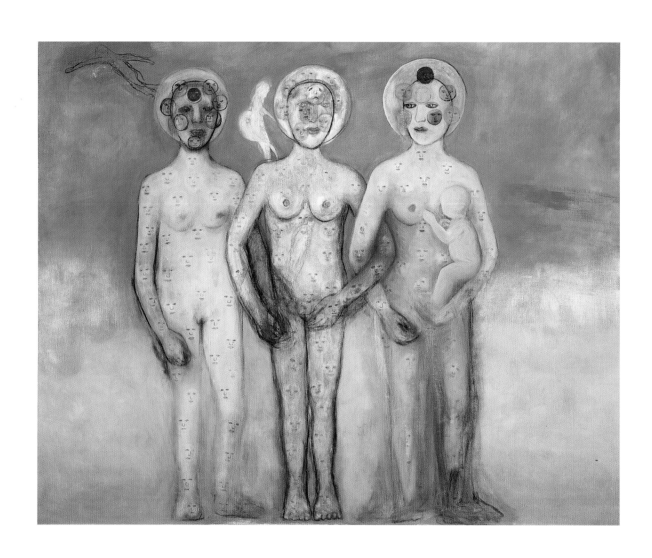

COLOUR PLATE 4 (CAT.10)

Carole Berman, *The Three Sisters*, 1995–6

Oil on canvas, 48 × 60 in / 122 × 152 cm

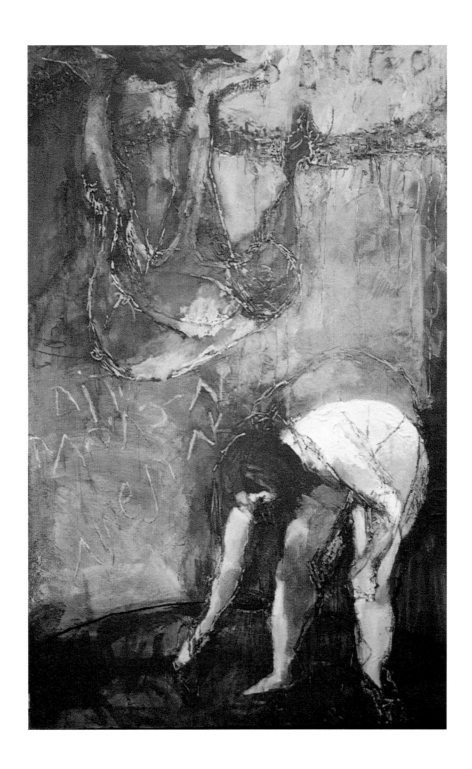

Abigail Cohen, *Psalm I,* 1995

Oil on plaster on board, 96 × 60 in / 244 × 152 cm

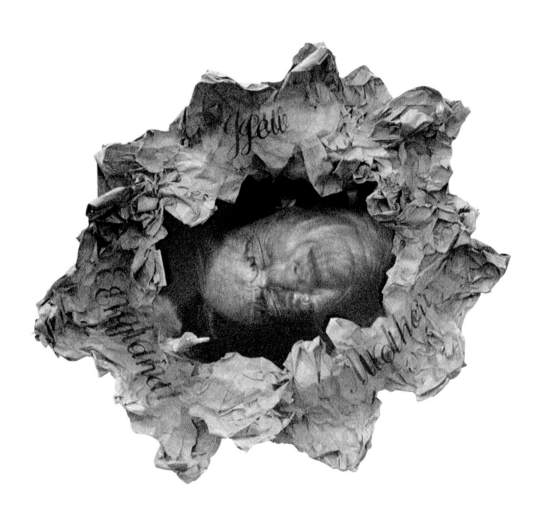

Jenny Polak, *Like It or Not*, 1993

Lightbox (steel, papier mâché, paint, duratrans, text on acetate)
24 × 28 × 12 in / 61 × 46 × 30 cm

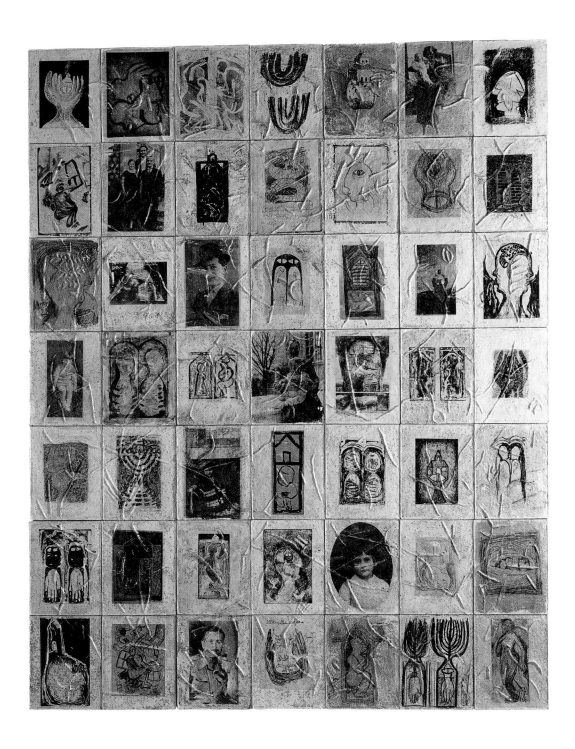

COLOUR PLATE 7 (CAT.102)

Gillian Singer, *Untitled*, 1996

Pulped paper and plaster with photographic emulsion,
105 × 84 × 1 in / 266 × 217 × 2.5 cm

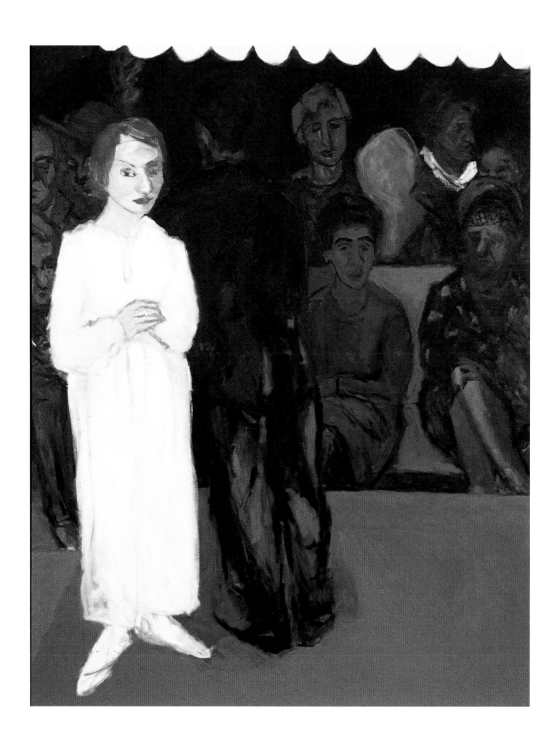

Julie Held, *The Wedding*, 1994–5

Oil on canvas, 60 × 48 in / 152 × 122 cm

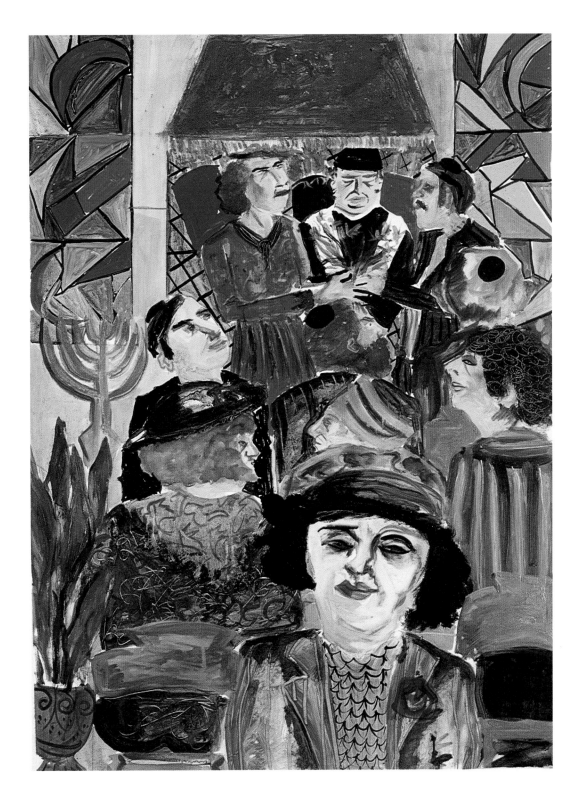

COLOUR PLATE 9 (CAT.92)

Hilary Rosen, *Synagogue*, 1990

Oil on paper, 24 × 36 in / 61 × 92 cm

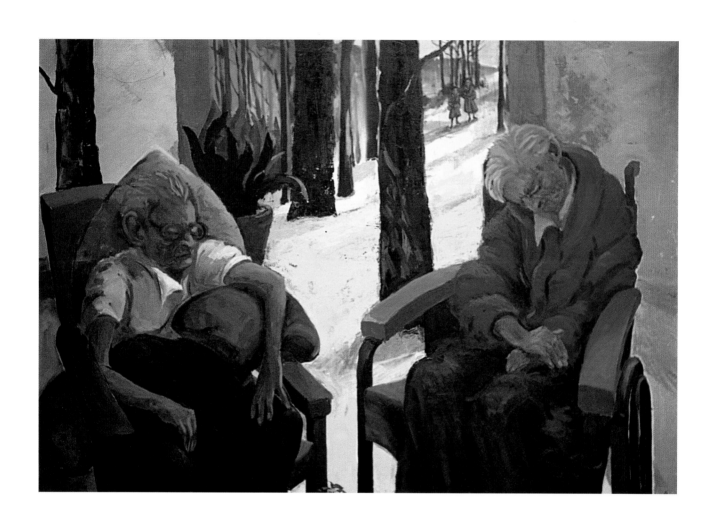

COLOUR PLATE 10 (CAT.84)

Marlene Rolfe, *Wandervögel*, 1993

Oil on canvas, 43 × 60 in / 109 × 152 cm

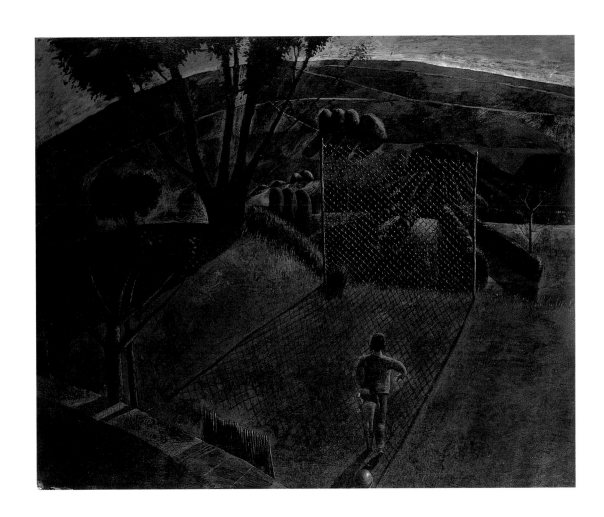

Sarah Raphael, *Whilst Attempting to Escape*, 1990

Acrylic on paper, 45 × 55 in / 114 × 140 cm

Courtesy of Thos. Agnew & Sons

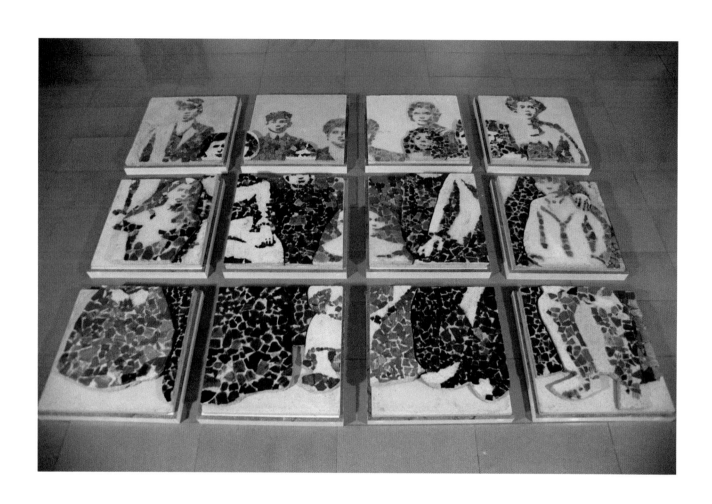

Rachel Lichtenstein, *Kirsch Family*, 1996

Mosaic (Herodian, Byzantine and Roman period ceramic, lime, lava, sand, concrete),

12 sections, each 24 × 24 in / 60 × 60 cm, total size 94 × 71 in / 240 × 180 cm

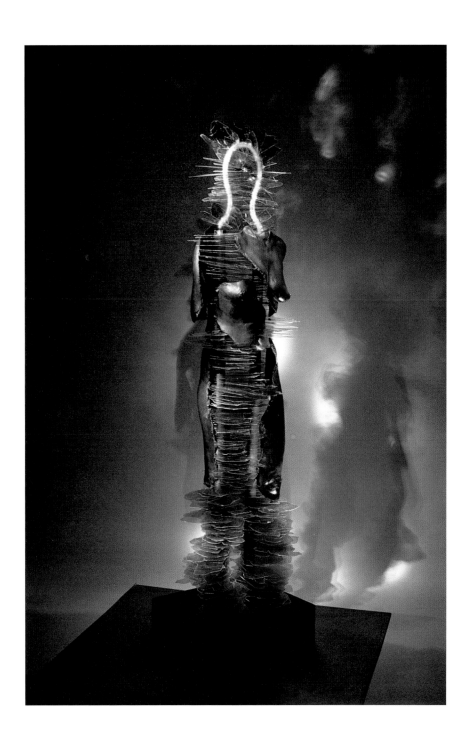

Liliane Lijn, *My Body, My Self*, 1996

Bronze, ruby mica, argon, 81 × 24 × 20 in / 205 × 60 × 50 cm

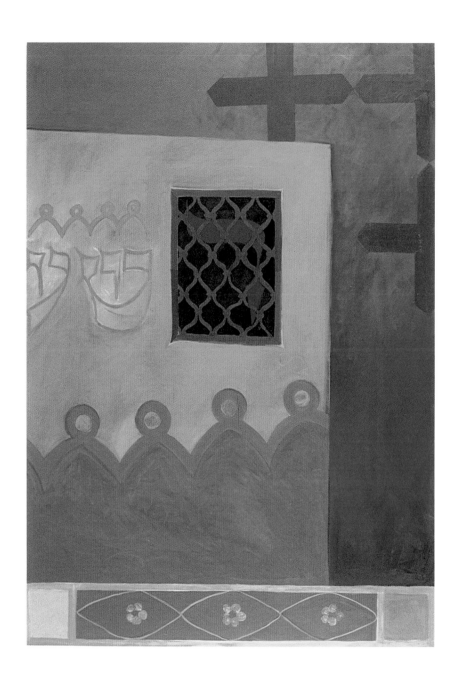

COLOUR PLATE 14 (CAT.39)

Rachel Garfield, *The Wicked Son*, 1994

Oil on canvas, 78 × 54 in / 198 × 137 cm

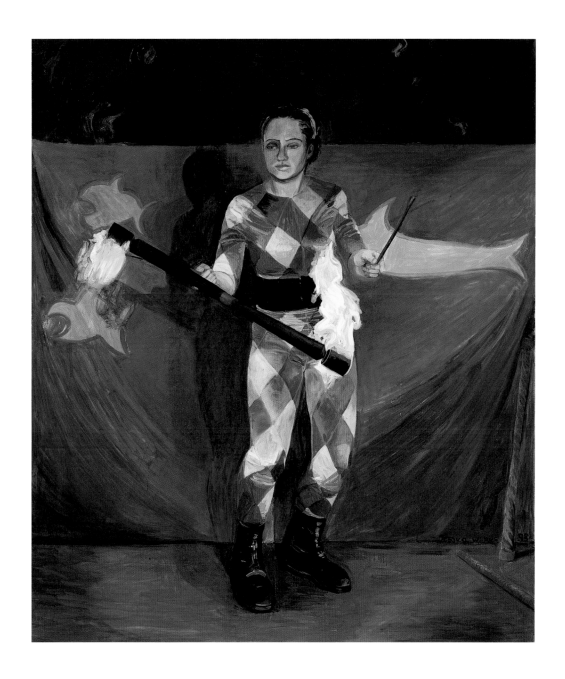

COLOUR PLATE 15 (CAT.105)

Jessica Wilkes, *Devil's Stick*, 1994

Oil on canvas, 70 × 60 in / 179 × 152 cm

COLOUR PLATE 16 (CAT.4)

Angela Baum, *Rachel*, 1995

Oil on canvas, 24 × 24 in / 61 × 61 cm

ANGELA BAUM

Born London 1945

Trained at Bristol Polytechnic and Cardiff Institute of Fine Art

Lives and works in Bristol

RECENT SOLO EXHIBITIONS

University of Bournemouth Campus, Bournemouth Music Festival, 1993

Silent Letters, *University of Bristol, Glyn Wickham Theatre, 1993*

Fat like the Sun, Exhibition of Paintings, *The Crypt, St George's Brandon Hill, Bristol, 1995*

My work comes out of living the life of a Jewish woman – it does not describe it. It is nourished by the intensely rich and varied experiences that we as a people have encountered. I was born at the time when the concentration camps were liberated and the news of the horrors of the Holocaust filtered back to my family in London, who were themselves fortunate recent immigrants. My birth was miraculous – after ten years of a childless marriage, I was conceived on the most holy night of the year, the eve of the Day of Atonement, when sexual intercourse is forbidden! My mother had been evacuated during the war and my father, who was working in London, was visiting her for Yom Kippur. I learned this a few months before my father died, aged eighty-four, in May 1995.

Since my birth I have been positioned in a paradox: engaging with the sacred and profane, the religious and the secular. My parents went to concerts, collected antiques, travelled the world. My only remaining grandparents lived a shtetl * life in Golders Green. We straddled both worlds: between the dark garments, black hats and flowing beards of restricted Hasidic* life and the liberal optimism of a modernist family. Then our lives totally changed. My mother died suddenly when I was barely six years old. My father sought consolation in work. I spent my time between home and a housekeeper, my grandparents' house complete with shtiebl* and a boarding-school nestling in the countryside near Arundel. I lived between Hasidism* – warm, magical and terrifying – and boarding-school – lacrosse, girls' dormitories and Irish Catholic teachers!

In 1967 I married and plunged with fervour into being wife and mother. I lit Shabbat* candles like my mother, made Seder* nights like my grandmother and over the next ten years I had the good fortune to create my nuclear family: our four fine sons. When my youngest went to nursery school in 1983, I embarked with serious intent on my other, as yet undeveloped, creative desire. And I became a full time art student when we moved to Bristol in 1985. As the lone woman in a Jewish male household, it was time to find my 'sheroes' and female voice. Paint and colour in particular have given me a voice in the public domain, allowing me to express my Jewishness without censorship.

My studio is a twenty-five minute walk from my home, alongside the floating harbour in Bristol. I find that the walk through the city to the 'Artspace' warehouse where I work provides a vital physical separation from the domestic part of my life. I need the change of environment, the psychic freedom to make my paintings.

Colour is central to my painting. I try to make it sing out, seduce the viewer into a world of veiled memories, intensity, pain and joy. I work intuitively and the process of applying the paint forms the painting. One painting feeds another until they build up into a body of work, a family. I frequently work in series. I start with an idea; a piece of text, an amulet, fragments of a Ketubah*. I choose a particular size and shape of canvas. I construct the foundations of the painting with combinations of pigment, oil paint, oil sticks, writing and collage. Eventually the painting takes over: it leads and I follow.

The series of paintings entitled 'Silent Letters' use the two silent Hebrew letters, *aleph* and *ayin* – these letters have no sound of their own but take up space (like K in Knit) they sit above and give guttural enhancement to the vowels. They are a visual calligraphic presence with their own particular 'sound-shapes'. Contradictions. These paintings are fabricated in layers, 'writing' the characters over and over again. The paintings are 'scrolls' of rhythms and repetitions. I have appropriated these letters, written my own mantras – 'silent chanting'. The most recent work, *Kaddish* (using this technique) was painted after the official period of mourning for my father was completed. My husband said Kaddish* on Shabbat* for

eleven months. Women in Orthodox* Judaism are not able to recite the Kaddish* prayer for their dead as part of the synagogue service. This visible 'chant' in black and white is my silent prayer for my father.

The *Matriarch* series came about after a visit to Israel in the spring of 1995, where I came across a retrospective exhibition of Lea Nickel's work at the Tel Aviv Museum. I instantly understood her paintings. Here was someone in her late seventies who had been using paint and text and imagery in an intuitive and dynamic way. I had found a 'shero'. When I returned to my studio, warmed by the Israeli sun, I began a new series using the colour yellow. *Fat like the Sun*, the first in the series, was a celebration of hotness and femininity. The matriarchs followed – *Chava (Eve)* – as the first woman, the birth of consciousness. Other women appeared – Sarah and Hagar share the same canvas – the mothers of two separate nations held together by the stretcher of the canvas. These abstract portraits are close-ups – they relate to surface detail, physical and psychological, tactile and sensuous. The symbols and colour in the painting make direct references, first to the curve of the Hebrew script and then to the atmospherics surrounding the women. Their names are sometimes etched into the paintings. These women take up only a few lines in the text yet participated fully in the biblical events, living dynamic and passionate lives.

CAROLE BERMAN

Born London 1952

Worked at Sotheby's and studied History of Art at University College London before attending Chelsea and Wimbledon Schools of Art

Based in London, although currently living in Jerusalem

RECENT AND FORTHCOMING SOLO EXHIBITIONS

Shamanic Heads, *Rebecca Hossack Gallery, London, 1995*

Recent Paintings and Works on Paper, *Artist's House, Jerusalem, 1996*

Mandalas, *Rebecca Hossack Gallery, London, 1997*

My work as an artist is about striving to find an outer expression for my inner life. It is a way of keeping track of myself, where I am on the journey. In Gauguin's words, which indeed form the title of his final painting, my overriding concern is 'Where Do We Come From? What Are We? Where Are We Going?' It is this mystery which compels my inner search and informs my art. The place of origins is perhaps where I should begin, for it is from there that I hope, like Ariadne, to unravel my own individual myth. This, therefore, is where my Jewishness plays an important role.

I remember that as early as three years old I was aware of my Jewish ancestry. What prompted this occasion was Seder* night, the festival of Passover* at my grandparents. It was a very colourful and awe-inspiring evening which is embedded deeply in my memory. Seated around a large table were my grandparents, parents, older sister (my younger sister was not yet born), cousins and myself. Each one of us, or at least the children, had a wonderful and mysterious Haggadah* with brightly coloured pull-outs. You could, for example, pull out a flap and watch the fish swimming about in the Red Sea during the Crossing of the Israelites and the Closing of the Waters on the drowning Egyptians. Totally absorbed in looking at these extraordinary images, I listened to my grandfather who was, in a wonderfully resonant voice, recounting the Passover* story. He talked about Moses and the Great Egyptian Pharaohs and how we were once slaves and still would be, had it not been for the Exodus. Thus, from a very early age, I was introduced to a dramatic and archetypal source.

A year or so later, my older sister and I were witness to a very strange ritual related to this feast – or so I was to believe. My grandfather took us fishing in a pond in his garden. We helped him throw bread to the fish, as we often did, but on this occasion, out came my grandfather's fishing rod and within a short while he had hooked a large carp. As my grandfather hauled in the fish, he bade my sister and myself hide behind the bushes while he put the fish out of its misery. From

where we stood we could hear some strange bashing sounds which slightly alarmed us. Soon afterwards my grandfather reappeared, a mischievous smile on his face, with his catch in an old metal pail. The fish was served up on a platter at the Seder* table the following night.

In my own mythology this incident has merged with a dream I had at the time. I was in my bed and I noticed some ducks landing on the table beside me one by one, until there were so many that they filled up the entire surface of the table. They picked me up and flew with me all the way to my grandfather's fishpond and dropped me into the deep water where I was gobbled up by the fish. This dream was to recur on many occasions thoughout my childhood. I was later to realise that this was a dream about transformation. I am sure these formative memories played an important role in the development of my sense of being Jewish. They instilled in me a longing for something mystical and at the same time it rooted me in something ancient. What has evolved is a mystical connection to religion rather than an orthodox one. Although firmly rooted in Jewish mysticism, my spiritual relationship to life is universal and reaches out into the pool of the Collective Unconscious, to embrace other ancient cultures that also enjoy a rich and mystical symbolism.

JUDY BERMANT

Born London 1939

Studied illustration at St Martin's School of Art and printmaking at the Camden Institute

Lives and works in London

SOLO EXHIBITIONS

The Sternberg Centre, London, 1987

New End Theatre Gallery, London, 1988

Julius Gottlieb Gallery, Carmel College, Wallingford, 1989

I was born in 1939 and grew up in a deeply observant North London community. In those early years the community was gravely troubled by fears for their loved ones on the Continent. The trauma suffered by survivors of the Holocaust who resettled in the neighbourhood – including many of my young classmates and friends – were also a crucial part of my formative years.

I specialised in illustration at St Martin's School of Art. This course included all the printmaking skills, except for etching, which I studied later at the Camden Institute.

I work mainly from observation and in all the usual drawing media, watercolour, gouache, and of course printmaking. My work centres on personal experiences – family, friends and community as well as still-life and landscape.

I often draw myself, and feel my self-portraits can reflect something of the strains involved in being both an artist and an observant Jewish housewife, mother and grandmother, constantly juggling with conflicting demands. Preparing for the Sabbath and festivals while finishing a piece of work in the studio next to my kitchen could either drive you mad or seem hilarious. You need a sense of humour.

My regular portrait commissions provide a welcome complement to printmaking where I work in the studio on my own. I find the two-way involvement with my sitters very stimulating. It feeds into my well-being and gives me a real high. When it flows I feel euphoric. I spent some years in Israel and was obsessed for a while with images from that country on which I still draw from time to time. I am presently involved in a series of London cityscapes – etchings, collographs and monotypes. These seem to me to hark back to my East End roots and reflect something of the devastation left by the Blitz and all that is invoked by that period. They also suggest something of the tension, dislocation – even fear – on those same streets today.

I am currently collaborating on a book of stories by my husband, Chaim, based on his childhood memories of Eastern Europe.

SANDRA BRANDEIS CRAWFORD

Born London 1955

Grew up in Australia and Austria; trained at Birmingham College of Fine Art and Royal College of Art, London

Lives and works in Vienna

RECENT SOLO EXHIBITIONS

Galerie Lilian Andre, Basel, 1994

Galerie Hilger, Vienna, 1995

Feszek Galerie, Budapest, 1995

'Was habe ich mit den Juden gemeinsam? Ich habe kaum etwas mit mir gemeinsam und sollte mich ganz still, zufrieden damit, daß ich atmen kann, in einen Winkel stellen.' Franz Kafka

('What do I have have in common with the Jews? I have hardly anything in common with myself, and I should be quite content to breathe and stand quietly in a corner.')

I grew up in Sydney, Australia, in the company of my mother, my grandmother and my sister with the emotionally coloured stories of a Jewish family, which had originally come from Austria, the Czech Republic and Germany. The family had followed the familiar pattern of either emigrating to America or dying in the Holocaust. My grandmother and mother were two of the few European survivors in their family. In 1938 my grandmother decided, against the will of the rest of the family, to send my mother on the last *Kindertransport* from Prague to an uncertain future in England, although it was a difficult decision to make. My mother spent her formative years in England, removed from all family ties. A few years after the war, my grandmother, who had survived the Holocaust, remarried and moved to Australia, where we joined her when I was four years old. We travelled on an ocean liner for six weeks before sailing towards the spectacular sight of Sydney harbour bridge.

When I was thirteen years old, I discovered Anne Frank's *Diary*. I identified completely with her wish to become an authentic artist. Her tragic life somehow made me realise that the stories about Europe were real and related directly to me too. Shortly afterwards my grandmother decided she wanted to go back to Europe to visit her old friends and relatives. She insisted on taking my sister and me with her. After my second long-distance sea voyage half way around the world, we landed in Southampton. I attended a grammar school for a short time in London, where I was laughed at because of my Australian accent and suffered generally from the damp and cold. Then we moved on again to Vienna. There I felt dwarfed by the omnipresence of history, suffocated by all the old buildings, and disoriented by a completely different mentality and strange people.

I found it very difficult trying to adjust to living in a boarding-school where everyone spoke another language. I acutely missed the wide, empty cultural and natural spaces I had experienced growing up in Sydney. As soon as I was old enough, I went back to England by myself, where I finished my schooling and decided to study Fine Art. In retrospect, I think I relate my love for the airiness and space found in early Renaissance art to the fact that I longed for the light, wide spaces of Australia.

I was also very conscious of a natural matriarchal order. My grandmother had a very close relationship with my mother; and as my mother was a single parent, she was very dependent on my grandmother for support. This meant that I felt my grandmother to be especially dominant. Men and masculine authority played a very subordinate role in my life.

I found it natural to relate to matriarchal and mythological themes, and became interested in matriarchy in an historical context. I became interested in how historically lived reality connected with contemporary feminine consciousness and my own subjective experiences. I was also interested in the subconscious functions generally, in feminine psychology and in the way women's experience can be translated into meaningful images. I tried to integrate what I found relevant to me as a woman into a concept of art expressed through the medium of painting.

My art is very eclectic, 'post-modern' in that I feel free to use any influences or elements from historical or contemporary art in my work if it reinforces what I am

trying to say. I have always been fascinated by painting, the tactile quality of the surface, colour, composition etc. and have always endeavoured to produce paintings that reveal the qualities inherent in the medium itself. I have obviously been strongly influenced throughout my career by American and British art in particular.

A few years ago I discovered the Brandeis family gravestone in the old Jewish section of the Viennese central cemetery, and was fascinated by the overgrown wilderness and sad beauty of the stones and the many forgotten names. At the same time the political and economic situation in central and eastern Europe was undergoing many fundamental changes. The new political freedom brought into the open many old conflicts which had been suppressed for the last fifty years, including anti-Semitism. A Jewish graveyard which I had discovered close to my studio was desecrated. I began concentrating on formal painterly solutions that portray this ambiguous sense of past and present, the remaining traces of a once-lived time, still passed down through the generations, hidden somewhere in the dark recesses of the mind, and recalled when external reality coincides with inner visions. Memory is a strong bonding factor. Those who share memories feel psychologically linked to one another.

I realise that the sense of my own historical and personal history is automatically handed on to my daughter, with whom I share this continuum, which in turn influences my relationship to her. External factors and personal family structures come together in my perception of a greater feminine reality which links generations through time. The gravestones became a symbol for my own family matriarchy.

As a cultural hybrid and a displaced person, I have found a way to orientate myself in society. I began by focusing on the international codified sign system which turns the world into an abstraction, within which each individual can construct his or her individual space with personal borders, as well as concentrating on my spiritual and emotional connections – my *Gegenüber* – my 'thou'. Translated into pictorial terms, this means that I can create a subjective personal world, using signs, symbols and images that function simultaneously as an external and psychological inner reality.

I have tried to integrate these factors into my work which is strongly influenced by the diasporic experience of living in different cultures and countries. I relate to them partly through memories and family ties, yet never feel completely rooted to one geographical or psychological space.

ABIGAIL COHEN

Born London 1972

Attended Camberwell School of Art and Design and University of the West of England, Bristol

Lives and works in London

EXHIBITIONS

Group Show, Julius Gottlieb Gallery, Carmel College, Wallingford, 1993

Solo Show, Psalms, *The Gate, London, 1994*

Fresh Art, *Business Design Centre, London, 1994*

Where does the spirit stand in relation to the body? Can a Jewish woman be seen to embrace both? My work can be seen as an ongoing exploration of this relationship between the spiritual and the earthly. Painting in the format of a series enables me to offer multi-faceted responses to these questions. From the huge figurative triptych, *Psalms I, II and III*, to the cluster of abstract paintings centred on the letter *aleph*, my work deals with the complex dynamic of sacred and profane typical of Jewish conceptions of the female body.

I am particularly concerned with the interplay of form and content, texture and imagery. I paint on plaster, as a means of invoking a long tradition of sacred painting, most notably the icons of Byzantium and the frescoes of the Italian Renaissance. The *Psalms* atttempt to translate this imagery into the visual language of Judaism.

I wanted the overwhelming size of the paintings to engulf the viewers, to give them a sense of being looked down upon, even looked at. Intimacy is put on hold, whilst the demandingly fleshy, tactile use of raw materials and colour demands of viewers that they think about their own perceptions of the body.

Buried in the skin of the paintings are a group of Hebrew letters; the translation of a poem I wrote, but also a series of illuminated marks, floating around and above the central figure. This figure, a repeated image of a stooping, naked female lighting candles beneath the letter *shin*, one of Judaism's most potent spiritual signs of the Divine, destabilises any strict opposition between Heaven and Earth, suggesting instead their sublime creative dialogue. This dialogue is realised in my inversion of the form of the stooping woman to produce the letter *shin*.

These paintings, then, are my own form of self-portraiture, representing my hybrid identity as Jew, woman and artist.

EDORI FERTIG

Born New York City 1957

Studied illustration at the Rhode Island School of Design and Art Education at the Massachusetts College of Art

Settled in London 1984

RECENT SOLO EXHIBITIONS

The Square Gallery, London, 1990

The Other Dulwich Picture Gallery, London, 1991

Birth, *Milton Featherstone Advertising, London, 1995*

I came from a town – New York City – where everyone seemed to be Jewish. It wasn't until I went to college that I realised that I was part of a minority. My parents were both Ashkenazi* Jews and we were raised in the liberal tradition, which nevertheless meant that we were culturally Jewish. I am from the post-Holocaust generation and my sister and I were both sheltered and over-protected. There was always the sense of hidden fear, that something very terrible and life-threatening could be around the corner, even though we were living in an affluent suburb.

I was studying illustration at the Rhode Island School of Design when my mother died suddenly and tragically. My work changed direction when I decided, in the wake of this event, that I could no longer restrict myself to illustrating other people's texts. I decided then that I needed to develop my own personal language and imagery and rejected the limitations of commercial briefs. I began to investigate the work of a broad variety of figurative artists such as Max Beckmann, Pablo Picasso, Käthe Kollwitz, Frida Kahlo, Diego Rivera and Ben Shahn as examples of ways to describe the human condition. Soon after leaving college, I began a residency at a children's theatre where the masks, costumes and puppets that I designed for performances of popular folk tales from a variety of cultures became incorporated into my paintings.

My work has always been closely linked with personal experience, and the fact that I had no maternal figure in my life at that time led me to begin creating a personal maternal icon, embodying hope and reassurance.

Since the birth of my son in 1992, I have become concerned with my Jewish identity. Having married out of the faith, I felt responsible for passing on a positive Jewish self-awareness to my son. I was acutely aware of being a continuation of an ancient maternal line through which Judaism had so far survived.

Using the theme of the Tree of Life to represent motherhood, I endow the female form with the characteristics of a mythical tree connecting heaven and earth. I am interested in constructing images of the mother and child that draw on sources and inspiration other than the Pietà. I depict an alternative to the ethereal, doll-like Madonna, by creating images of strong, corporeal women.

One of the ideas to emerge while creating new images for this exhibition has been the concept of the fossil and relating family objects, such as photographs, to the process of remembering. The technique of making the collograph entitled *Shabbat (My Grandmother's Gloves)* involved pressing her actual gloves into a paste that preserved their impression from which I could then take a print. Embedding her gloves symbolises the way images of my grandmother are embedded in my memory.

In the *Fossil* series I am concerned with the idea of light and how it permeates Jewish symbolism and mythology. The use of wax in the collages relates them to the candles used both in celebration and festivity (Hanukkah*) and in bereavement (yahrzeit*). The work is back-lit and also suggests how images go in and out of focus as time erases and blurs our memory.

RACHEL GARFIELD

Born London 1963

Studied Fine Art at North East London Polytechnic

Lives and works in London

RECENT SOLO EXHIBITIONS

Bedford Hill Gallery, London, 1993

New End Theatre Gallery, London, 1994

My imagery has its source in Jewish cultural history. I use it to create a mood and a sense of place that are both emblematic and evocative. Colour and pattern lie at the heart of my work.

I was brought up in an Orthodox* religious home, which was otherwise liberal. I am no longer a practising Jew, but there still exists within me conflicting feelings both of affection for, and alienation from, the forms and rituals of my childhood. This translates into my use of composition and colour, in fact in my whole approach to painting which shows itself in a slight unease but also a celebration. There is a sense of loss, but also nostalgia for the wonder of ritual. I had to escape nonetheless because I felt that my future and the expectations imposed on me as a woman were limiting and in opposition to my needs. My work is created out of these emotions.

The paintings are thus both a celebration of the richness of ritual and an acknowledgement of its decline as a social vehicle, a common loss in a secular world.

The emblems I use derive from a range of sources, such as details from synagogues, textiles adorning places of worship, ritual objects and Hebrew illuminated manuscripts. The pattern and decoration associated with this material is central to my approach. Whether or not this is specifically recognisable as Jewish, or whether there has been such a cross-cultural borrowing that no form belongs totally to one culture, is something that my work addresses. The Jews have always formed a minority group whose taste mutates according to the larger surrounding culture, whilst remaining distinctive in their way of life. Since I operate in the visual world, these ambiguities of origin and interpretation feed my own questioning and doubts about assumed cultural limits and boundaries.

This questioning is extended into the role of the 'feminine' and its place in the arenas of ritual and spirituality. Adornment is often associated with femininity. The embellished objects and embroidered textiles in my paintings may seem to comply with that assumption. There is a contradiction, however, as the source material, for the most part, is objects made by men to be used by men, since women are traditionally bystanders in the synagogue – as opposed to ritual within the home where women, of course, come into their own. In Jewish thought, women are said to hold the key to spirituality; the rabbis say that it is inherent in our being and is one of the reasons why women are exempt from the 'mitzvahs * of time'. Painting the objects of men allows me to own them, become part of the ritual – in my work at least; and as I reinterpret these objects I seek to conceal their true identity, revealing the spiritual presence in their source. So the relationship between my painting and my femininity is one of questioning and reclaiming, rather than of negating, the notions of womanhood I grew up with.

Extensive travel has helped me to look at other cultures and at Jewish culture in a wider context. My experiences in places where the Jewish population is absent, such as in parts of Spain and in Prague – where the remnants of Jewish existence have become anthropological curiosities, not a living thing as I know it – have been particularly poignant.

I draw on my Jewish heritage and an awareness of the spiritual presence of religious experience within a contemporary painting practice. In a way, I have translated the aspirations of a Jewish faith into my intentions as an artist. If I speak of the sublime, it is muted and rooted in the texture and shapes of an intimate and domestic cultural world, which is real and present to the senses.

JULIE HELD

Born London 1958

Trained at Camberwell School of Art and Royal Academy Schools

Lives and works in London

RECENT SOLO EXHIBITIONS

Lichfield Festival, Artist-in-Residence, 1995

Piccadilly Gallery, London, 1996

Ben Uri Art Society, London, 1996

I don't take any self-conscious stance towards my Jewishness and gender, but I know that both are closely interwoven and, to a degree, imbue my work. My femaleness, in the context of a sense of power and vulnerability, does have considerable bearing on how I view myself as a human being as well as a painter.

I am greatly aware how women are empowered now in a way which is historically quite radical and marvellous. I have always positioned myself politically as a feminist. I do not, however, make explicitly 'political' statements in my work. Nor do I engage directly with feminist issues, preferring to reflect them through traditional subject matter. I enjoy painting both historical and mythological women; I enjoy representing them as a woman painter.

I reflect on how women have changed the course of history, and by contrast try to understand in a personal way how I, as a woman, have been transformed by different events in my own life. For example, mythological figures such as Circe, which I like painting, become vehicles by which to represent transformations in perceptions and the agency of women. To paint *Circe and Her Lovers* today is to invest her with something more than the power to transform men into animals. One can see her as someone who can initiate and thereby change her 'fate'. In this way I can identify with a figure who escapes 'fate' and is proactive. Painting the Old Testament subject of *Judith and Holofernes* has a similar significance for me. However, this must be considered in the context of other aspects of my painting.

My sense of Jewishness is broadly based within the German Jewish tradition in which I grew up. I was aware at an early age that I had a different home life from many of my schoolfriends. Also, the direct experience of pre-war Nazi Germany on my parents influenced me.

As much as my father and mother wanted us to feel assimilated, it was always difficult to feel so. All emigrés must experience the dilemma of assimilation and the retention of identity. Whilst this enriches one's life it also creates differences which can be quite ambivalent and alienating at certain times. This influenced my subjects and the form they take, though not overtly.

LYNN LEON

Born Tynemouth 1947

Studied at College of Art and Industrial Design, Newcastle-upon-Tyne and University of Northumbria

Lives and works in Newcastle

SOLO EXHIBITIONS

Lynn Leon Photographs, *Alsager Art Gallery, Cheshire, 1982*

Givat Haviva Art Centre, Israel, 1995

Municipality Gallery, Haifa Auditorium, Israel, 1995

Being both Jewish *and* female is a potent mixture. Sometimes intoxicating, at other times unpalatable. There are many jokes about 'Jewish guilt', but unfortunately guilt is a feeling that encompasses 'our' psyche from a very early age. The Jewish family is a wonderful institution – one that is admired and emulated. It can, however, also be stifling, soul-destroying and exasperating. The child is presented with strong stereotypical role models and can often feel guilty and inadequate if he or she cannot live up to expectations. Male dominance features strongly in Jewish family life, and the females are automatically expected to adhere to a prescribed course. Failure to do so leaves the individual with an inherent feeling of guilt.

The creative person by nature is an individual who fights against conformity and thus finds the constraints of traditional Judaism hard to accommodate. I am still struggling with this dilemma. How can one be a 'good' wife, mother, daughter, sister, daughter-in-law, and still retain one's independence and individuality? Is it important? And if so, to whom? The next generation of more equality-aware offspring may hopefully alter the status quo, but for the religious Jewish female, her role will remain unchanged. In Israel, the ultra-Orthodox* establishment holds great power in political and social spheres and will undoubtedly continue

to create obstacles in the fight for sexual equality in that society.

Over the years, my art has attempted to confront these personal and social issues. My earlier photographic work dealt with the anguish and frustration experienced by myself and women in general, who were struggling with the demands and responsibilities of home and parenthood, while at the same time striving to fulfil their potential as individuals and to retain their own sense of identity. This emotional dilemma became the subject of much of my work. My conscience as a human being also required me to address the question of violence and persecution, the Holocaust, Vietnam, Bosnia. The historical significance of my Jewishness was always in my mind, but at that time I did not relate to it directly. I used my daughter as my model, and this has taken on a new and frightening relevance now that she lives in Israel.

Surrealism has always fascinated me. My *Heads* are not Magritte's *Amants*. But what are they? What is their relationship? In my drawings, I question the relationship of Jew to Jew (religious to secular), Arab to Arab (those who want peace and those who choose terrorism) and the way in which Jew perceives Arab and vice-versa. They will never be 'lovers', but can the keffiyah * and the tallit * share common ground?

More recently, my feeling of impotence as a Diaspora* Jew has become overwhelming, and the only contribution I can make to the Arab-Israeli dilemma is through my art. There are those, however, who resent any form of comment by a Jew who does not reside in Israel. My intention is to encourage the viewer to reassess his or her preconceived ideas and to promote a dialogue. Not a dialogue based on anger and fear, but a rational assessment of ways in which all the citizens of Israel and her neighbours might live in mutual respect and dignity. Israel's fundamental right to secure borders is of paramount importance. I do not, however, believe that this can ever be achieved at the expense of innocent civilians. Jews have endured years of persecution, and yet those in political power seem to be blind to the negative effects of domination and collective punishment. Thus the cycle of violence is repeated time and time again. One people dominating another. Misery in the name of defence. An eye for an eye.

While Israel remains in a state of conflict, the military will maintain its powerful role in that society, placing women in subordinate and subservient positions. Women do not generally identify with the 'glory of war' – or the macho gratification that violence seems to engender, but with the sorrow and pain caused by war. Only when more men and women from the peace movements assume political roles might the situation be viewed from a new perspective and an acceptable path to peace be explored. The Judaism in which I believe *must* embrace social justice and human rights. 'We' were not 'chosen' to rule over another people – such arrogance!

I have received threats and abuse because of my visual statements. When I exhibited in Haifa, I was accused of being 'anti-Semitic, anti-Jewish and anti-religious'. Such is the power of art and the vulnerability of the artist.

RACHEL LICHTENSTEIN

Born Rochford, Essex 1969

Attended Southend College of Technology and Sheffield City University

Based in London, although currently living in Arad, Israel

RECENT EXHIBITIONS

Forever Green, *Heritage Centre, London, 1992*

Moffet Gallery, Ra'anana / Teffen Gallery, Omer, Israel, 1996

Arad Museum, Israel, 1996

To keep forever green the memory of those who have preceded us is a preoccupation that has generated my working practice since the death of my grandfather in 1987. He was the last survivor of the Polish Jews in my family, as well as the last bearer of the family name (my father and his brothers anglicised theirs to Laurence).

Determined not to allow my heritage to disappear with him, in 1988 I took the first step towards a reaffirmation of my past and present by reclaiming (through deed-poll) the original family name – Lichtenstein. Since then I have embarked on a series of personal and creative journeys that map the trail of my ancestors, travelling repeatedly to Poland, Israel, London and New York, reuniting with family and conducting research in many institutions and geographical locations.

I spent many summers in Poland interviewing the dwindling Jewish community there (including my great aunt Guta, who is herself a survivor of Auschwitz and lives in Lodz). The Jews in Poland are referred to in the past tense like a lost tribe. These trips had a profound effect on me and my work, fuelling a need to tell the stories of the large number of undocumented people whose life histories have been lost without trace. Through my artwork I began to narrate my family history, aware that in its resemblance to so many others, it forms part of a collective Jewish experience.

Following my family's story took me to London's East End, where in 1991 I became Artist-in-Residence at The Spitalfields Heritage Centre, on the site of London's third oldest synagogue. During my time there I intensified my research, giving many lectures and guided walking tours of the area alongside the production of my artwork. In 1992 I visited New York to compare the American Jewish immigration experience with the British and to meet with more family members. On my return I was commissioned to produce a permanent exhibition on the Holocaust (for West London Synagogue) that took two years to complete.

My connection to my Jewish identity up to this point in time had been formed by my preoccupation with the history of my immediate ancestors, the experience of twentieth-century immigration from eastern Europe and the Holocaust. I felt a desperate need to immerse myself in a contemporary Jewish environment and have consequently spent the past six months living and working in Israel. This experience has challenged and transformed my previous identification with my Jewishness and this is reflected in my current work.

On my journeys, in the homes of relatives all over the world, I have come across one recurring image – a photograph of my grandmother's family taken in Lodz, Poland, probably in 1915. Attempting to escape from persecution, the family came to England soon after the picture was taken. They found it impossible to settle: my grandmother and one brother decided to stay, two sisters emigrated to Argentina, two brothers to New York. The other six family members returned to Poland – none survived the Holocaust. This image is the only remaining record of the entire family.

During my recent stay in Israel I have reconstructed this image, life-size, out of ancient ceramic shards from various archaeological sites. The shards pre-date the image by thousands of years, connecting the history of those in the photograph with the past and present history of Israel. The image enlarged, separated into cast layered sections and rendered in tile, has become blurred and faint. A reminder of the impossible task of presenting a complete picture of the past. Although fragmented, this once ephemeral image has now become a permanent memorial to extinguished lives. The permanence of the work has been ensured by using authentic materials and correct procedures for conservation purposes

(which I learnt in Israel while training with the conservation department in Caesarea). Using these methods for preserving antiquities, I have reconstructed fragments of my family's history, enabling their memory to live on.

Due to the way the work is lit when installed, it is the viewer who becomes transient, as his or her shadow fleetingly passes over the image, now made concrete. The shadow becomes the connection in time, making us contemplate ourselves in relation to these distant figures. The work is a labour of remembrance in their honour. Although I am too young to have known most of those in the photograph, I am aware that my contemporary identity has been formed by them.

LILIANE LIJN

Born New York 1939

Studied archaeology and art history in Paris

Lived in New York, Paris and Athens, before settling in London in 1966

SOLO EXHIBITIONS

Heads, *Galerie Peter Ludwig, Cologne, 1985*

Imagine the Goddess, *Fischer Fine Art, London, 1987*

Poem Machines 1962–1968, *National Arts Library, Victoria & Albert Museum, London, 1993*

My recent work has been motivated by a conscious examination of myself and my origins. I have never felt that I belonged to a specific group, whether national, ethnic or religious. My parents were not religious Jews, and I grew up with a very broad humanist religious education. My grandparents both spoke Yiddish* and between them and my parents at least five languages were routinely spoken. I was sent to boarding-school at a young age, and there I tried to blend in with the other children, most of whom came from Anglo-Saxon homes. As I grew older I felt that I could absorb the qualities of different cultures and ethnic groups without completely identifying with them. When I became an artist, I felt that within this vocation would lie my true identity.

My early work as a sculptor was preoccupied with light as a metaphor for spirit or mind, and with its physical properties. This preoccupation led me to an interest in science, technology and science fiction. In 1979 I began to make larger-than-life female figures. I wanted to give them a definite physical presence and to do this I used highly textured materials such as plastic fibres, mica and glass beads. I also used the female voice, smoke and laser beams. I activated the figures and made them respond and communicate with each other. The sculptures were archetypes enacting ritual dramas. I tried to uncover the hidden face of the feminine. I looked for her many faces in drawings, poems and sculptures. My interests slowly shifted from physics and astronomy to mythology, psychology and the archaeology of ancient cultures where traces of matriarchies had been unearthed.

I began to focus on the feminine within myself. Since 1990 I have been working on a series of self-portraits made from cast bronze fragments of my body, mica and argon. In these works I want to make visible the stuff of the psyche. I also began to write about myself and became aware that as far back as I could remember, my family's history had been one of fragmentation and dispersion. So much so that I had very little information about my parents' lives, not to speak of going back any further into their genealogies. When I realised I didn't even know where my mother was born, I decided to ask her. This was the beginning of two years of talks and taped interviews with my mother, during which I asked her questions about her life and listened to her memories.

My first thoughts were to use these interviews as information, which I would subsume in my own text. However, on listening to the tapes I felt charmed by my mother's voice; I wanted to transcribe the oral document so as not to lose the flavour of her personality. I felt that, told by her, my history took on an ineffably

sweet nostalgia which brought out all the varied and contradictory emotions which are so much a part of being human. In turning the essence of her voice into print, my interest in synaesthesia continued to manifest itself, as it had done in my earlier bookworks and sculptures.

Memory is fuelled not only by the quantity of information received but by the quality. That quality or distinctness comes naturally through all our senses and artificially when channelled through a single sense. I am using art to distill the information about my mother which I have acquired since birth, from visual memories, smell, tactile sensations and the inarticulate feelings about her which I still retain, into book form. Having asked my mother to speak of her own life and of my early childhood, I began to think of the book as the first volume in a trilogy. I would have liked to talk to my father in the same spirit but he is no longer alive. I thought it would be interesting to remember him through those who knew him and I have already begun to talk with relatives and friends about him and to tape these conversations. I find it interesting to approach the mother through her own intimate voice and see the father as reflected by the world. Their world exists only in memory and those who still retain memories of that period are growing old. My parents belonged to a generation of Jews who faced extermination. They were both born in Russia at the time of the Revolution, and the whole period of their youth was one of ferment and upheaval. Through their stories, as in a cracked and smoky mirror, I see myself reflected as if I were formed before my birth by the choices that they made.

I have written, illustrated and printed the book entirely on my own computer using hand-made Japanese paper. The result is an extraordinary combination of high and low technology, of oral history presented on the fragile and tactile medium of this paper, thus mirroring the fragility of human life in general and in particular the fragility of a Jewish woman who lived through the anxious years preceding the Second World War.

I videotaped a large part of the interviews with my mother because I plan to use the material in a new series of sculptures incorporating video. Viewing these tapes, I realised that to mask a painful life history my mother had developed a way of blocking out unpleasant memories and events – the events which were, in fact, the most significant episodes in her complex and troubled life. Questioning her, I asked her to look back at the very events she preferred to forget; and through her hesitant recall she relived, often in pain, forgotten parts of her life.

BARBARA LOFTUS

Born London 1946

Trained at Harrow School of Art, Brighton College of Art and Brighton University

Lives and works in Hove

SOLO EXHIBITIONS

Grange Museum, Brighton, 1973

Angela Flowers Gallery, London, 1982

My mother came to England in 1939 as a Jewish refugee from Nazi Germany, trying to obtain visas for her family to escape. However, she was too late; the war started, her family were trapped in Germany and eventually were transported to Auschwitz where they perished – my mother was her family's sole survivor. I was born in England after the war, and grew up with little knowledge of my mother's past and German identity; there were no relatives, only a sense of a void that was too painful to be discussed. But in old age my mother has begun to talk more easily about her past. She has described events, both happy and sad, with a vividness that has made me want to reconstruct them in my image-making.

I have been working on a sequence of paintings and drawings which tell the story of a day in 1938, shortly after *Kristallnacht*, when members of the SA came to my mother's Berlin home to confiscate the family collection of Dresden and Meissen porcelain. Collectively entitled *A Confiscation of Porcelain*, my sequence of images takes the form of a series of paintings, a short film and a limited edition hand-made book.

For the past ten years one of the chief preoccupations of my work as a figurative painter has been the interaction between images in narrative sequences. My images are involved with the texture of reality; they seek to define or entrap a finite piece of space. Once enclosed, the space becomes a setting for incident. By entrapping space so deliberately I feel that I am also entrapping time – almost as if the cubic volume of air which swells up and invisibly touches the edges of the defined space contains within it an identical volume of time. This enclosed time has paradoxical qualities: it is both frozen and flowing – actual yet Platonic. It belongs to the existential moment, never-to-be repeated; yet, by being trapped and therefore still, it has affinities with both past and future. I use my enclosed spaces as a kind of theatre of incident. These incidents are often autobiographical fragments.

My work progresses through confronting the realness of things. By setting down the essential lineaments of concrete things, knowing their edges, voids and volumes, I hope I can come to know some of the invisible aspects of reality and experience. In my work as a painter I have employed traditional methods – drawing, preparatory studies, oil paint on canvas. Although I am deeply involved with, and committed to the practice of painting, I have always felt a strong affinity with the narrative language of film. This has led me to experiment with paintings about sequence, in an attempt to introduce the element of time into my work; and I have recently begun to explore the possibilities of juxtaposition between filmic and painted images.

JENNY POLAK

Born England 1957

Educated at Cambridge University, St Martin's School of Art, London and School of Visual Arts, New York

Currently lives and works in New York

Included in the following recent Group Exhibitions:

Death Penalty – Death of Culture, *SUNY Purchase Vis Arts Gallery, New York, 1995*

In Alliance, *Oxford House, London, 1995*

Women in the Streets, *Camerawork, London, 1995*

'"Are there any Jews in here?" the Cossack asked me.' Our late grandmother's account[1] of pogroms* in her town in the Ukraine during the civil war after 1917 rings with her own charmed presence, and the courage it gave her. Baba's charm had a literalness, when necessary; she could pass as Russian. Between looks and secular non-conformism, I wonder if her authenticity as a Jewish woman was in doubt, like mine is.

Never in victim mode, Baba 'thought, not of death near at hand, but that we are all responsible for the evil of all the world, and this murderer was not more guilty than I whom he intended to murder'. A humanist thought, constructing equality among people: it goes with a revelation of difference among Jews. Baba, mid-pogrom*, has her holy grandfather tell his grandfather's tale about a Jew lamenting the dispersal of Jews, obstacle to survival, eventually comforted by God saying that he will make us immensely diverse, and we will survive.

I progressed from work about immigration and settlement, at a distance, via works that are exercises in 'claiming noxious terms' such as 'shoddy' and 'trade-in' – slurs associated with assimilation – and ultimately to work involving inner city youth and their experience of violence and the criminal justice system, the relations of black women and white women to feminism, each other, and child-care.

I once reckoned, from the women in my family, that Jewish women were exempt from the oppression of women in the dominant culture. This gave us a responsibility to build liberation with others. I still love, and try to make, art that takes part in these struggles. But, catching an idea of 'working contamination' from Judith Butler, I said, 'I can go after liberatory goals knowing myself inextricable from the dominant culture.' In the throes of un-identity amid US identity politics, I developed *To Self Destruct: To Identify (Jew Life among Christians)*. I will overturn Rahel Varhagen's 'For do what I will, I shall be ill, out of *gêne*, as long as I live: I live against my inclination, I dissemble, I am courteous.'[2] – but refuse Zionism's* coercive fortifications. I was slow to find out how, 'over the years, security rather than equality or justice came to form the overriding value of Zionism*.'[3] Now let's displace the imposed premise that 'Jews need a home all of their own'.

Concentrating questions of access and discrimination, it was Disability Arts politics that taught me art activism, and the subtle strength of alliances. Even so, when US racist supremacy hit me, I still took a while to find some rejoinders to the phrase, 'this is not your battle', and get to work. I work on Walter Benjamin's principle that art 'is better the more consumers it is able to turn into producers – that is, readers or spectators into collaborators'.[4]

My most recent hearings of the ominous 'Are you a Jew?' question (whose possible ramifications obsessed me as I grew up) have been in the mouths of Orthodox* New Yorkers enraged by a work I made called *Jews Join Palestinians* (Brooklyn, 1994). The work invites viewers to play David to a Goliath: representations of US interests in the Middle East: weaponry and oil, settlements and settlers in occupied Palestine.

A recent seminar on 'Israeli-Palestinian Women's Movements'. Panellist Jewel Bellush is fuming, supported by other American Jewish women in the audience. She wouldn't have agreed to speak if she'd known: 'Why is there no Israeli on this panel?' Panellist Simona Sharoni, an Israeli nurtured by one of the progressive women's centres that Bellush's organisation supports, is being erased. Her presentation has named the Oslo Accord as the main obstacle in the path towards peace and progress in Israel-Palestine. My heart shouts gratitude to Sharoni, who had spoken with evident trepidation, true words which are ever more of an anath-

ema to some Jews than references by Palestinian US representative Somaia Barghouti to her people's national aspirations, and to Jerusalem as their capital. A couple of women express fury that a programme on this theme should have turned out to be about politics, to contain propaganda! Some of us counter – it's about time they wise up to the fact that women's oppression is the fabric of politics transnationally. There has been a suicide bombing. I think but am afraid to voice what Ella Shohat articulates well, invoking Fanan: 'The anger and violence of a subjugated group is first and foremost a reaction and rebellion *against* violence, the violence rooted in the asymmetries of power.'[5]

[1] Esther Salaman, *Two Silver Roubles*, 1932.

[2] Arendt on Rahel Varhagen, née Levin.

[3] Ella Shohat, *Israeli Cinema: East, West, and the Politics of Representation*, 1989.

[4] Walter Benjamin, *The Author As Producer*, 1934.

[5] ibid.

SARAH RAPHAEL

Born Suffolk 1960

Trained at Camberwell School of Art

Lives and works in London

RECENT SOLO EXHIBITIONS

Agnew's, London, 1989

Agnew's, London, 1992

Desert Paintings and Other Recent Work, Agnew's, London and Fitzwilliam Museum, Cambridge, 1995

People are affected by their race. How much, depends upon their upbringing and their sense of how the world views that race. Jews of my generation are in a strange position. We have grown up on stories of horror, tragedy and injustice. We experience a borrowed rage about something we never witnessed. Heartbroken by the death and humiliation of people we never knew, but who, we realised, could have been us.

The post-war years also saw the birth and empowerment of Israel. A nation which provoked anger and outrage in others. It is a strange duplicity to sustain, accorded the status of victim and aggressor, innocent and guilty. It is difficult to form an opinion of one's own about what it means to be Jewish. By comparison, being a woman seems pretty straightforward. I would feel fraudulent saying that I have suffered directly as a result of being a woman or a Jew.

To be a Jew has meant, at various times in history, to have been subject to different laws, exclusions and status to gentiles. The diasporic communities have been despised, envied, marginalised, ghettoised and finally mass-murdered. Ironically, since the Holocaust, we are supposed to feel safer.

Women have been viewed and treated with condescension, cruelty and disrespect. Things changed relatively recently. It is perhaps not surprising that being a Jewish woman might make a person feel at a slight disadvantage, even in 1996. But what better place to be an artist from, than one of exclusion, a place set a little apart from the world one is trying to observe? Isn't it the artist's job to sit on the periphery of society and dare to speak the truth?

Perhaps the paranoid view of the Jew as enemy infiltrator into the gentile world (Hitler feared and hated most of all the Jews who looked and behaved just like gentiles) is simply an exaggerated and absurd version of society's fear of the artist, who shows it up for what it is. Isn't the artist supposed to observe society to smithereens, or be cast outside it for a clearer aerial view? It isn't such a bad thing to feel outraged and frowned upon (provided one's life is not in danger) if it gets you into the studio on a cold morning.

But I would hate to think that a person's art were being judged to be better than it actually is because that person's great-grandparents wore funny hats. All art must ultimately be judged by the same measure. I, for one, would not want allowances to be made for my works on the basis of my race or gender.

MARLENE ROLFE

Born London 1946

Read English at Cambridge University and Fine Art and Critical Studies at Central St Martin's School of Art

Lives and works in London

RECENT SOLO EXHIBITIONS

In the Attic, *Ben Uri Art Society, London, 1993*

Dreaming of Home, *Highgate Literary and Scientific Institute, London, 1994*

An Incomplete Picture, *Ravensbrück Memorial Centre, Germany, 1996*

I was born in London at the end of the war. I played on bomb-sites with fireplaces and wallpaper on the exposed walls. I was the only child of eccentric parents. My father wrote books and was terribly English. He explained the rules of cricket to me and took me to church on Sundays. I loved the stained-glass windows and the high voices of the choirboys. It may even have been the beauty of the Book of Common Prayer and the King James Bible that later led me to study English Literature.

But my mother spoke with an accent and had a name, Ilse, which no one English could pronounce. She came from Berlin. Before the war she had been a political prisoner in concentration camps for three years. She hardly ever spoke of it. When I was little, she was plump and jolly, worked hard, loved sweet things and talked non-stop. Sometimes she would tell me about the lakes and forests round Berlin where she had played when she was young, and about her twin sister, Else, whom I hadn't yet met. Else was clever and determined, although she had been born disabled. She lived in New York and sent big, thrilling parcels of clothes and goodies.

You will see from all this that my relationship to my Jewishness is oblique. I don't even remember hearing the word Jewish before I was about ten. My mother and aunt were Germans and socialists first, Jewish after. They rebelled against their extended assimilated family because it was bourgeois. My mother was imprisoned because of her politics, not her ethnic origin. Yet hers is also in its way a Jewish story, and so is my story, and my story about her story as well.

In the 1950s she gave a testimony to the Wiener Library about her imprisonment. Afterwards she wrote: 'Reading through my account, it again became very clear to me that in fact I have "nothing" to report. "To be imprisoned" is an unnatural condition. Every day and every night brings endless pain and sorrow. My account does not in any way manage to express this… Very often it was not the external events that were so tragic, but the effect of imprisonment on the life of the individual… I am sorry that although I was in the camp, I am unable to give a more complete picture.'

Her inexpressible experience marked her life, and most particularly her old age. She could not complete the picture, she had 'nothing' to report, and in the end nothing to say at all. She always felt herself to be in exile, torn up by the roots from her family, her *Heimat,* her language, like the gooseberry bushes she remembered the prisoners had to pull out, when they were moved from KZ Lichtenberg to KZ Ravensbrück.

It was only when she grew old and frail, when she gave up speaking and then eating, then, when it was too late, that I desperately wanted to know her story, to reclaim the lost worlds of the past. I looked things up, I went to Berlin, I visited her sites of imprisonment. I tracked the details of my grandmother's deportation to Belzec. I met and talked to all kinds of people. I rummaged about among deeply varying kinds of material, like the Trümmerfrauen who shovelled the rubble of bombed Berlin.

But the story is never finished, the picture is never complete. The foraging goes on. I work with images that are not self-sufficient, and with different media in different contexts. So my work is hard to categorise. It doesn't fit in, though it has clearly female, feminist subject matter and methods. It yokes together heterogeneous images and elements without comment or judgement. What is absent is as important as what is there. And this, I now begin to see, isn't just me. It is also characteristically Second Generation*, allied to other work in art and literature whose form, characterised by split narratives and things left out, struggles to express knowing and not knowing, and the conflicting aspects of past and present, inner and outer reality.

HILARY ROSEN

Born London 1953

Trained at Trent Polytechnic and Royal College of Art, London

Lives and works in London

RECENT SOLO EXHIBITIONS

Barbican Centre, London, 1992

Royal National Theatre, London, 1994

Galerie Rose, Hamburg, 1994

My maternal grandparents lived in Cable Street, in the East End of London, during the Second World War. When I was a small child I remember being driven to their flat, which was above a kosher* butcher's shop. I can recall seeing huge carcasses hanging up, a very large wooden fridge, a blood-stained chopping block and rows of glittering knives. The area had been severely bombed in the war, and corrugated iron fences surrounded devastated buildings. The living area of the flat was quite modest. I remember the room being dark, with heavy beige curtains, deep maroon velvet chairs and a bookcase with blue leather-bound, gold-embossed Hebrew texts.

Neither of my grandparents talked much about the 1939 'Battle of Cable Street' and they died before I myself had any real awareness of such issues. My grandmother did once tell me about the Fascists marching through the East End and the locals throwing potatoes with razor-blades concealed in them. She also told me about a wartime bomb hitting a cinema in Bethnal Green: 'There were arms and legs all over the place.' I had forgotten this until I later visited the 'Blitz Experience' at the Imperial War Museum. There the voice-over was describing the very same catastrophe.

This set of grandparents were first-generation English, their own parents being Russian. My paternal grandparents had been in England longer and were considerably more affluent. My grandmother had clothes specially made for her, long dresses or gowns of luxuriously patterned silks, velvets or beaded brocades. Her bedroom was very bright and airy with long mirrors reflecting light, and lovely art deco artefacts. She had once been a dancer and formed a duo with her sister who later became a milliner. Neither of them would go shopping without a hat studded with diamanté hatpins.

Such early experiences formed my vision as a painter, and in retrospect I feel that my two grandmothers had the strongest influence on my becoming an artist. As a child I enjoyed drawing and painting, and when I was five my maternal grandmother entered one of my paintings for a 'Rupert Bear' competition, and I won first prize. I won other prizes for art at primary and secondary schools and as I was not 'academic' I went to art school.

My earlier schools had been Jewish but here I mixed freely with non-Jewish students and teachers. We had very good teachers and often visited galleries. I was having a lot of trouble with oil paint and one of my tutors gave me some sable brushes, a box of watercolours and paper. I was also able to travel to Berlin, and this experience changed my life. I have been much influenced by the German Expressionists, especially the artists of the *Neue Sachlichkeit*, George Grosz and Otto Dix. In Berlin I studied Grosz, Nolde and Kollwitz at first-hand. Never before had I seen watercolour used in such a way, nor drawings of people that possessed such intensity. In London at the Tate, Picasso's *Weeping Woman* of 1937 is one of my favourite paintings: on one level, because of the period, on another level, because of the capturing of the facial expression contorted by raw grief and desperation.

There is a feeling of anguish and despair in my painting, and such feelings are also reflected in today's tragic sites of human conflict in many parts of the world. Other pictures, though, are more celebratory and full of colour. Yet there is a certain ambiguity here. Although on the one hand I loved the colour, atmosphere, smells, sequins and all the paraphernalia of the Jewish festivals, I began to feel critical of the ostentation and expense of these occasions.

I feel that being an artist tends to have an alienating effect on some people, who feel awkward even talking about painting. Others make me feel that, in their view, such a profession makes one a spokesperson for twentieth-century art and come out with ridiculous clichés such as 'a child of five could do that' and the like. The truth is that I feel acutely aware of being Jewish in my work and general attitude to life, and grateful to my family and all those who have encouraged and influenced me.

ANNE SASSOON

Born in North Wales 1943

Grew up in South Africa; but returned to Britain in 1986

Studied Fine Art at Middlesex University

Lives and works in London

RECENT SOLO EXHIBITIONS

Coffee Gallery, London, 1994

College of the Atlantic, Maine, USA, 1996

Coffee Gallery, London, 1996

Painter. Female. Jewish. If I apply those labels to myself it is in that order, but although each one is a fact of my life, they do not sit comfortably with each other.

Painting and drawing have provided the richest language since early childhood and I have always thought of myself as a painter; but as I grew up never hearing of a woman painter let alone seeing any work by one, I expected it to be a very private activity and did not think in terms of a career.

Female and Jewish have also been problematic since childhood, when the small Sephardi* community of Johannesburg met in our house for services and I, aged seven, was relegated to a back alcove with the girls and women while my four-year-old brother lorded it in the main room. When my father showed me his family tree, which excluded all daughters, it only confirmed what I already felt.

Jewish and painter makes me think of Chaim Soutine, punished by his father for making graven images and forced to flee the shtetl * to pursue his vocation. When I think of the painters of the New York School – so many of them the children of those shtetl * dwellers – it occurs to me that Abstract Expressionism was their most logical next step.

Facts of life can be ignored but not escaped. My South African background makes me hate attitudes that exclude or keep apart, and the thought of investigating roots has offensive connotations. But I accept that female and Jewish are two of the labels that I carry, and think that they apply to the body of work included in this exhibition.

Of the many self-enclosed communities in England, I have access to one: the Baghdadians who live in London. My father left Baghdad in 1918, when he was eight. I have a photograph taken of the family just before they left – his parents, brothers and sisters, and an uncle wearing a fez. My father is sitting cross-legged in the front looking uncomfortable in his Victorian-style sailor suit. Rich carpets hang behind the group. In this photograph my father's name is Selim; but soon after arriving in London, on the advice of a worldly-wise cousin, all the children's names were anglicised and he became Sidney. Only one aunt, a long-haired adolescent in the photograph, refused to take on the name of Fanny and is Fahima to this day.

Immigration is intrinsic to the Jewish experience and to my own life. The family photograph was the basis for a series of paintings – most of them small enough to go into a suitcase because I was living in America at the time, where I was a stranger. I was reading the Book of Ruth and thinking about the dislocation and change of identity that immigrants experience.

Photography has always been an important reference in my work. I am attracted to studio photographs, where the subjects present themselves as they wish to be seen, posing in an artifical, impersonal environment, pretending to be at ease. Many of the characters in my paintings are based on people who were migrants in South Africa, and had themselves photographed in studios which simulated their middle-class aspirations complete with dummy telephone, plastic flower arrangements and draped backgrounds. There is a certain sense of alienation which I find very moving.

Specific narrative is not important to me. I like to establish a strong human presence, then let the process of painting take over. Characters and relationships may emerge and disappear as I work, but the uneasiness or awkwardness of the individual in the environment is a constant theme.

I try to emulate the movement of television, the continual flicker and flow of images across the screen. The dispassionateness of television, the remoteness it imposes even in close-ups, the flattened perspective and altered colour, all

require adjustments that we are used to making easily and immediately. Each paradigm has its own logic, and we have become as familiar with looking at life through a mechanical lens as we are at looking at it through our own eyes. Neither vision is more true or accurate than the other, and I find it enriching to move between the two.

People do not easily transplant themselves. The Baghdadian Jewish community in London has its own club and synagogue, prefers its own cuisine, and some of its members still choose spouses for their children from among themselves. The smell of bamia and stuffed vegetables; the oriental cakes studded with pistachio nuts; the click of the backgammon games; the hard-backed chairs lined up against the walls leaving the centre of the room, with its inevitable Persian carpet, quite bare; the uncles pinching my cheeks; the aunts in tight satin dresses: all this evokes for me the poignancy of immigration.

GILLIAN SINGER

Born Leeds 1954

Studied sculpture at Sheffield Polytechnic and Chelsea School of Art and printmaking at Central St Martins School of Art

Lives and works in Leeds

GROUP EXHIBITIONS

Cohn and Wolfe Exhibition, *Lethaby Gallery, London, 1992*

Bankside Open Print Exhibition, *Bankside Gallery, London, 1992*

New End Theatre Gallery, London, 1992

In much of my work I have been drawn towards the ritualistic processes attached to experimenting and manipulating material for sculptural purposes. I did this in my early work, stopping at a point of transformation whereby the object acquired its own history. Smell, texture and tactility were important aspects of the work. I used materials as varied as rubber, tar, earth or even mothballs. I tried to use hand-made processes so that the objects had the appearance of being self-evolved and timeless.

The use of seductive materials and processes was later abandoned in favour of purer form and idea. The earlier work invented its own subject matter, but as I developed psychologically, so my work became more directly autobiographical.

I have now made some sort of return to my early methods, but in a more fundamental way. I am once again using materials which, within the process of making, adopt their own history. My work has never been specifically about my origins and culture, but I realised when I first became involved with the *Rubies and Rebels* exhibition that a lot of my peripheral ideas have been to do with Jewish identity.

My work had often been to do with ritual and death, but after my father died in 1990, I became more interested in the visual aspects of Judaism and its 'ancientness' through symbols and artefacts. It is this, rather than religious observance, which has influenced me.

It was after visiting the overcrowded Jewish cemetery in Prague, where the tombstones are stacked like cards, with images depicting a person's trade in life shaped on the stones, that I made a series of tomb prints. The idea of being buried underground alongside a partner, like sleeping figures, became a theme, together with a preoccupation with confinement and decay. I found etchings a very sympathetic medium for these ideas, scratching away at the surface of things, revealing areas below like an archaeologist discovering pieces which have been buried

and concealed. I filled notebooks with these ideas for the prints, and found printmaking after sculpture a refreshingly immediate way of experimenting with ideas and images. There was, however, an iconic element I wanted to incorporate. This was developed in *Tomb Sculpture* with its steel trays, encased plaster figure and clouds.

The menorah* and the flame, ancient maps and manuscripts have been recurrent images in my work. Very often, it is the calligraphy of ancient Hebrew writing, as much as the illustrations, which has influenced the marks and shapes in the work.

I have always been influenced by patterns in nature. Diagrammatic analysis, such as anatomical and zoological illustrations and microscopy, are sources I use. I am drawn to anthropomorphic forms: birds, fish, plants, fossils and skeletons.

Some of my recent work has explored fertility through a series of reliefs. One, made up of twenty-eight 'slices', is a 'calendar' or 'map of time', which describes feeling and mood during the twenty-eight day reproductive cycle, using marks and shapes which travel through the days.

By revisiting all these themes, the forty-nine-sectioned relief in the exhibition encompasses a considerable number of elements and symbols. It contains a history within itself, a general history and a personal history of memory. I wanted to create the feeling of a compendium of images rather like flicking through the pages of a notebook. The photographs include themes of:

Ritual Artefacts | Death | Tombs | Family History | Buried Relics

whereas the background relief incorporates elements such as:

Maps | Roots | Fossils | Boundaries | Fences | Bones | Veins | Earth | Ancient Hebrew

In conclusion, I like ambiguity and duality in my work, used here to convey my mixed feelings about my 'Jewishness'. It also reflects another recurrent theme (linked to this idea) about homelessness, and the feeling of being an outsider who never really 'belongs'.

JESSICA WILKES

Born Newcastle-upon-Tyne 1948

Trained at Newcastle Polytechnic and Chelsea School of Art

Lives and works in London

EXHIBITIONS

Southwark Open, *South London Gallery, London, 1994*

Small Paintings Group, *Duncan Campbell, London, 1995*

Eger Architects, 2 D'Eynsford Place, London, 1996 (solo exhibition)

My father, who died in 1991, was Jewish by birth; my mother is of North Country and Scottish descent. I have gradually come to understand my identity as being both Jewish and non-Jewish. Although I was brought up knowing nothing of Judaism and was baptised in the Church of England, as I grew older it became more and more apparent that I could not ignore my Jewishness. I began to teach painting at Nightingale House – a home for older Jewish people in Clapham, South London. While there I have found out something about Jewish customs and the calendar of festivals and holidays. I have also visited my Jewish cousins in the United States and attended my only synagogue service there at the Lesbian and Gay Synagogue in New York. At Nightingale House I encourage my students to paint about their experiences and their identity.

I grew up with a great awareness of events in Europe during the 1930s and 1940s. My mother's family were very politically conscious and had Quaker connections. My grandfather was saying 'Hitler must be stopped' as early as 1933. My father was politically active from the age of sixteen, and as a left-wing intellectual, while a student at Oxford in the 1930s, campaigned against National Socialism in Germany. My father served in the British army and was sent to occupied Greece as a British liaison officer. In 1945 he was elected Labour MP for Newcastle Central.

Born in 1948, I grew up believing that we had defeated Fascism and Nazism, and it therefore came as an enormous shock to me to realise that there were people who were still racist and anti-Semitic, and that others by keeping silent condoned their actions and beliefs. I think that my family had tried to protect themselves and me from the horror of it all – it was only when my Jewish grandmother died that I realised, from her papers, how much she had done to raise money for Palestine in the 1930s and that she and my grandfather had worked with committees bringing children out of Europe. My work for the Departments of Art and Sound Records at the Imperial War Museum enabled me to find out at first-hand about the effects of the Second World War on British artists and I discovered how the Artists International Association had helped refugee artists both personally and by organising exhibitions.

I can remember being five or six years old and saying that I wanted to be an artist. I had always drawn and painted and this interest was very much encouraged by my mother and father. My father and uncle collected paintings, so I grew up with art around me – such as English watercolours and oils by Stanley Spencer. During my time as a student at Newcastle and Chelsea, I was very interested in abstract painting by Mondrian and the New York School. I thought a lot about composition and structure in painting, about the flatness of the surface and the possibilities of the picture plane. When I left Chelsea I returned to figurative painting – concentrating on the derelict urban landscape in which I found myself. I was fortunate to have a home and studio in a low-rent ACME Housing Association house – which gave me the opportunity to continue painting. This work culminated in the 1982 Summer Show I at the Serpentine Gallery and the Artist-in-Industry Fellowship in Yorkshire in 1983.

In 1984 I began to change direction. I wanted to use imagery from sources other than landscape. Since 1979 I had been drawing from life with Leonard McComb and I began to include figures in my paintings and find subjects from within myself. Inspired by childhood experiences, I began to work on the fairground and carousel paintings. In this I felt strengthened by discovering the work of Frida Kahlo. I wanted my work to be about my own subjective experience. To make my own experience the subject of the work, rather than woman seen from the outside by male artists.

The fairground and the circus are territories where for me, fantasy and reality, inner and outer meet. The performing acrobats are real people with whom I have worked since 1992, who through their skill and training give poetry a human form. In 1990 I visited Crete and made drawings of the famous Leaping Bull fresco in the Heraklion Museum. I did not realise then that this was to be the beginning of my own circus paintings. I am interested in trying to make a still image that contains the possibility of movement. The acrobats move in the air between light and shadow and although they are actual people they also represent part of my own psyche. The circus performers also appeal to me because they are outside the mainstream of ordinary life and society. I think that this has always been recognised by artists, particularly during this century – I am thinking of the School of Paris, including also Chagall and Mark Gertler's fairground imagery. Film-makers like Wim Wenders have also been affected by the circus: in *Wings of Desire* his central character is a trapeze artist, and the fairground in movies is almost a cliché in which the associations of child-like pleasures contrast with the darker motives of adult dramas. I feel too that 'the strolling player' and 'the wandering Jew' have something in common; the circus people in my paintings travel about performing, they belong to an international culture – as of course do artists.

When I began the fire paintings, I was conscious that they were about sexuality and desire – not a subject for a woman to be dealing with, and certainly not in the canon of European oil painting. So, like Prometheus, I feel as if I am stealing fire from the gods 'to play with fire', something my mother expressly told me not to do. Painting for me is a very physical experience – I gain understanding of the medium by my practice of it. This knowledge and understanding cannot be given by anyone else (although some of it can be taught); ultimately it must be discovered by the individual. The qualities of oil paint make handling it a sensuous experience and I quite literally get my hands dirty – again this is a transgressive thing for a woman to enjoy. In *Devil's Stick* I deliberately painted the flame on the woman's body to make the metaphor with desire explicit but as I was painting I realised that it refers to a particularly Jewish experience of burning. I saw the remains of the crematoria at Auschwitz myself on 28 January 1995, when I drove with a friend, whose grandparents had died there, to Poland to mark the fiftieth anniversary of the liberation of Auschwitz by the Russian army. I have chosen not to hide from these things.

VERDI YAHOODA

Born Aden 1952

Family settled in Britain in 1962. Studied at Goldsmiths' College and Royal College of Art

Lives and works in London

SOLO EXHIBITIONS

Window Dressing, *The Photographers' Gallery, London (and tour), 1988*

Pathways/Landmarks *(installation), Princelet Street, London, 1990*

Lost Thread, *Metro Cinema, London, 1993*

In addressing this exhibition's manifesto, I would state at the outset that being Jewish and female have always been secondary in establishing the identity of my art practice. The dominant preoccupation in this art practice is the exploration of the photographic medium and how to use it as a visual language. The complexity of this art practice makes it difficult to define concisely, but let me attempt to outline certain concerns that are present in the work.

The depiction of the humble object as iconic – be it a hairpin or a mantelpiece; a plate wrapped in cloth; a picture hanging on a wall. Then in turn rendering the photograph as object. The one reinforcing the other.

The interiors of rooms and the presence of objects within those spaces.

Recontextualising the implements of sewing through an implied narrative.

These brief outlines do not offer anything more than a reassertion of my initial premise, and do not exclude other motifs. However, looking back over twenty years of work, references to Jewishness and femaleness are elements that recur, and one recognises a fluctuating rhythm in the way these issues surface and subside.

Being invited to participate in this exhibition gives me the arena where their role in my work can be examined. I shall do this in the context of the photographs in this exhibition, which were selected from a series of works made during 1984–6 – a period when I began tentatively to acknowledge my Jewish faith and my Orthodox* background with its particular set of traditions and customs, that hitherto had been kept private. These works gave a visual voice to the influences I grew up with.

Works like *Sifting Through* were emerging that referred to the female role within this culture. In part, this work is an acknowledgement of a certain harmony of domestic rituals, as well as a reflection of the limitations they represented for the woman. Visually, this work offers no overt Jewish identity. It would suggest oriental origins because of the motifs in the plate/cloth/table. The vessels, on the other hand, are distinctively Western. The merging of the two cultures perhaps speaks more of assimilation.

Seven Wrapped Objects – This series of seven diptychs shows objects wrapped in cloth that were found in my parents' home. The cloth enveloped not only the object, but also a history that belonged to my family. In re-enacting the wrapping of these objects and photographing them, I was perhaps drawing upon the importance of that history for myself.

A Question of Faith – The images in these two panels are more overt in their reference to a Jewish identity. The question is a private one.

On reflection, I may now even admit to the perversity of once suppressing that Jewish identity. And though the feminine is referred to in the content of some of these works, they were not made from a feminist stance. These photographs were made in response to the instinctual need to make works that hold personal references, within a formal framework influenced by the discipline of a Western art school training.

CATALOGUE OF WORKS IN THE EXHIBITION

Unless otherwise stated, all works come from the artist's own collection. Height precedes width.

ANGELA BAUM

1 AGUNAH, 1992
 Oil and collage on canvas
 24 × 34 in / 61 × 86 cm

2 CHAVA (EVE), 1995
 Oil on canvas
 24 × 24 in / 61 × 61 cm

3 ESTHER, 1995
 Oil on canvas
 24 × 24 in / 61 × 61 cm

4 RACHEL, 1995
 Oil on canvas
 24 × 24 in / 61 × 61 cm

5 HAGAR AND SARAH, 1995
 Oil on canvas
 24 × 24 in / 61 × 61 cm

6 YAEL, 1995
 Oil on canvas
 24 × 24 in / 61 × 61 cm

7 ZIPPORA, 1995
 Oil on canvas
 24 × 24 in / 61 × 61 cm

8 KADDISH, 1996
 Black and white ink on gesso
 47 × 99 in / 120 × 251 cm

9 SAMSON AND DELILAH, 1996
 Oil on canvas
 68 × 74 in / 173 × 188 cm

CAROLE BERMAN

10 THE THREE SISTERS, 1995–6
 Oil on canvas
 48 × 60 in / 122 × 152 cm

11 ADAM, 1996
 Oil on canvas
 60 × 48 in / 152 × 122 cm

12 EVE, 1996
 Oil on canvas
 60 × 48 in / 152 × 122 cm

JUDY BERMANT

13 NEGATIVE/POSITIVE SELF-
 IMAGE, 1995
 Aquatint
 11 × 15½ in / 28 × 40 cm

14 BROWNED-OFF SELF, 1996
 Collograph
 11 × 7¾ in / 28 × 19 cm

15 DIS-LOCATED SELF, 1996
 Collograph
 11 × 7¾ in / 28 × 19 cm

16 EXASPERATION, 1996
 Collograph
 11 × 7¾ in / 28 × 19 cm

17 FRAGMENTED SELF, 1996
 Collograph
 11 × 7¾ in / 28 × 19 cm

18 RESIGNATION, 1996
 Collograph
 11 × 7¾ in / 28 × 19 cm

SANDRA BRANDEIS CRAWFORD

19 ISRAELITE SECTION OF THE
 VIENNA CENTRAL CEMETERY,
 1992
 Photographic collage on paper
 22 × 30 in / 56 × 76 cm

20 NIKOLSBURG JEWISH
 CEMETERY, 1992
 Photographic collage on paper
 22 × 30 in / 56 × 76 cm

21 STAR OF DAVID AND HIDDEN
 CROSS, 1992
 Pigment on paper
 22 × 30 in / 56 × 76 cm

22 VIENNA FROM PRAGUE, 1992
 Mixed media on canvas
 63 × 36 in / 160 × 140 cm

23 DEAR MOTHER, 1995
 Mixed media on canvas
 67 × 71 in / 170 × 180 cm

24 GUARDIAN OF THE SWIM, 1995
 Mixed media on canvas
 69 × 72 in / 175 × 180 cm

25 FEMINIST SELF-PORTRAIT, 1996
 Mixed media on canvas
 50 × 39 in / 126 × 100 cm

ABIGAIL COHEN

26 PSALM I, 1995
 Oil on plaster on board
 96 × 60 in / 244 × 152 cm

27 PSALM II, 1995
 Oil on plaster on board
 96 × 60 in / 244 × 152 cm

28 PSALM III, 1995
 Oil on plaster on board
 96 × 60 in / 244 × 152 cm

EDORI FERTIG

29 THE TWO SELVES, 1994
 Etching
 13 × 13 in / 32.5 × 32.5 cm

30 BIRTH, 1995
 Etching on plaster, ink, acrylic
 7½ × 5 in / 19.5 × 13 cm

31 HAMSA, 1996
 Collograph with chine collé
 12 × 7 in / 31 × 17 cm

32 HANNUKIAH, 1996
 Etching
 15½ × 12 in / 39.5 × 30 cm

33 MATERNAL LINE, 1996
 Etching
 18½ × 14½ in / 47 × 37 cm

34 MOTHER AND DAUGHTER, 1996
 Hand-made paper, collage, wax, acrylic
 12 × 8½ in / 31 × 21.5 cm

35 MY MOTHER, 1996
 Hand-made paper, collage, wax, acrylic
 16 × 9 in / 41.5 × 24 cm

36 NANA, 1996
 Hand-made paper, collage
 8½ × 9 in / 22 × 23 cm

 Above three form part of *Fossil Series*,
 1996

37 SHABBAT (MY GRANDMOTHER'S
 GLOVES), 1996
 Collograph and chine collé with photo
 etching
 25 × 17½ in / 63 × 44.5 cm

RACHEL GARFIELD

38 PLENTY II, 1994
 Etching, sugarlift and aquatint
 8 × 10 in / 20 × 25 cm

39 THE WICKED SON, 1994
 Oil on canvas
 78 × 54 in / 198 × 137 cm

40 UNTITLED, 1994
 3 plate etching and aquatint
 5½ × 6½ in / 13 × 16 cm

41 AMULET III, 1995−6
 Oil on canvas
 68 × 50 in / 173 × 126 cm

42 BIRTHRIGHT, 1995−6
 Oil on canvas
 45 × 66 in / 114 × 168 cm

43 BIRTHRIGHT, 1996
 Etching and aquatint
 6 × 7 in / 15 × 18 cm

44 UNTITLED, 1996
 Etching and aquatint
 8½ × 6½ in / 22 × 16 cm

JULIE HELD

45 DYING WOMAN, 1988−90
 Oil on canvas
 40 × 30 in / 102 × 76 cm

46 JUDITH AND HOLOFERNES,
 1993
 Oil on canvas
 48 × 36 in / 122 × 91 cm

47 THE WEDDING, 1994−5
 Oil on canvas
 60 × 48 in / 152 × 122 cm

48 MYSELF REMEMBERED, 1995
 Oil on canvas
 30 × 36 in / 76 × 91 cm

49 COUPLE, 1996
 Oil on canvas
 36 × 33 in / 91 × 84 cm

50 SUPPER, 1996
 Oil on canvas
 72 × 48 in / 183 × 122 cm

LYNN LEON

51 CAPTIVE PROFILE, 1985
Composite black-and-white
photograph
23¾ × 29 in / 60 × 75 cm

52 CENSORED, 1985
Composite black-and-white
photograph
35½ × 28¾ in / 90 × 73 cm

53 WITNESS, 1985
Composite black-and-white
photograph
28¾ × 35½ in / 73 × 90 cm

54 IDENTITIES I, 1994
Pen and ink on paper
8 × 11½ in / 20.5 × 29 cm

55 IDENTITIES II, 1994
Pen and ink on paper
11½ × 16¼ in / 29 × 41 cm

56 IDENTITIES III, 1994
Pen and ink on paper
10¼ × 15 in / 26 × 38.5 cm

57 IDENTITIES IV, 1994
Pen and ink on paper
8 × 11½ in / 20.5 × 29 cm

58 PRIESTLY BLESSING, 1994
Pen and ink on paper
7 × 10¼ in / 18 × 26 cm

59 TALLIT LANDSCAPE I, 1994
Pen and ink on paper
8 × 11¼ in / 20 × 28.5 cm

60 TALLIT LANDSCAPE II, 1994
Pen and ink on paper
8 × 11¼ in / 20 × 28.5 cm

61 TERRITORIAL RIGHTS, 1994
Pen and ink on paper
11½ × 16¼ in / 29 × 41 cm

RACHEL LICHTENSTEIN

62 KIRSCH FAMILY, 1996
Mosaic (Herodian, Byzantine and
Roman period ceramic, lime. lava,
sand, concrete) 12 sections, each 24 × 24
in / 60 × 60 cm, total size 94 × 71 in / 240
× 180 cm

LILIANE LIJN

63 HER MOTHER'S VOICE, 1996
10¼ × 9 × 1 in / 26 × 23 × 2.5 cm (134 pp,
129 images)
Designed and printed by the artist on
hand-made Japanese Tosa Shoji paper;
hand-bound by Romilly Saumarez-
Smith in K. Yoseishi and Ogura mould-
made paper; published in an edition of
25 copies signed and dated by the artist

BARBARA LOFTUS

64 HILDEGARD DANCING, 1993–5
Oil on canvas mounted on board
25 × 37 in / 63 × 94 cm

65 MOTHER AT THE DOOR, 1993–5
Oil on canvas mounted on board
24 × 14¼ in / 61 × 36 cm

66 PACKING THE TEA CHEST,
1993–5
Oil on canvas mounted on board
23 × 28 in / 58 × 71 cm

67 THE EMPTY CABINET, 1993–5
Oil on canvas mounted on board
25½ × 21½ in / 65 × 55 cm

68 THE STAIRCASE, 1993–5
Oil on canvas mounted on board
22 × 15 in / 56 × 38 cm

69 WRAPPED PORCELAIN, 1993–5
Oil on canvas mounted on board
9 × 23 in / 23 × 58 cm

70 REMOVING THE PORCELAIN I,
1994
Oil on canvas mounted on board
21 × 9 in / 53 × 23 cm

71 REMOVING THE PORCELAIN II,
1994
Oil on canvas mounted on board
21 × 9 in / 53 × 23 cm

72 REMOVING THE PORCELAIN III,
1994
Oil on canvas mounted on board
21 × 13 in / 53 × 33 cm

73 REMOVING THE PORCELAIN IV,
1994
Oil on canvas mounted on board
21 × 9 in / 53 × 23 cm

74 THE BRIDGE PARTY, 1995
Oil on canvas mounted on board
25 × 33 in / 63 × 84 cm

All above form part of
A Consfiscation of Porcelain series,
1993–5

75 A CONFISCATION OF
PORCELAIN, 1996
Video

JENNY POLAK

76 LIKE IT OR NOT, 1993
Lightbox (steel; papier mâché; paint;
duratrans; text on acetate)
24 × 18 × 12 in / 61 × 46 × 30 cm

77 REPATRIATE (ENGLAND STILL),
1993
Wood; polythene; paint; lightbox;
duratrans; texts (jetty/boat of bolted
wood, to be walked up)
96 × 60 × 192 in / 244 × 152 × 488 cm

78 TO SELF-DESTRUCT: TO
IDENTIFY (JEW LIFE IN A
CHRISTIAN COUNTRY NO.6),
1993
Display unit (steel, light, 36 × 60 × 12 in
/ 91 × 152 × 30 cm; positive film images
10 × 10 in / 25 × 25 cm; acetate; ink;
elastic + TAKE ME books, 2½ × 4½ in / 6 ×
11 cm, to take away

SARAH RAPHAEL

79 WHILST ATTEMPTING TO
ESCAPE, 1990
Acrylic on paper
45 × 55 in / 114 × 140 cm
Courtesy of Thos. Agnew & Sons

80 THE EMIGRATION GAME, 1991
Charcoal on paper
54½ × 36½ in / 138 × 93 cm

81 TRIPTYCH, 1993
Charcoal, compressed charcoal, conté
60 × 84 in / 152 × 213 cm

MARLENE ROLFE

82 TWINS, 1989
Oil on canvas
42 × 32 in / 107 × 81 cm

83 FAMILY, 1990
Oil on canvas
36 × 30 in / 91 × 76 cm

84 WANDERVÖGEL, 1993
Oil on canvas
43 × 60 in / 109 × 152 cm

85 AND HOW EVERYTHING TURNED
OUT SO DIFFERENTLY, 1995
Oil on canvas
20 × 28 in / 51 × 71 cm

86 EMPTY BUILDING, 1995
Oil on canvas
20 × 28 in / 51 × 71 cm

87 GERMAN ROMANTICISM, 1995
Oil on canvas
20 × 28 in / 51 × 71 cm

88 ROOF, DOOR, GATE, 1995
Oil on canvas
20 × 28 in / 51 × 71 cm

89 SCAFFOLDING, 1995
Oil on canvas
20 × 28 in / 51 × 71 cm

90 SELF-PORTRAIT WITH
PHOTOGRAPH, 1995
Oil on canvas
20 × 28 in / 51 × 71 cm

HILARY ROSEN

91 THE BOAT, 1990
Charcoal and mixed media
45 × 35 in / 115 × 89 cm

92 SYNAGOGUE, 1990
Oil on paper
24 × 36 in / 61 × 92 cm

93 THE ESCAPE, 1994
Watercolour and charcoal
20½ × 13½ in / 52 × 34 cm

94 EVACUEES, 1994
Watercolour
14 × 21½ in / 36 × 55 cm

95 THE SELECTION, 1996
Watercolour and mixed media
43½ × 45½ in / 110 × 114 cm

ANNE SASSOON

96 FAMILY LINE-UP WITH FEZ,
1995
Oil on canvas
14 × 11 in / 36 × 28 cm

97 FAMILY LINE-UP, 1995
Oil on canvas
14 × 11 in / 36 × 28 cm
Collection of Frank and Sonia Sassoon

98 ORIENTAL COUPLE WITH
CHILD, 1995
Oil on canvas
12 × 10 in / 31 × 25 cm

99 SELIM AND UNCLE MOSHE, 1995
Oil on canvas
16 × 18 in / 41 × 46 cm

100 THE CHILD IS FATHER TO THE
MAN, 1995
Oil on canvas
40 × 40 in / 102 × 102 cm

101 THE ELDER SISTER, 1995
Oil on canvas
12 × 10 in / 31 × 25 cm

GILLIAN SINGER

102 UNTITLED, 1996
Pulped paper and plaster with
photographic emulsion
105 × 84 × 1 in / 266 × 217 × 2.5 cm
(h. × w. × d.)

JESSICA WILKES

103 CAROUSEL, 1989–91
Oil on canvas
70 × 112 in / 178 × 285 cm

104 KISS, 1993
Oil on canvas
22 × 20 in / 56 × 51 cm

105 DEVIL'S STICK, 1994
Oil on canvas
70 × 60 in / 178 × 153 cm

106 HEAVENLY BODIES, 1994
Oil on canvas
12 × 10 in / 30 × 25 cm

107 HOLD ME, 1994
Oil on canvas
24 × 18 in / 61 × 46 cm

108 OLYMPIANS, 1995
Oil on canvas
12 × 10 in / 30 × 25 cm

VERDI YAHOODA

109 A QUESTION OF FAITH, 1986
2 sets of 3 black-and-white
photographs
Each set 20 × 30 in / 51 × 76 cm

110 SEVEN WRAPPED OBJECTS, 1986
Series of 14 black-and-white
photographs, framed and mounted in
pairs, each pair measuring 20 × 16 in /
51 × 41 cm

111 SIFTING THROUGH, 1986
Panel comprising 6 black-and-white
photographs (from series of 4 panels)
32½ × 42 in / 82.5 × 170 cm

BIBLIOGRAPHY

Antonelli, Judith S., *In the Image of God: A Feminist Commentary on the Torah*, Jason Aronson, New York, 1996

Baker, Adrienne, *The Jewish Woman in Contemporary Society, Transitions and Traditions*, Macmillan, London, 1993

Balka, Christie and Rose, Andy (eds). *Twice Blessed: On Being Lesbian or Gay and Jewish*, Beacon Press, Boston, 1989

Beck, Evelyn Torton, *Nice Jewish Girls: A Lesbian Anthology*, Beacon Press, Boston, 1989

Biale, Rachel, *Women and the Jewish Law: The Essential Texts, Their History and Their Relevance for Today*, Schocken Books, New York, 1984–95

Bohm-Duchen, Monica (ed.), *After Auschwitz: Responses to the Holocaust in Contemporary Art*, NCCA Sunderland, and Lund Humphries, London, 1995

Brook, Stephen, *The Club: The Jews of Modern Britain*, Constable, London, 1989

Cantor, Aviva, *On the Jewish Woman: A Comparative and Annotated Listing of Works Published 1900–1979*, Biblio Press, New York, 1979

Cesarani, David (ed.), *The Making of Modern Anglo-Jewry*, Blackwell, London, 1990

Cheyette, Bryan, *Constructions of 'the Jew' in English Literature and Society: Racial Representations, 1875–1945*, Cambridge University Press, 1993

Cohen, Stephen M. and Hyman, Paula E., *The Jewish Family: Myths and Reality*, Holmes and Meier, New York, 1986

Cooper, Howard and Morrison, Paul, *A Sense of Belonging: Dilemmas of British Jewish Identity*, Weidenfeld and Nicolson, London, 1991

Frankiel, Tamar, *The Voice of Sarah: Feminine Spirituality and Traditional Judaism*, Harper, San Francisco, 1990

Ghatan. H.E., *The Invaluable Pearl: The unique status of women in Judaism*, Bloch, New York, 1986

Greenberg, Blu, *On Women and Judaism: A View from Tradition*, The Jewish Publication Society of America, Philadelphia, 1981

Grossman, Susan and Haut, Rivka (eds), *Daughters of the King: Women and the Synagogue*, The Jewish Publication Society, Philadelphia/Jerusalem, 1992

Guy, Frances, *Women of Worth: Jewish Women in Britain*, (exhibition catalogue), Manchester Jewish Museum, 1992

Hamelsdorf, Ora and Adelsberg, Sandra, *Jewish Woman and Jewish Law: A Bibliography*, Biblio Press, New York, 1980

Harway, Danielle, Chester, Gail, Johnson, Val and Schwartz, Ros, *A Word in Edgeways; Jewish Feminists Respond*, J.F.Publications, 1988

Henry, Sandra and Taitz, Emily, *Written out of History: Our Jewish Foremothers*, Biblio Press, New York, 1983

Heschel, Susan (ed.), *On Being a Jewish Feminist*, Schocken Books, New York, 1983

Holden, Pat (ed.), *Women's Religious Experience*, Croom Helm, Beckenham, 1983

Jacobs, Louis, *The Jewish Religion: A Companion*, Oxford University Press, 1995

Kampf, Avram, *Chagall to Kitaj: Jewish Experience in Twentieth-Century Art*, Lund Humphries, London / Barbican Art Gallery, 1990

Kaye – Kantorowitz, Melanie and Klepfisz, Irena, *The Tribe of Dina: A Jewish Women's Anthology*, 1986; reprinted Beacon Press, Boston, 1989

Koltun, Elizabeth (ed.), *The Jewish Woman: New Perspectives*, Schocken Books, New York, 1976

Kuzmack, Linda Gordon, *Women's Cause: The Jewish Women's Movement in England and the United States*, Ohio State University Press, 1990

Lacks, Roslyn, *Women and Judaism: Myth, History, and Struggle*, Doubleday, Garden City, USA, 1980

Loewenstein, Andrea Freud *Loathsome Jews and Engulfing Women: Metaphors of Projection in the Works of Wyndham Lewis, Charles Williams and Graham Greene*, New York University Press, 1993

Lyndon, Sonja and Paskin, Sylvia (eds), *The Dybbuk of Delight, An Anthology of Jewish Women's Poetry*, Five Leaves Publications, Nottingham, 1995

Mazow, Julia, *The Woman Who Lost Her Names. Selected Writings of American Jewish Women*, Harper, New York, 1980

Niederman, Sharon (ed.), *Shaking Eve's Tree: Short Stories of Jewish Women*, The Jewish Publications Society, Philadelphia/Jerusalem, 1990

Neuberger, Julia, *Whatever's Happening to Women?*, Kyle, London, 1991

Neuberger, Julia, *On Being Jewish*, Heinemann, London, 1995

Nochlin, Linda and Garb, Tamar (eds), *The Jew in the Text: Modernity and the Construction of Identity*, Thames and Hudson, London, 1995

Pardes, Ilana, *Countertraditions in the Bible: A Feminist Approach*, Harvard University Press, Cambridge, Mass., 1992

Pirani, Alix, *The Absent Mother: Restoring the Goddess to Judaism and Christianity*, Mandala, London, 1991

Plaskow, Judith, *Standing Again at Sinai: Judaism from a Feminist Perspective*, Harper Books, San Francisco, 1990

Preston, Rosalind, Goodkin, Judy and Citron, Judith, *Women in the Jewish Community: Review and Recommendations*, Office of the Chief Rabbi, London, 1994

Priesand, Sally, *Judaism and the New Woman*, Behrman House, New York, 1975

Ruether, Rosemary (ed.), *Religion and Sexism: Images of Women in the Jewish and Christian Traditions*, Simon and Schuster, New York, 1974

Schneider, Susan Weidman, *Jewish and Female: Choices and Changes in Our Lives Today*, Simon and Schuster, New York, 1984

Shepherd, Naomi, *A Price Below Rubies: Jewish Women as Rebels and Radicals*, Weidenfeld and Nicolson, London, 1993

Sheridan, Sybil (ed.), *Hear our Voice: Women Rabbis Tell their Stories*, SCM Press, London, 1994

Siegel, Rachel Josefowitz and Cole, Ellen (eds), *Seen But Not Heard: Jewish Women in Therapy*, Haworth, New York, 1991

Swirsky, Ruth et alia (eds) (Jewish Women in London Group), *Generations of Memories: Voices of Jewish Women*, The Women's Press, London, 1989

Weinberg, Sydney Stahl, *The World of our Mothers: The Lives of Jewish Immigrant Women*, Schocken Books, New York, 1988 [US experience only]

GLOSSARY

COMPILED BY VERA GRODZINSKI

All words marked * have their own entry in the glossary. Variant spellings of the following terms the reader may encounter elsewhere are due to different transliterations from the original Hebrew or Yiddish. The spellings used here are those found in *The Jewish Religion: A Companion* by Rabbi Dr. Louis Jacobs (Oxford University Press, 1995). Quotations come either from the latter or from the *Encyclopaedia Judaica* (Keter Publishing House, Jerusalem, 1971).

AFIKOMAN
A small piece of Matzah*. Traditionally, the head of the household hides the Afikoman during the Seder*; the youngest child present is encouraged to 'steal' it and to hand it back in return for the promise of a present. The latter practice is common primarily among Ashkenazi* Jews; in Sephardi* communities, it became a folk custom to preserve a piece of Afikoman as protection against the 'evil eye' and as an aid to longevity.

AGGADAH
'The aspects of Jewish, especially Talmudic*, literature that embraces all non-legal topics, like Jewish history, ethics, philosophy, folk-lore, medicine, astronomy, popular proverbs, pious tales and so forth.'

AGUNAH
A woman bound or 'chained' either to a miss-ing husband or one who refuses to divorce her.

ASHKENAZI (*pl.* ASHKENAZIM)
Jews whose ancestors lived in Germany during the Middle Ages; now, term refers to Jews of Central or Eastern European origin (in contrast to Sephardim*).

BAR MITZVAH
Religious ceremony, usually but not always held in a synagogue, to mark the initiation of a thirteen-year old boy into the Jewish commu-nity. A comparable ceremony known as a Bat Mitzvah is held for twelve-year old girls.

BRITH MILA
The ritual of male circumcision as emblem-atic of the covenant between God and Abraham, traditionally practised in all Jewish communities.

CHUPPAH
Wedding canopy under which a Jewish mar-riage ceremony is performed. Term can also refer to the ceremony itself.

CONSERVATIVE JUDAISM
A form of Judaism, with its original centre in the United States, that occupies the middle ground between Orthodoxy* and Reform*. The nearest equivalent in Britain is the Masorti* movement.

DIASPORA
from the Greek for 'dispersion'
Refers collectively to all the places outside Palestine where Jews have resided since the destruction of The First Temple of Jerusalem in 586 BCE.

FEMINISM (JEWISH)
The movement to obtain equal rights and opportunities for women in Jewish religious life. In Orthodox* Judaism, women – although valued for their role in the domestic sphere – are virtually excluded from public religious life and worship. Within Liberal* and Reform* Judaism (and to a lesser extent Conservative* and Masorti* Judaism), the religious status of women has been improved.

GET
The bill of divorce, which has to be given by a husband to his wife, and accepted by her in order to dissolve a marriage. It is not possible for a woman to give a Get to her husband.

HAGGADAH
from the Hebrew for 'narrative'
The usually illustrated book, containing an account of the Biblical Exodus from Egypt, as well as prayers, songs and stories, which is read aloud at the Passover* Seder*.

HALAKHAH
from the Hebrew root, halakh, *'to go' or 'walk'*
The legal aspect of Judaism; the rules and regulations according to which the Jew 'walks' through life.

HAMSA
An amulet in the shape of an open hand, showing the palm; designed to ward off the evil eye, and used as a protective and good luck charm.

HANNUKAH
from the Hebrew for 'dedication'
An eight-day winter festival in memory of the re-dedication of the Temple after its defile-ment by the Greek despot Antiochus in 168 BCE.

HANNUKIAH
A nine-branched candelabrum; on each night of Hannukah*, an additional flame is kindled, so that by the eighth night the whole Hannukiah is lit. The ninth candle is the 'servant', which lights the others.

HASID (*pl.* HASIDIM)
from the Hebrew hasidut, *'piety'*
Members of a movement known as
HASIDISM, established in Southeast Poland-
Lithuania in the 1730s. In reaction to what was
perceived as the élitism, intellectual pedantry
and over-rationalism of Orthodox* Talmudic*
Judaism, the Hasidim placed great emphasis
on an ecstatic, mystic and intuitive commun-
ion with God. From Poland, the movement
spread to the whole of Eastern Europe, and
ultimately to the USA, Israel, England and
other parts of western Europe.

HAVDALAH
from the Hebrew for 'separation'
Ceremony observed in Jewish homes on
Saturday night, to mark the end of the Sab-
bath and the start of the working week; in-
volves the reciting of blessings over spices,
and the extinction of a Havdalah candle.

HIGH HOLY DAYS
Term used to refer to the two most important
festivals in the Jewish calendar: Rosh
Hashanah, the Jewish New Year and Yom
Kippur, the Day of Atonement.

KABBALAH
The Jewish mystical-philosophical system
developed during the Middle Ages, which has
been reinterpreted by rabbis and scholars
ever since.

KADDISH
A prayer recited by a son in synagogue for
eleven months after the death of a parent and
on the anniversary of that death (known as
Yahrzeit*). Only in Liberal* and Reform*
communities is a daughter allowed to recite
Kaddish in public.

KEFFIYAH
Traditional headscarf worn by male Palestin-
ians.

KETUBAH
from the Hebrew root, katav, *to write*
The Jewish Marriage Contract, essentially a
statement of the husband's obligations to his
wife. Originally, the purpose of the Ketubah
was to prevent a husband divorcing his wife
against her will. No provision was made,
however, for a wife wishing to divorce her
husband.

KITTEL
A Yiddish term referring to the white gown
traditionally worn by Orthodox* Ashkenazi*
Jews on a variety of special occasions: during
High Holy Day* synagogue services; by the
man presiding over the Passover* Seder*; by
the bridegroom during a wedding ceremony.
The same gown can later be used as a burial
shroud.

KOSHER
from the Hebrew for 'fit' or 'suitable'
Orthodox Jews are only permitted to eat food
that is kosher, that is, 'suitable' according to
Halakhah*; hence the abstract term KASHRUT
for dietary laws.

LIBERAL JUDAISM
A British-based movement that goes even
further than Reform* to anglicise synagogue
services and rituals.

MASORTI JUDAISM
The British counterpart of American Con-
servative Judaism*: that is, a form of Judaism
that occupies the middle ground between
Orthodoxy* and Reform*.

MATZAH
Unleavened bread eaten during the Festival of
Passover*.

MENORAH
Seven-branched ritual candelabrum, origi-
nally used in the Jewish Temple in Jerusalem.
After the Destruction of the Second Temple in
70 CE, the Menorah became one of the princi-
pal visual symbols of the Jewish People, and is
today the national symbol of the State of
Israel.

MEZUZAH
A small parchment scroll containing two
passages from Deuteronomy (6:4–9, 11:13–21)
in a decorative case, often with the word
Shaddai* inscribed on it, which is traditionally
fixed to the doorpost of Jewish households.

MIDRASH
from the Hebrew darash, *'to enquire' or
'investigate'*
A method of delving beneath the surface of
the Scriptures, compiled into a written body
of laws and teachings which forms part of the
Talmud*.

MIKVEH
The ritual bath, to be visited after a period of
'uncleanness', used by women after childbirth
and menstruation. Orthodox* males visit the
Mikveh before the Sabbath and the High Holy
Days*.

MITZVAH (*pl.*MITZVOT)
Religious commandment, both negative and
positive; term also used to refer to a 'good
deed'. Only men are obliged to fulfil all 613
Mitzvot; women are exempt from those con-
tingent upon a particular time or season.

NIDDAH
The period of sexual abstinence after men-
struation and childbirth, which ends with a
visit to the Mikveh*; after which marital sexual
relations are permitted, even prescribed.

ORTHODOX JUDAISM
A form of the Jewish religion faithful to the
ancient principles and practices of Judaism.
Orthodox Jews view Halakhah* as immutable.
There are many different Orthodox sects.

PASSOVER (or PESACH)
An eight-day spring festival commemorating
the Biblical Exodus from Egypt, and hence a
celebration of freedom and redemption.

POGROM
An apparently spontaneous, but often carefully
orchestrated attack on Jewish communities,
involving the looting and destruction of prop-
erty, rape and murder. Most often applied to
such attacks in Russia and Eastern Europe in
the nineteenth and twentieth centuries.

REFORM JUDAISM
A movement that first emerged in early nine-
teenth century Germany, which aimed to
'reform' the Jewish religion to bring it more in
line with western customs and practices,
without sacrificing any of its basic tenets. It is
within the Reform and Liberal* Movements
that most of the changes affecting the status of
women have taken place.

ROSH HODESH
from the Hebrew for 'head of the month'
The first day of the lunar month, in biblical
times, a women's minor festival. In recent
times, this festival has been revived in the form
of 'women only' gatherings for prayer and
discussion.

SECOND GENERATION
Refers to the children of Holocaust survivors;
sometimes also used to apply to children of
refugees from Nazi Europe.

SEDER
Festive, ceremonial meal held in Jewish homes
or communal venues on the first night of
Passover*; outside Israel, Orthodox* Jews hold
a Seder on the second night as well.

SEFIROT
The ten 'mystic spheres', or aspects of God in his capacity as Creator; a concept fundamental to the Kabbalah*.

SEPHARDI (*pl.* SEPHARDIM)
Descendents of Jews resident in Spain, Portugal, Africa, the Middle and Far East (in contrast to the Ashkenazim*).

SHABBAT
Saturday, the Jewish day of rest.

SHADDAI
The Divine Name, the Almighty, the 'Dispenser of Benefits'.

SHEITEL
A Yiddish word denoting the wig worn by Orthodox* Jewish women as a sign of modesty; a headscarf can be worn as an alternative. In fact, the rules governing the covering of hair have been relaxed in some circles.

SHIN
The penultimate letter of the Hebrew alphabet, and first letter both of Shaddai* and Shekhinah*, hence endowed with considerable spiritual power.

SHEKHINAH
from the Hebrew for 'dwell'
The in-dwelling spirit, often conceived of in specifically female terms as 'the feminine element in Divinity'. 'Jewish feminists have welcomed the doctrine of the Shekhinah in its Kabbalistic* understanding as providing powerful support … to their refusal to describe God solely in male terms.'

SHIVAH
Usually a seven-day period of mourning (involving, among other things, prayer, the covering of mirrors and sitting on low stools) following the funeral of a close relative.

SHOAH
from the Hebrew for 'destruction' or 'catastrophe'
Refers to the persecution and killing of Jews during the Nazi era. Tends to be used by those who find 'Holocaust', derived from the Greek for burnt offering, an inappropriate term.

SHTETL
A diminutive Yiddish form of the German word for town, *Stadt*. Denotes small, exclusively Jewish communities that existed within the politically demarcated area known as the Pale of Settlement in Russia and eastern Europe before the Second World War.

SHTIEBL
A diminutive Yiddish form of the German word for room, *Stube*. A prayer room, often situated in a private home.

SIMCHAH
A joyous Jewish celebration, such as a wedding or Bar or Bat Mitzvah*.

SMICHAH
The ordination of a rabbi.

SUCCOTH (or FEAST OF TABERNACLES)
Originating as a Harvest Festival, this commemorates the wandering of the Jews in the desert in Biblical times. Religious Jews live in a temporary dwelling (or Succah) for the seven days of the festival.

TALLIT
The prayer shawl which male worshippers wrap around themselves while praying, both in the synagogue and elsewhere. Jewish feminists have successfully claimed the right to wear a tallit as well.

TALMUD
from the Hebrew root, lammed, *'to learn'; also denotes 'teaching' or 'study'*
A vast body of Jewish law, studied and commented on by scholars throughout the ages. There are two Talmuds from different historical periods, pre- and post- Diaspora*: the Jerusalem Talmud and the Babylonian Talmud.

TORAH
The Hebrew Bible is divided into three sections: the Torah (i.e. the Pentateuch or first five books of the Old Testament), the Prophets and the Hagiographa. It is from the holy Scrolls of the Law (or Torah) that weekly portions of the Pentateuch are read out in the synagogue during Sabbath and Holy Day services.

YAHRZEIT
from the Yiddish for 'time of year'
The anniversary of the death of a parent or close blood relative, usually commemorated by the lighting of a special candle that burns for twenty-four hours.

YIDDISH
from the German word Jüdisch, *'Jewish'*
The language spoken by Jews of German origin, which later spread throughout central and eastern Europe; an amalgam of Old German, Hebrew and Aramaic, written in Hebrew characters. Until the late eighteenth century, women, whose education denied them a full command of Hebrew, often read the Bible, prayerbooks and fiction in special Yiddish versions.

ZIONISM
Although small numbers of Jews had settled in Palestine for many centuries, it was only in the late nineteenth century that the Zionist movement came into being, with the aim of creating a homecoined by Nathan Birnbaum in 1891; Theodor Herzl (1806–1904) became the founder of political Zionism, arguing the case for a modern Jewish state – ultimately established in 1948.

ZOHAR (or BOOK OF SPLENDOUR)
from the Hebrew for 'illumination' or 'brightness'
The classic and most important text of the Kabbalah*, a mystical commentary on the Torah* revered by many Orthodox* Jews as a work of sacred literature.